IMPORTANT INFORMATION INSIDE

Books by John Wilmerding

Fitz Hugh Lane, American Marine Painter　1964
A History of American Marine Painting　1968
Pittura Americana dell'Ottocento　1969
Robert Salmon, Painter of Ship & Shore　1971
Fitz Hugh Lane　1971
Winslow Homer　1972
Audubon, Homer, Whistler and 19th Century America　1972
The Genius of American Painting (with others)　1973
American Art　1976
American Light (with others)　1980
American Masterpieces from the National Gallery of Art　1980
An American Perspective (with others)　1981
Important Information Inside　1983

John Wilmerding

The Art of John F. Peto
and the Idea of Still-Life Painting
in Nineteenth-Century America

Harper & Row, Publishers
National Gallery of Art, Washington

This catalogue was produced by the Editors Office, National Gallery of Art, Washington. Printed by Eastern Press, Inc., New Haven, Connecticut. The type is Electra, set by Composition Systems Inc., Arlington, Virginia. The text paper is Northwest Vintage Velvet. Designed by Frances P. Smyth.

Exhibition dates National Gallery of Art, Washington: 16 January —29 May 1983; Amon Carter Museum, Fort Worth: 15 July—18 September 1983

Published simultaneously in Canada by Fitzhenry & Whiteside Limited, Toronto.
FIRST EDITION

Frontispiece: *Office Board for Christian Faser* (detail), 1881 (fig. 202).

Library of Congress Cataloging in Publication Data

Wilmerding, John.
 Important information inside.
 Bibliography: p. 258
 Includes index.
 1. Peto, John Frederick, 1854-1907—Exhibitions.
2. Still-life painting—19th century—United States—Exhibitions. I. Title.
ND237.P43A4 1983 759.13 82-18963 (paper)
ISBN 0-89468-059-5 (paper)
ISBN 0-06-438941-3 (cloth)

Contents

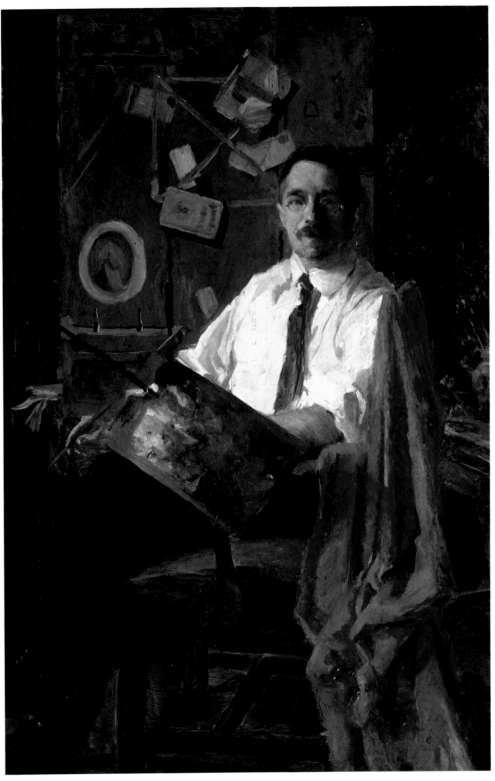

220. Peto. *Self Portrait with Rack Picture*, 1904. Private Collection.

Foreword

The NATIONAL GALLERY OF ART is pleased to join with the Amon Carter Museum in Fort Worth in sponsoring the first monographic exhibition in over thirty years devoted to the art of John F. Peto. One of America's most intriguing still-life painters and evocative colorists, he offers an artistic presence which has been incompletely known until now and which should be a pleasant surprise to our visitors. At the end of the nineteenth century his pictures span a subtle range of moods from the brooding to the whimsical, while his familiar subjects allude to a domestic and materialistic Victorian world, but with unexpected cerebral and emotional overtones.

This exhibition, *Important Information Inside,* has been organized by the Gallery's curator of American art and senior curator, John Wilmerding, who is also the author of this reappraisal of his art. We are indebted to him and the staff of the American art department —Linda Ayres, Deborah Chotner, and Maria Mallus—for their support in the various technical preparations and administrative tasks of bringing this project to fruition. Our thanks, as well, to Carol Clark, curator of paintings at the Amon Carter Museum, for coordinating arrangements at that institution.

The National Gallery, in cooperation with the Amon Carter Museum, is also delighted to publish this book jointly with Harper & Row, Publishers. We hope that both the public showing of Peto's paintings and this well-illustrated volume will contribute to a new understanding of his place in the history of American art and culture. By emphasizing in our selection those paintings that have seldom been seen or reproduced before we hope to reveal new pleasures in looking at the work of this appealing painter.

The exhibition was made possible in Washington by a generous contribution from S. C. Johnson & Son, Inc. We are especially grateful to the Alex and Marie Manoogian Foundation for a grant to increase substantially the number of color plates in this volume. We are also happy to acknowledge a gift from Sandra and Jacob Terner enabling the Gallery, in conjunction with The Dunlap Society, to produce a slide set of works by Peto in the exhibition.

To those who have consented to let us illustrate their examples of Peto's art in this publication, and especially to the several public and private owners of his paintings who have most kindly lent to our exhibition, we express our appreciative thanks.

J. CARTER BROWN
Director
National Gallery of Art

JAN KEENE MUHLERT
Director
Amon Carter Museum

Acknowledgments

THIS BOOK BUILDS ON the well-recognized initiatives in the history of American still-life painting taken by Wolfgang Born, William Gerdts, and especially Alfred Frankenstein, who pioneered in the uncovering of Peto's artistic identity during his work on Harnett. This is a study which seeks to move beyond the biographical and historical facts assembled primarily by Frankenstein, to examine Peto within the complex artistic and intellectual context of the late nineteenth century.

For additional family information and generous access to a good deal of unpublished documentary material, I am indebted foremost to the artist's granddaughters, especially Blossom Bejarano and Joy Smiley, who are working with intelligence and affection to preserve his house, The Studio, at Island Heights, New Jersey. Most of Peto's important work has been dispersed onto the market and into private or public collections over recent decades, and all of the dealers in American art who have handled his paintings at one time or another have graciously cooperated in providing photographs. In particular, Stuart P. Feld and M. P. Naud of Hirschl & Adler Galleries and Lawrence Fleischman of Kennedy Galleries have been exceptionally helpful in making available their extensive files of prints and transparencies of Peto's work.

At the National Gallery, able support has been forthcoming from many colleagues, most notably Maria Mallus and Deborah Chotner, who assisted with the preparation and indexing of the manuscript, and Mei Su Teng and Frances Smyth, who edited and designed the book. Two associates elsewhere, James M. Cox, Avalon Professor in the Humanities at Dartmouth College, and Albert J. Gelpi, Coe Professor of American Literature at Stanford University, have provided the stimulus for many ideas pursued here. The contributions of all these individuals have been indispensable to what follows.

Finally, I want to acknowledge the gracious influence of Andrew Oliver, to whose memory this book is dedicated. He generously touched the lives of many individuals, not least my own.

J. W.

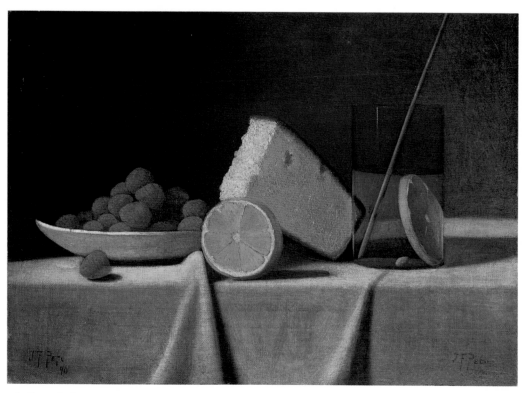

78. Peto. *Cake, Lemon, Strawberries and Glass*, 1890. Collection Mr. and Mrs. Paul Mellon, Upperville, Virginia.

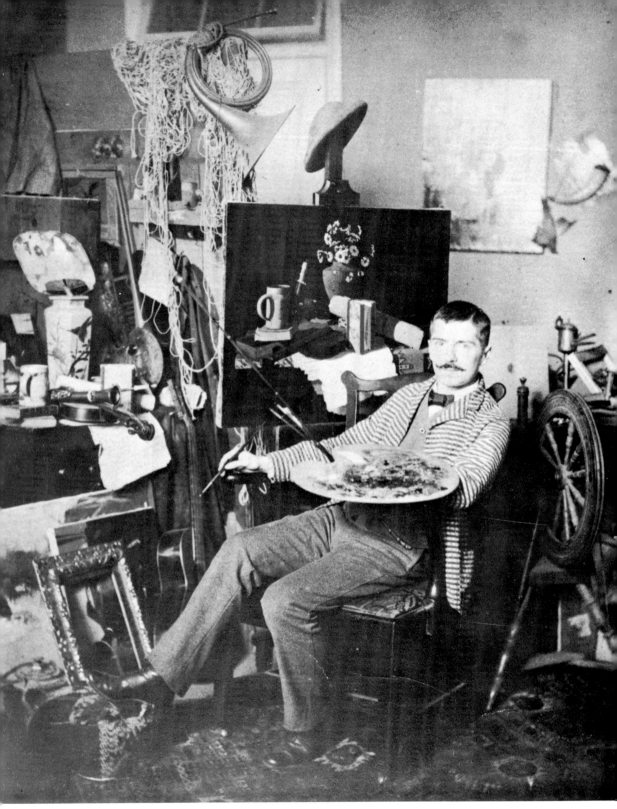

1. Peto in his Philadelphia studio, mid-1880s.

1

LEGAL INTELLIGENCE
The Art of John F. Peto

THIS IS A SPECULATIVE BOOK. It examines the career of an American artist only partially discovered; it contemplates the reasons for that partial appreciation; and it probes the significance of his paintings in America at the close of the nineteenth century. A sustained, close scrutiny of the many still lifes painted by John Frederick Peto of Philadelphia begins to yield clarifications about neglected connoisseurship in this field, provocative correlations with other contemporary currents in American culture, and ultimately the meanings intimated by ordinary and familiar objects chosen for aesthetic attention. What is most clear, ironically, is that the penumbra of incomplete information about Peto's personal and artistic biography has an expressive counterpart in his whimsical, ambiguous, often mysterious images.

Peto himself, from the few personal accounts and documents we have, appears to have been a bit of an eccentric, and the idiosyncracies of personality and habit we are conscious of have been accentuated by his reclusive later years and hermetic creative life. A photograph taken of him as a young mature artist (fig. 1) shows him in his studio in a comfortable and self-possessed relationship to the surrounding artifacts of his work. Born in 1854, he looks here to be in his late thirties, just about at that moment of confidence when his painting was emerging with a personal style and expression in its own right. This would also be close to 1889, the major turning point in his mature career when he moved from Philadelphia to settle permanently in Island Heights, New Jersey.

A typical canvas of this period (compare fig. 104) rests on an easel behind his chair. Peto assumes a notably relaxed pose, almost slouching, as he leans to one side, stretches out his painting hand and rests his right foot on a hassock. His gaze is open and direct, and by it we are led first to notice his assured presence, then the finished still-life painting behind, and finally the density of accumulated objects nearby. In this surrounding clutter are his raw materials, the domestic bric-a-brac which Peto spent his creative energies alchemizing into art. Recognizable at his feet in the lower left of this photograph are several canvases and prints, evidently not his own work, whose imagery found its way into some of his compositions (see figs. 141 and 144). The various musical instruments which would make up an important series of pictures for him are here (figs. 128 and 132): by Peto's knee stands a guitar, on the table at the left lie a violin and clarinet, while on the wall at the back hangs his cornet (see fig. 143). Also standing on this table are other objects ubiquitous in his work: the double-striped mug and candlestick (figs. 34 through 41). On the table to the right we note the familiar pipe, lard oil lamp, and powder horn hanging above (see figs. 124 and 143). Among the rarer objects he included in his paintings were antiques such as the Chinese vase

and Japanese fan seen here at the left (fig. 128). Generally Peto preferred the commonplace to the rarefied; artifacts like these had perhaps too precious and fragile a quality for his sensibility.

It remains to point out the prominence, conscious or unconscious, given in this photograph to recording Peto as an artist. A portrait of an individual in his intimate professional milieu, it gives special and central attention to the palette held in hand before us, brushes at the ready, as if fresh from work on the very canvas nearby. But also noteworthy on the table to the left is another painter's palette, obviously stood upright intentionally to be seen within Peto's scheme of things here. For this artist we shall see that the palette was both a functional agent of making art as well as an object itself capable of being transformed into art (see figs. 148 and 149). Of course, we can never fully know how planned the conjunction of artist, artifacts, and works of art was in the posing and taking of this image. But it is obvious that Peto's artistic life was foremost within his studio, where resided the materials of knowledge, culture, and art. He immersed himself in the clutter of this world, and as his best images make clear, he so selected and invigorated things that his still-life art was truly an act of salvaging order out of chaos.

To confirm that this is not an accidental or arbitrary reading of the life of this artist we need only turn to his one painted *Self Portrait with Rack Picture* (fig. 220), executed in 1904 at the end of his life. While a more simplified composition than the youthful photographic portraits, it retains much of the attitude and spirit of juxtaposition of that work. Again palette, painter, and picture coalesce into a statement about the inseparability of this man from his work. What we learn is that Peto's art was his life, that his still-life arrangements were indexes of his autobiography, and that his work was about the mysterious struggle of creation.

Fortunately, this book does not have to unearth and narrate Peto's biography, for most (though not all) of the facts as are generally known have been gathered in Alfred Frankenstein's various studies, the summary one being *After the Hunt: William Harnett and Other American Still Life Painters, 1870-1900*.[1] Born on 21 May 1854, Peto was one of four children of Thomas Hope and Catherine Ham Peto. During the 1860s the future artist's father was in business as a dealer in picture frames, a profession which must have brought canvases and prints to the young boy's attention and possibly channeled the direction of his own intellectual interests. Subsequently, the senior Peto served as an honorary member of the Philadelphia Fire Department, and one of the son's first and few professional portraits was that of his father at age forty-nine as *The First Fire Chief of Philadelphia* in 1878 (fig. 2). It is a competent enough image, with the torso and head solidly and centrally placed, the features broadly blocked in. A firm, no-nonsense likeness, its simplicity of form as well as its isolation against a dark undefined wall anticipates the painter's continuing interests in somber, carefully massed still-life objects.

Many years later Peto photographed his father as an old man, on the occasion of a parental visit to the artist's Island Heights house (fig. 3). With his wife, the elder Peto is carefully seated against one of the studio walls, a spare selection of still-life objects arranged on the table and wall behind them. Like his own self-portrait, this composition reflects Peto's characteristically thoughtful posing of forms, whether human or still life. Thomas Peto

maintained an active business into the 1890s as a buyer and seller of fire department supplies, and the familiar presence of his various business cards and printed invoices (figs. 4 and 5) later provided the personal scraps of paper often incorporated into his artist-son's pictures (see figs. 162 and 202).

Peto was evidently devoted to his father, and Frankenstein has proposed that the young man may have taken up another of his pursuits, playing the cornet, through acquaintance with the fire department's activities, such as parades and recreational band music.[2] Peto did not grow up with his parents but lived instead with his grandmother Mrs. William Hoffman Ham until he was in his mid-twenties. Nonetheless, he cared enough for his father to have painted in 1904 an unusual trompe l'oeil tombstone plaque, *Memento Mori for Thomas Peto* (fig. 6), reminiscent of the family business signs. And during the decade following his father's death in 1895 Peto painted a series of so-called rack pictures (figs. 182 through 184) notable for their imagery of Lincoln, whom the painter appears to have identified as another lost father figure. While this group will receive fuller scrutiny later, it is worth noting here that in one of these paintings, *Reminiscences of 1865* (fig. 174), a painted calling card next to the Lincoln photograph appears to read in part, "Head of the House." A hanging bowie knife obliterates the first word, as if referring to two lives cut down by death, individuals who were heads of national and personal families, respectively. Such psychological issues only hint at the complex meanings Peto buried in his later still-life paintings. Like the phrases he inscribed on some of his canvases, such as "Legal Intelligence" and "Important Information Inside," there are repeated playful references to ideas, facts, or knowledge that ambiguously conceal as much as they reveal. The death of Thomas H. Peto was but one of those biographical events which resonate in his son's often enigmatic, eloquent

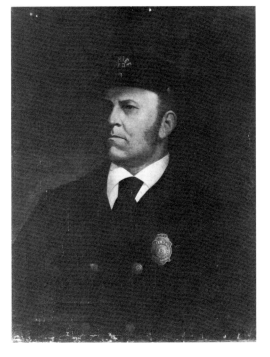

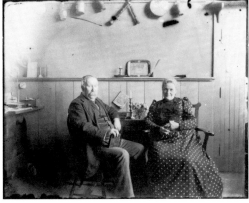

2. Peto. *The First Fire Chief of Philadelphia: Portrait of the Artist's Father*, 1878 *(left)*.
3. Peto. Thomas Hope and Catherine Ham Peto in the Island Heights studio, early 1890s *(right)*.

4. Business invoice of Thomas H. Peto, 1890s *(left)*.
5. Business card of Thomas H. Peto, 1890s *(right)*.
6. Peto. *Memento Mori for Thomas Peto, 1904 (below)*.

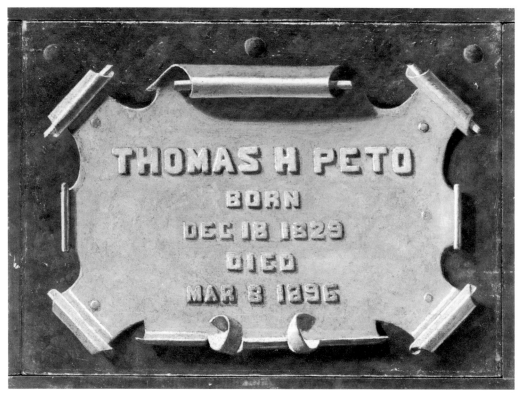

meditations on the mortality of things.

From his childhood Peto had taken an interest in drawing and sketching. As a boy he had filled up more than one album with pencil vignettes of local scenes and details, observed barns and imagined castles, single birds or animals (figs. 7 and 167). Also in his youth he executed several flower studies in watercolor (fig. 8). In a few instances we can find visual notations, such as a clump of grapes or head of a dog, which actually became subjects

for his paintings many years later (see figs. 81 and 164). By the mid-1870s he had committed himself to be an artist: his first known dated picture survives from 1875, and the following year the Philadelphia city directory carried his first listing as a painter. A tintype of him taken by a Lynn, Massachusetts, photographer on 29 June 1877 (fig. 9) shows a self-confident young man dressed in the uniform of the Third Regiment Band of Philadelphia and holding the cornet he would enjoy playing for the rest of his life. There are other studio photographs taken at this time in which he poses in different formal attire, sometimes holding a derby hat and cane, more often his favored cornet (fig. 10).

In 1877 Peto enrolled at the Pennsylvania Academy of the Fine Arts, and periodically over the next half dozen years he contributed works to its annual exhibitions. Through most of the 1880s he maintained a studio, generally on Chestnut Street, though in a different block every year. Nearby were a number of paintings dealers, several of whom carried the work of both Peto and his colleague William Michael Harnett (1848-1892). Models frequently came to these studios to pose for photographs, and it is clear from surviving glass

7. Peto. Childhood sketches of boat and buildings.

8. Peto. *Apple Blossoms*, probably 1860s.

plate prints that Peto himself had begun working with a camera. On one occasion he stood for a shot with three of the models, his violin in hand, and on another with his friend Harnett, this time holding the instrument to his chin (figs. 11 and 12). In the second photograph, the two painters look to the camera, presumably operated by one of the models whose head is just vaguely visible in the lower left corner of the mirror. This last certainly gives us a friendly and collegial picture, partially dispelling the repeated notion that these two men were bitter rivals and artistic enemies.

One intriguing speculation is that Peto most probably gained his fascination with the camera from the well-known Philadelphia photographer William Bell (1830-1910), who had married his aunt Louisa Ham. On the reverse of a photograph of the young Peto, now kept in one of the family albums at Island Heights, an inscription by his daughter Helen Smiley reads, "Your father when a boy," and the printed caption, "Bell, Photographer, 1200 Chestnut St., Philada., Pa." For two years Peto rented quarters but a block from Bell's address, in a building owned by Weber and Company, the most prominent local supplier of artists' materials. He regularly procured his canvases and pieces of academy board from

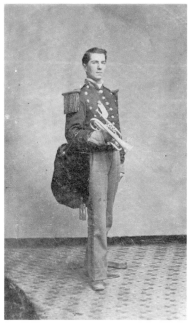

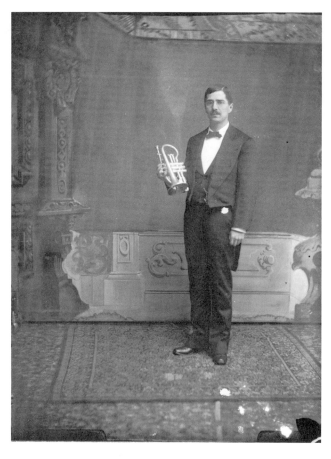

9. Unknown photographer. Peto in the Third Regiment Band of Philadelphia, 29 June 1877 (above). 10. Peto in a Philadelphia studio, 1870s (right).

Weber, and it seems likely he participated in a lively interchange with other artists who traded there.

Bell had been born in England, but was active in Philadelphia by n. ' .:ury, exhibiting there in 1851. He began as a Daguerrean photographer and worked as chief photographer for the Army Medical Museum in Washington during the later 18$0s. Returning to Philadelphia in 1869, he bought out the studio of James E. McClecs and was active in the city through the seventies, taking stereo views of local buildings and streets. Bell remains best known today for his work with Lt. George M. Wheeler's government survey expedition of the 100th meridian in the western territories during 1872.[3] From his Philadelphia days on, Peto enjoyed taking carefully posed photographs (see figs. 9 through 14). Whether or not directly inspired by Bell, his photographic experience may well have contributed to the sense of astutely arranged still-life subjects in his subsequent paintings.

After a decade of work in Philadelphia, Peto's professional and personal life came to a turning point. In 1887 the artist went to Cincinnati, evidently on commission to paint a canvas for the Stag Saloon (fig. 142). There he met Christine Pearl Smith from nearby suburban Lerado, Ohio, and the two were married that June.[4] Fifteen years younger than he was, she posed wistfully for his camera not long after (fig. 13). Her striking auburn hair and

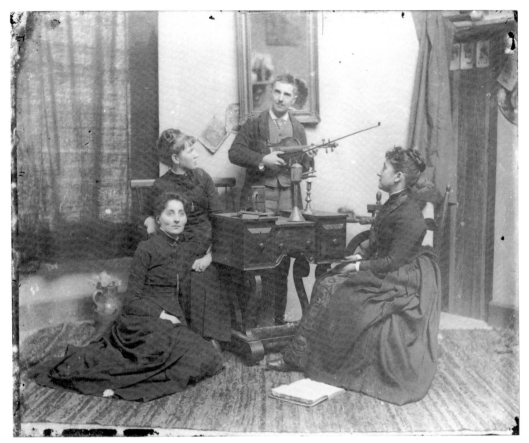

11. Peto with models, Philadelphia, 1870s.

sky-blue eyes, according to a granddaughter, must have particularly caught his painter's eye. About this time Peto also began visiting Island Heights, New Jersey, a resort community on the coast near Toms River. There he was in continual demand to play the cornet for local camp revival meetings.

In those years the area was still largely open fields with occasional groves of trees descending gently to the river just before it opens out to Barnegat Bay and the Atlantic Ocean (figs. 14 through 16). Nearby Seaside Heights and Island Beach were attractive spots for vacationing Philadelphians, and handsome Victorian summer houses dotted the coast here as they did farther north at places like Long Branch, painted so memorably by Winslow Homer after the Civil War. For a while Peto continued to travel back and forth to Philadelphia, but his obligations as cornetist and the appeal of this gentle countryside increasingly captured his attention (fig. 14). Toms River had one of the oldest established yacht clubs, and the sailing activity off its alternating low bluffs and beaches stimulated him to paint one of his rare landscapes (fig. 15). *Afternoon Sailing* is a simply composed work of generally blond coloring, giving little hint of the darker compressions in his typical still-life paintings, though it does capture the area's pastoral charm, which he also caught in a photograph of his visiting in-laws and young daughter at the river's edge (fig. 16).

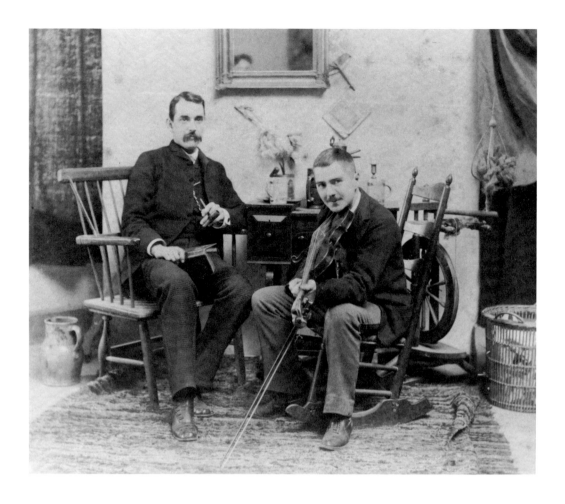

In 1889 Peto decided to build a house in this shore community and to move there permanently. He chose a site in what was then open fields, about half a mile up from the riverbank. This would have given him some protection in the blustery winter months as well as a more sweeping view, now obscured by other houses, down across the water. The house he built and photographed (figs. 17 and 18) is a comfortable wood structure still occupied by the artist's descendants. A large veranda surrounds the front corner; on the second floor various small bedrooms are fitted into the eaves and gables rising above. In one of the smaller rooms on the front, which Peto occasionally used as a quiet study, he painted a trompe l'oeil mural of an extended shelf of books running around the entire room (see figs. 112a and b). At the back, facing a side street, is the largest room of the house, Peto's studio (fig. 18). Rising almost a full two stories up to its exposed rafters, and punctuated by windows opening both outward and into the adjacent hallway, this spacious room contained his easel, piano, and countless objects used in so many variations on his canvases. What is striking about the dark interior passageways, the compact massings of forms, the variegated patterns and textures of wood shingles, and the playful contrasts in the silhouetted lines of the gabled roof, is how close in spirit this dwelling is to Peto's still-life arrangements (see figs. 117 and 126).

Peto later built a barn and a playhouse nearby. As a child he had sketched in his album

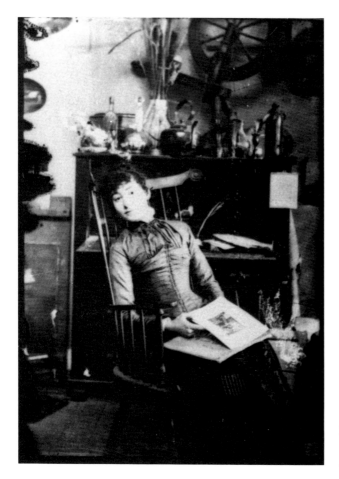

12. Peto and William M. Harnett in Peto's Philadelphia studio, 1870s *(left)*.
13. Peto. Christine Smith Peto in the studio at Island Heights, 1890s.

different farm buildings on land belonging to his family in upstate New York, and these provided occasional subjects for paintings. Typical is *Landscape with Duck Pond* (fig. 19), one of a few such scenes he painted. Several details suggest that this is a relatively early work based as much on memory as on observation: its careful tight signature, bright coloring, and elements of genre. The self-consciousness of the barn's angular volumes and the orderly disposition of the landscape's components not surprisingly recall the sense of design in his own house. After the turn of the century Peto drove his family on visits to Harper's Ferry, West Virginia, a trip of some two hours. There he painted in 1907 a colorful view of the famous hillside town (fig. 20), in which the bright blocks of buildings appear piled across the landscape like so many books, pots, or inkwells on a studio shelf (compare fig. 122). Always in the rare scenic or genre works that he tried Peto thought in still-life terms, so that his landscapes acquired the intimate charm of an interior studio arrangement, while his actual still-life paintings aspired to the monumentality and breadth of a personal landscape environment.

At Island Heights Peto apparently was a well-liked, sensible, and practical individual. From all family accounts he was certainly a devoted father. The Petos had one child, Helen (fig. 21), to whom the artist gave special affectionate attention. He built her a playhouse of

14. Peto on Holly Avenue, 1893.

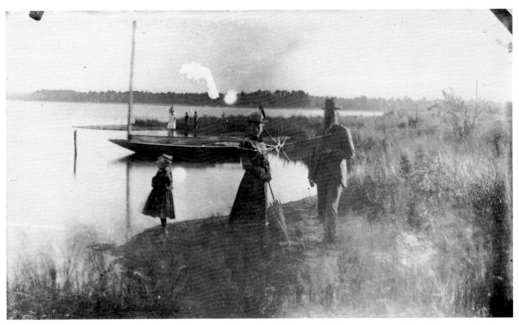

16. Peto. The artist's daughter Helen with his parents at Toms River, early 1890s.

15. Peto. *Afternoon Sailing*, 1890s *(right)*.

her own and made a point of writing her letters and cards on his travels. On the occasion of her birthday he painted an illusionistic letter picture for her, and he frequently photographed her ethereal image as a child (see figs. 171 and 172). He later incorporated these portrait photographs into some of his paintings (fig. 170).

Years after her father's death Helen recounted that her family's life was often turbulent and not always happy. Peto's three maternal aunts were constantly present, and two came to live in the Island Heights house. Although one was strongly supportive, the other was demanding and troublesome, causing strain between Peto and his wife. Ultimately this aunt in senility had to be confined to her room upstairs, frequently rattling her door while in his studio below the beleaguered artist kept at his painting. In one haunting photograph from these years (fig. 22), he captured the forceful presence of these three women—Margaret, Maria, and Louisa Ham—seated on a branch as if in a woodland still life.

Other painful difficulties impinged on Peto's later life. His mother, Catherine Marion Ham, had an aunt Caroline whose family owned two hundred and fifty acres of apple orchards going down to the Hudson River in Red Hook, Duchess County, New York. A dispute over the land with her lawyer resulted in an unpleasant and time-consuming lawsuit, to which Peto was forced to give a tiring amount of his energy. At issue was the control which Caroline Ham's lawyer and companion, Frank S. Ormsbee, had exercised over her in her later years. In 1896 he persuaded her to deed to him much of her land in Red Hook, and even with family around or visiting he controlled her finances. When she died in 1899, the property went to Ormsbee, precipitating the fight by Peto and his relatives to regain their inheritance. In testimony given in the New York Supreme Court, Duchess County, Peto, his mother, and a local neighbor, Charles R. Cole, described Caroline variously as "utterly and absolutely incompetent to attend to any business . . . [of] weak and unsound mind and condition . . . thoroughly incompetent to engage in any sustained conversation, or suggest

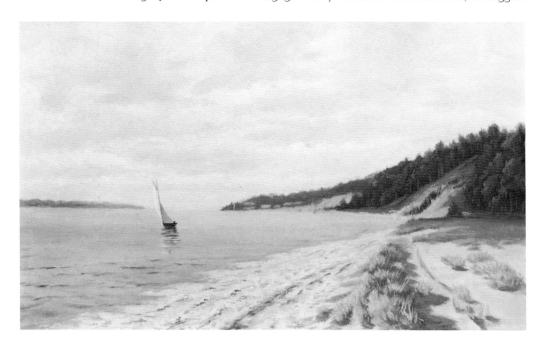

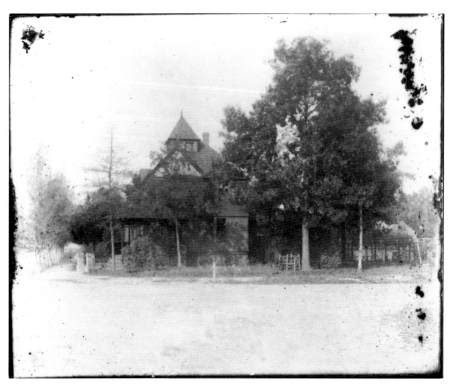

17. Peto. The Studio, front view, 1890s.

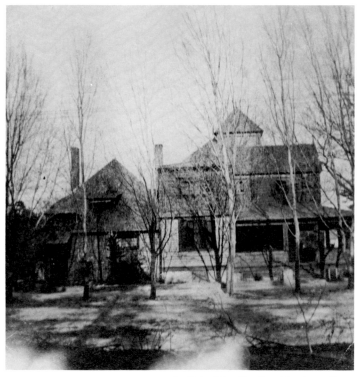

18. Peto. The Studio, side view, 1890s.

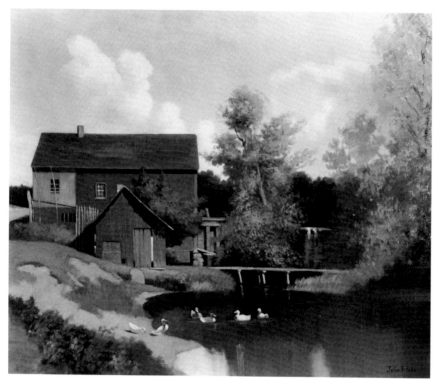

19. Peto. *Landscape with Duck Pond*, probably 1880s.

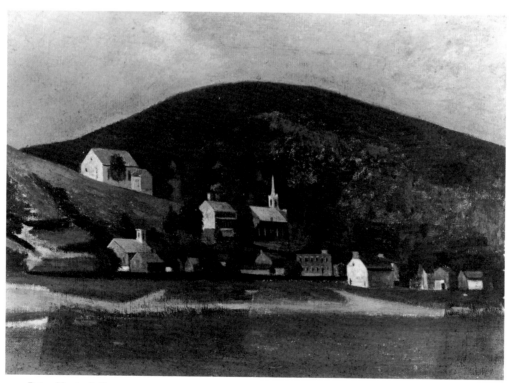

20. Peto. *Harper's Ferry*, 1907.

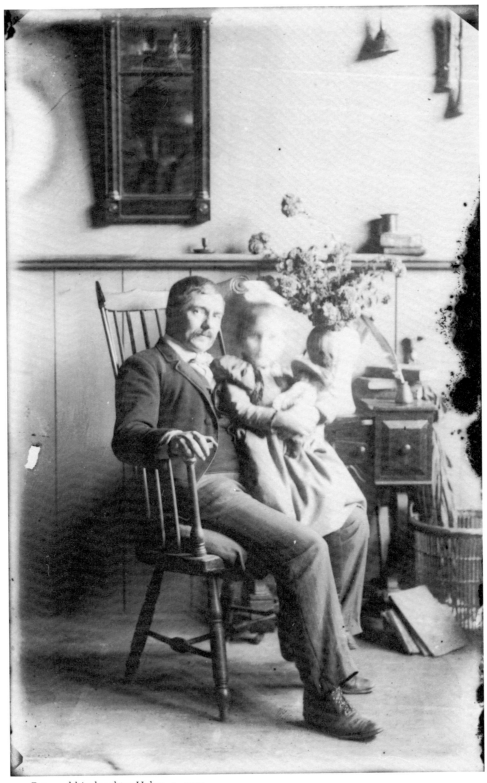

21. Peto and his daughter Helen, c. 1900.

anything of a sensible nature. There was a lack of intelligence, not through any want of education but a feebleness of mind." Peto further recounted that his aunt was "very illiterate, with an impediment in her speech which made it exceedingly difficult not only for herself but all others to have any dealings with her." Cole added that she was "suffering from a stroke of paralysis." Ormsbee had obviously ingratiated himself with Caroline totally, and he fought long and cleverly against "those damned Philadelphia heirs." Peto had to travel frequently to Poughkeepsie, with his own early death occurring before the case was settled.

To this familial disquiet was added for him the lingering suffering of Bright's disease. Helen told her own children about her memories of being sent to the barn or playhouse when the doctor came to examine her father; from the house would come Peto's anguished cries of pain as his kidneys were prodded in some treatment or other. She also recalled his consuming countless bottles of quack medicine supposed to dissolve the kidney stones. Peto was actually on a visit to New York when his final attack came. One day in November 1907, he went to a doctor in Greenwich Village, who performed some operation on Peto in his office. Peto then walked all the way up to 86th Street and Riverside Drive to his sister's apartment. He was feverish, and his wife Christine was called the next day. She sat at his bedside for four days, but he failed quickly. The morning of the fifth day he roused sufficiently to squeeze her hand and say, "You've been a good wife, Pearl," after which he lapsed into unconsciousness. With complications of high blood pressure Peto died at the age of fifty-three.[5] It should not be unexpected, then, that the work of his last years is often qualitatively uneven, sometimes unfinished (see figs. 177 and 211), and tinged by an air of sad exhaustion.

Such a fragmented outline of this artist's life only introduces us to some of the complications which have shaped our perceptions of his painting and its place in the history of American art. Almost from the first moment he was discussed in the literature, Peto was misrepresented, his pictures confused with those of Harnett. The first comprehensive effort to survey American still-life painting was Wolfgang Born's pioneering *Still-Life Painting in America* published in 1947.[6] In this book Born identifies Peto as a separate figure, although for understandable reasons a number of paintings now clearly recognizable as his are reproduced as Harnett's. After all, Peto led an insistently withdrawn life from the mainstream of Philadelphia art activities and exhibited only a few works at the annual exhibitions of the Pennsylvania Academy, and these all before his removal to Island Heights, New Jersey.[7] Harnett, on the other hand, became solidly established early in his career, remained preeminently popular throughout his lifetime, and left for our century a generally familiar and well-documented oeuvre.

Thus Harnett emerged foremost with an orderly career. His own early works were undeniably an influence on his slightly younger friend and colleague during their days at the academy in Philadelphia. Even later Peto was to take subjects, attempted only once or twice by Harnett, and make his own multiple versions. Although as a rule these acquired new personal meaning and an original power quite independent of Harnett, they have nonetheless been obscured by his shadow. Initially, almost all subjects associated with the two artists—pipes, mugs, books, rack and door compositions—were given to Harnett. As obvious stylistic variations became more clear, he was thought to have worked in two distinctive

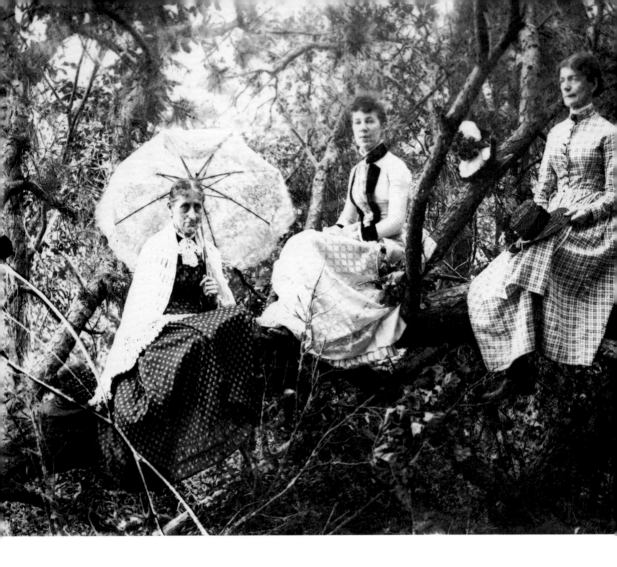

manners: one tight, jewellike, and rational; the other softer, more painterly, and romantic. It was under this latter rubric that many of Peto's textured, even sensuous, images were credited to the supposedly protean artistic personality of Harnett.

Alfred Frankenstein also began to publish his important research on Harnett and Peto during the 1940s, and a Guggenheim fellowship enabled him to prepare his major study on these artists and their colleagues in 1953. Leading up to his book's publication was the appearance of parts of it as articles in *Antiques* magazine, *Art News*, and elsewhere. Accompanying one essay in *The Art Bulletin* in 1949 was a sensitive analysis of the stylistic differences between Peto and Harnett by Lloyd Goodrich. At the same time, in conjunction with a small exhibition of Harnett's *After the Hunt* series and related pictures (see fig. 24), Frankenstein summarized his findings on that influential image. And for the Brooklyn Museum he assisted in organizing the first comprehensive exhibition of Peto's work in 1950. The accompanying catalogue was subsequently adapted as a chapter in his book.[8] For publication in conjunction with later, more comprehensive exhibitions of this tradition in nineteenth-century American still-life painting, Frankenstein updated his original corpus of work as newly discovered paintings came to light.[9]

22. Peto. The artist's maternal aunts: Margaret, Maria, and Louisa Ham, 1890s.

Frankenstein's *After the Hunt* has generally been accepted by scholars since its publication as the definitive treatment of trompe l'oeil still-life painting in Victorian America. Recognized virtually as a model of detective work, it traces the first revival of Harnett's work in the 1930s, noting the important exhibition of his painting at the Downtown Galleries in 1939, which included a number of Petos with forged Harnett signatures (see fig. 210). This confusion continued in Born's 1947 still-life book, and led Frankenstein to attempt separating the two hands. Conclusively documenting Harnett's life and career and including an indispensable catalogue raisonné of his paintings, Frankenstein also provided summary chapters devoted to Peto, John Haberle, and the younger, sometimes lesser figures of the following generation. Methodically, through records, photographs, and interviews, he described Harnett's artistic personality and in effect created Peto's.

Conservation examination of certain crucial works permitted Frankenstein to recognize incorrect signatures and, more importantly, to characterize some of the essential stylistic differences between the two painters. For example, whereas Harnett usually worked on fresh canvases, made few changes as he proceeded, painted rather thin backgrounds, and almost always signed and ordinarily dated his pictures; Peto frequently reused or reworked

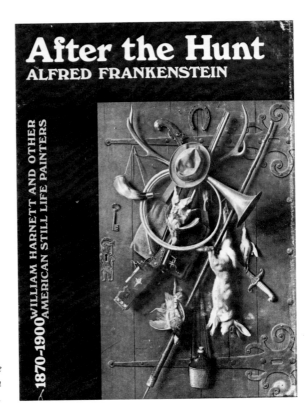

23. Cover of Alfred Frankenstein's *After the Hunt: William Harnett and Other American Still Life Painters*, 1870-1900.

his canvases, altering both minor and major details, painted with thick and solidly textured pigments, and often left his paintings unsigned, undated, and even unfinished.[10] In the revised edition of his volume, published in 1969 sixteen years after the first printing, Frankenstein admitted he had insufficiently delineated Peto's style and newly set forth a perceptive distillation of several key aspects: his art's "baroque restlessness" and its "strong undercurrent of violence"; his own isolation which put him "out of tune with the Gilded Age"; and his stylistic anticipation of such modern artists as Robert Rauschenberg (see fig. 188).[11]

Yet, if ever the cover of a book revealed its substance, Frankenstein's would surely be a case in point (fig. 23). It takes its title from and reproduces *After the Hunt*, Harnett's most famous image. One of the artist's largest and best paintings, it undeniably had a pervasive influence on subsequent variations by other younger colleagues. Indeed, Frankenstein devotes approximately half of his book to Harnett, while the section given purely to Peto represents but a tenth of the whole. This division in part reflects the differing quantities of information accumulated, respectively, about each painter. But this title, and its relationship to the subtitle, *William Harnett and Other American Still Life Painters*, judges and compartmentalizes Peto from the outset as a follower, with all the implications, whether intentional or not, of being lesser in quality and significance.

This assumption is embedded in ironies, for the very book which first resuscitates Peto's reputation relegates him in the title to the status of an anonymous "other." Further, while Peto was often initially indebted to Harnett's pictorial precedents, the cover image of *After the Hunt* was, despite Harnett's masterful technical abilities, itself derived from a

German photographic source (figs. 24 and 25). Thus the relationship and comparison between these two American rivals are unexpectedly complex issues, and have confounded much of the scholarship in American still-life painting published since Frankenstein's investigations.

Unquestionably, the most important and ambitious examination of this material to be undertaken since Born's and Frankenstein's work of the late 1940s/early 1950s was the collaborative volume *American Still-Life Painting*, published in 1974 by William H. Gerdts and Russell Burke. Their study has been significant in bringing to light many heretofore little-known figures and in illustrating the entire field extensively in black and white as well as color. Although this book breaks much fresh ground, even establishing its authors as the foremost authorities on the material, probably its most traditional chapter is that covering Peto. Entitled "Trompe l'oeil: William Michael Harnett and His Followers," it accepts and confirms the precedents of Frankenstein's views, seeing Harnett as the central shaping figure of his generation.[12] Indeed, Gerdts and Burke pay tribute in their opening paragraphs to their predecessor,

largely through whose efforts we know so well the work of the artists treated in this chapter. . . . Frankenstein's documentation of Harnett's career is more complete than any of the other artists; Harnett merits it—a fact recognized both now and in his own lifetime. . . . Frankenstein really covers Harnett well and completely. For that reason, the authors would like here to acknowledge their debt. . . .[13]

Gerdts and Burke credit Frankenstein with establishing Peto as "the second most important artist of the American trompe l'oeil school," though they themselves prefer to see him as "the most individual of all the followers of Harnett."[14] "Perhaps the finest of all the followers" they judge to be Jefferson David Chalfant (1856-1931).[15] At the same time these authors sensitively distinguish between the convivial domesticity and bright palette of pre-Civil War still lifes (see figs. 28 and 30) and the sense of pessimistic isolation and the darker tonalities of Harnett's world. The work of both Harnett and Peto correctly relates on the one hand to the antisocial reclusiveness seen in Winslow Homer, Thomas Eakins, and Albert P. Ryder, and on the other hand to Victorian tastes for bric-a-brac and antique collecting. Less convincing is the application by Gerdts and Burke of the term luminism, generally defined as a distinctive type of landscape painting, to Peto's interior subject matter.[16]

This basic appraisal of Peto has consequently found its way into most other recent publications, whether devoted to focal aspects of American still-life painting or to broader surveys of the field. For example, Theodore E. Stebbins writes in his definitive monograph on Martin Johnson Heade that

the third—and, in a sense, final—generation of realistic still-life painters is now best known for the hard-edged realism, somber colors, and "masculine" subjects of William Harnett and his chief followers, John F. Peto (1854-1907) and Jefferson David Chalfant (1856-1931).[17]

The approach of most histories of American art has been similar. Oliver Larkin's famous *Art and Life in America* was a prize-winning and, for many years, standard textbook in the field. The first edition, published in 1949 before the appearance of Frankenstein's research, had close to nothing on late nineteenth-century trompe l'oeil painting, but even the

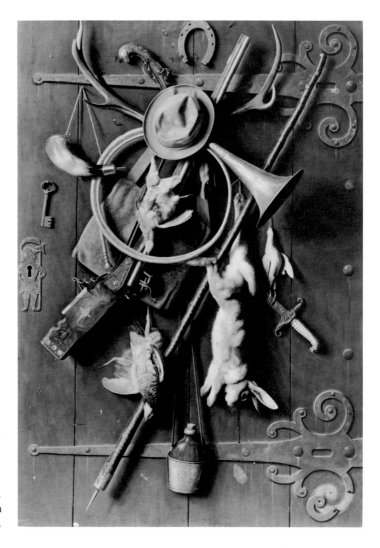

24. William M. Harnett. *After the Hunt* (fourth version), 1885.

second revised edition of 1960 only mentioned Peto's name and gave just a few lines to Harnett. The equally distinguished writing of E. P. Richardson did little more than quote Frankenstein directly, suggesting that Peto's art was "neither so lustrous nor so forceful as Harnett's" but nonetheless possessed a "touching and appealing quality that is indescribable."[18]

Occasionally, historians have attempted a thoughtful broadening of the perspective, usually in the context of probing the stylistic differences between the painters. So Matthew Baigell asserted that

Harnett was the more disciplined, exhibiting a wider interest in varieties of objects and their textures. Peto, who worked within a more loosely conceived structural system, manipulated color more freely. Harnett's work is the more tactile; Peto's emphasizes pictorial qualities.[19]

Likewise, in her notably influential book of 1969, *American Painting of the Nineteenth Century,* Barbara Novak understandably turns from her passionate scrutiny of the crystal-

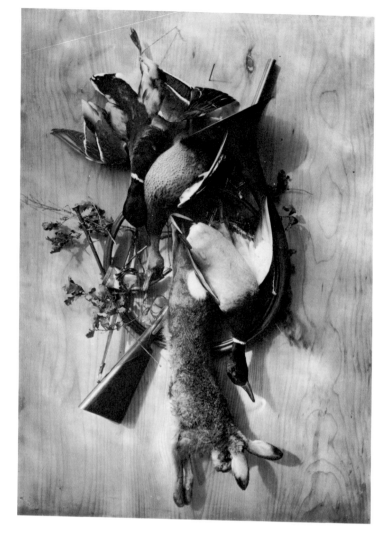

25. Adolphe Braun. *Hare and Ducks*, c. 1860.

line designs of luminist landscape painting to the formal clarities of Harnett's vision. She includes a sympathetic, though parenthetic, reading of a contrasting work by Peto (fig. 210), in which

the light cascades down over the objects carefully tilted to receive it, and in that flicker of light, the sense of weight, of gravitational pull, somehow disappears. This is understandable, since Peto . . . at times tended to place design, light, and color factors above object reality, and in this picture, the feeling for paint never gives way to the alchemistic transmutation into literal texture that characterizes Harnett's work.[20]

But all this comes in a chapter which is titled "William Harnett, Every Object Rightly Seen," and which concludes, speaking about that painter's work, "At their best, they are perfect pictures."[21]

Milton Brown's comprehensive textbook of 1977 in part follows the observations of Gerdts and Burke while also introducing some fresh insights. He admits Harnett's greater success, but stresses Peto's originality with the form of the so-called rack picture (see figs.

207 through 211). Peto is cast now as an "admirer" of Harnett, at once more tragic and more anecdotal and sentimental. Significantly, Brown compares Peto's aspirations to elevate the commonplace to the monumental, the humble to the immortal, with the eighteenth-century images of Jean-Baptiste-Siméon Chardin (1699-1779) (see figs. 69 and 70). In this spirit he speculates that Peto

was not really a *trompe-l'oeil* painter . . . he merely used *trompe-l'oeil* subjects. . . . The feeling for paint is always more pronounced than the illusion of reality, and in that sense Peto is often a more satisfying painter than Harnett. Despite a tendency to clutter in his paintings, the strong shadows create an abstract pattern of volumes and an unexpected nobility. [22]

When we turn to the several substantial exhibition catalogues recently devoted to Peto's period, few can find a place for him. Though a case might be made for connecting his art respectively to the style of tonalism, the subjects of symbolism, and the period of the turn of the century, Peto's name or art is nowhere mentioned. [23] Rather, in the surprising context of a discussion by Roger Stein of American marine painting is to be found a brief but pointed commentary on Peto. Following his thought that in the work of Albert Ryder the artist is calling "renewed attention to the act of painting itself," Stein shows how Peto similarly addresses the nature of his art. By painting illusions of his own earlier canvases within his picture (see fig. 165), Peto forms the "message that we are dealing with a pictorial past." [24] This concern with the life of art will be a crucial clue to Peto's quite independent originality, and will occupy our attention repeatedly hereafter.

Thus, in joining the issues of Peto's artistic achievement, we need not lower our estimation of Harnett. But due to a number of interlocking factors our inherited assessment of Peto is at least arguably uncertain and incomplete. Because the level of Harnett's technical accomplishments was so consistently high, and Peto's by contrast so distractingly uneven, we have not exercised sufficient connoisseurship in evaluating the latter's work. The fact is that Peto's best paintings are not merely very different from Harnett's; they can ultimately be seen to carry profound meanings and feelings of their own. Peto's personal withdrawal from the artistic mainstream, the fragmentary nature of records, the dearth of his pictures appearing in contemporary exhibitions or in the subsequent art market—all have helped shape the image of a disorderly and flawed oeuvre.

One inhibiting factor in the appreciation of Peto has been the fact that barely a handful of his paintings have been reproduced in color [25]—significant since, far more than Harnett, he is one of the most evocative colorists in American art. Actually, a good deal of Peto's work, much of it among the most touching and revealing he did, is simply unknown and unpublished—for example, his landscapes, his portraits, his early glass-plate photography, and his still lifes of food. Frequently it is among this unfamiliar material where we come upon a vision of great tenderness and power, and of old traditions made modern.

Notes

1. Alfred Frankenstein, *After the Hunt: William Harnett and Other American Still Life Painters, 1870-1900*, rev. ed. (Berkeley and Los Angeles, 1969).

2. Frankenstein, *After the Hunt* (1969), 99. An undated and unidentified newspaper clipping in the Peto family albums at The Studio, Island Heights, New Jersey, gives a glimpse of Thomas Hope's company and their activities:

> ### The Hope's Trip to New York
> The Hope Hose, S. F. E. Co., No. 2, of Philadelphia, will participate in the Civic procession on Wednesday. They will assemble in their hall, Pine street above Second, on Tuesday evening, April 30, at 7 o'clock, full equipped, which consists of dark blue fire coats, black pants, red shirt, black neckties, buff gloves, black fire hats with white front, belts and fatigue caps. They will take with them their original steam fire engine, which has been in service since 1858, and the first steam engine that ever played in the City of New York; also their silverplated hose carriage.
>
> They will proceed to New York by the Pennsylvania Railroad, after making a short street parade. . . .

In 1894, Thomas Peto wrote to his son with a special request. Dated 7 September, the postcard, now in the Archives of American Art, reads in part: "If I send the front of my fire hat out to you will you paint a picture of a hand engine on it . . .?"

3. Another family document (at The Studio, Island Heights) indicates that Peto at one point studied architecture, though with whom is not known. Possibly such work was done with an instructor at the Pennsylvania Academy or as apprentice with some other professional in the city. Peto was apparently also commissioned as a young man to design a large ornate monument of a general astride his horse. The figure's outstretched arm holds a banner, while below a mythological head dominates a fountain incorporated into the stone base. One of Peto's in-laws was the Reverend Tomlin of Trinity Church in Rittenhouse Square, and he was on the commissioning committee with a Dr. Swan, who ultimately presented the statue to the city. Now torn down, the piece is known only from an old stereo photograph in the Peto family albums at Island Heights. On the back it bears the inscription: "Fountain designed by John F. Peto. 19th and Walnut st. (Rittenhouse square) Philadelphia Pa. Presented by Dr. Swan to the city." The family believes Peto was about twenty-six at the time he undertook this project.

For further biographical details on Peto at this time see Frankenstein, *After the Hunt* (1969), 99-100; for information on Bell see Kenneth Finkel, *Nineteenth-Century Photography in Philadelphia, 250 Historic Prints from the Library Company of Philadelphia* (New York, 1980), 217. Among the mounted prints in the Peto family albums at Island Heights is a photograph Peto took of Bell as an older man; at the bottom is printed, "Peto, artist. 1020 Chestnut St., Philada." When Peto left Philadelphia to settle in Island Heights, New Jersey, he set up a photography studio on the block-long main street of the town (correspondence with the artist's granddaughter, Blossom S. Bejarano, 1 June 1981 and 10 August 1981).

4. This was the recollection of Peto's daughter Helen Peto Smiley, as recorded by Frankenstein, *After the Hunt* (1969), 103. But Frankenstein also states that documents suggest the Stag Saloon commission may not have occurred until several years later.

5. See Frankenstein, *After the Hunt* (1969), 106; and R. S. [Regina Soria], "John F. Peto's Studio," *Journal of the Archives of American Art*, (January 1964), 8. For additional biographical information I am much indebted to the artist's granddaughters, Mrs. Joy Smiley of Island Heights and especially Blossom S. Bejarano of Greenwich, Connecticut. Quotations from the legal testimony come from the various dispositions before the New York Supreme Court, Duchess County, xeroxed copies of which are in The Studio, Island Heights, New Jersey. Details of Peto's final days from Blossom Bejarano, correspondence with the author, 10 August 1981. Peto was buried in a family plot in Toms River, New Jersey, beside two of his aunts, and was joined later by Pearl and his beloved daughter Helen.

6. Wolfgang Born, *Still-Life Painting in America* (New York, 1947).

7. 1879—*Any Ornaments for Your Mantelpiece* ($150)
1880—*Still Life* ($40)
 The Poor Man's Store ($200) (see fig. 86)

1881—*Still Life* ($75)

1885—*Your Choice* ($100) (see fig. 122)

1886—*Fish House Door* (see figs. 140 and 141)

1887—*For a Leisure Moment*

See Frankenstein, *After the Hunt* (1969), 101-102.

8. Alfred Frankenstein, *After the Hunt: William Harnett and Other American Still Life Painters*, 1870-1900 (Berkeley and Los Angeles, 1953). See also Frankenstein, "Harnett, True and False," *The Art Bulletin* 31 (March 1949), 38-56; Lloyd Goodrich, "Harnett and Peto: A Note on Style," *The Art Bulletin* 31 (March 1949), 57-58; Frankenstein, *"After the Hunt"—and After* [exh. cat., California Palace of the Legion of Honor] (San Francisco, n.d.); and Frankenstein, *John F. Peto* [exh. cat., The Brooklyn Museum] (Brooklyn, 1950).

9. Frankenstein, *The Reminiscent Object* [exh. cat., La Jolla Museum of Art] (La Jolla, California, 1965); and Frankenstein, *The Reality of Appearance: The Trompe L'Oeil Tradition in American Painting* [exh. cat., University Art Museum, Berkeley] (Berkeley, California, 1970).

10. See the laboratory report by Sheldon Keck given to Frankenstein, *After the Hunt* (1969), 18.

11. Frankenstein, *After the Hunt* (1969), xv.

12. William H. Gerdts and Russell Burke, *American Still-Life Painting* (New York, 1974), 133-158.

13. Gerdts and Burke, *American Still-Life Painting*, 133.

14. Gerdts and Burke, *American Still-Life Painting*, 143. Gerdts updates and elaborates his discussion in his more recent survey of the field, *Painters of the Humble Truth: Masterpieces of American Still Life*, 1801-1939 [exh. cat., Philbrook Art Center, Tulsa, et.al., with the University of Missouri Press] (Columbia, Missouri, and London, 1981). Chapter 8 is titled "William Michael Harnett and Illusionism."

15. Gerdts and Burke, *American Still-Life Painting*, 144-145.

16. Gerdts and Burke, *American Still-Life Painting*, 134-135 and 144.

17. Theodore E. Stebbins, Jr., *The Life and Works of Martin Johnson Heade* (New Haven and London, 1975), 112. One finds almost identical phrases in survey texts: "Harnett had many followers . . . the best was John F. Peto" (Joshua C. Taylor, *The Fine Arts in America* [Chicago and London, 1979], 107). Or: "John F. Peto was inspired by Harnett and was nearly as fine an artist" (Samuel M. Green, *American Art, A Historical Survey* [New York, 1966], 418). And: "John F. Peto (1854-1907) was strongly influenced by Harnett and was sufficiently skillful so that some of his work has been confused with that of the older man" (Daniel M. Mendelowitz, *A History of American Art* [New York, 1970], 299-300).

18. Oliver W. Larkin, *Art and Life in America*, rev. ed. (New York, 1960), 265; and E. P. Richardson, *Painting in America, From 1502 to the Present* (New York, 1956), 322-323.

19. Matthew Baigell, *A History of American Painting* (New York, 1971), 152-153.

20. Barbara Novak, *American Painting of the Nineteenth Century: Realism, Idealism, and the American Experience* (New York, 1969), 231.

21. Novak, *American Painting*, 221, 234.

22. Milton W. Brown, *American Art to 1900* (New York, 1977), 539-541. See also Brown et al., *American Art: Painting, Sculpture, Architecture, Decorative Arts, Photography* (New York, 1979), 285-286. Taking the lead of Gerdts and Burke, Brown continues the assertion about Peto that "the general quality of light dominates his painting and connects him with the luminists" (Brown et al., *American Art*, 286). The argument for luminism as a style defined for mid-century landscape painting is fully made in John Wilmerding et al., *American Light: The Luminist Movement*, 1850-1875 [exh. cat., National Gallery of Art] (Washington and New York, 1980).

23. See Wanda M. Corn, *The Color of Mood: American Tonalism*, 1880-1910 [exh. cat., M. H. de Young Memorial Museum] (San Francisco, 1972); Charles C. Eldredge, *American Imagination and Symbolist Painting* [exh. cat., Grey Art Gallery and Study Center, New York University] (New York, 1979); and Patricia Hills, *Turn-of-the-Century America: Paintings, Graphics, Photographs*, 1890-1910 [exh. cat., Whitney Museum of American Art] (New York, 1977).

24. Roger B. Stein, *Seascape and the American Imagination* [exh. cat., Whitney Museum of American Art] (New York, 1975), 123-124.

25. See Baigell, *A History of American Painting*, 155; Gerdts and Burke, *American Still-Life Painting*, 156; Brown et al., *American Art*; and James Thomas Flexner, *Nineteenth Century American Painting* (New York, 1970), 203. A few other works in color have appeared in occasional exhibition or dealers' catalogues; see Lyn Wall Smith and Nancy Dustin Wall Moure, *Index to Reproductions of American Paintings* (Metuchen, New Jersey, and London, 1977), 453-455.

32. Peto. *Lamps of Other Days*, c. 1900.

2

IMPORTANT INFORMATION INSIDE

The Idea of Still-Life Painting in Nineteenth-Century America

Before turning to thematic considerations in Peto's career proper, we may take the opportunity to address the nature of still life generally and some aspects of the subject specifically in the American tradition. Although the field by definition has its own distinctive iconography, discussion of American still-life painting has for the most part taken place in a vacuum, isolating the material both from other contemporary subjects and from a larger cultural context. Specialized studies as well as general surveys have tended to see still life in a near-hermetic tradition with an idiosyncratic development of its own. As a consequence, some surveys neglect still-life painting, not knowing how or where to place it, or insert self-contained sections amongst the broader ongoing narratives given to other subjects or media.

Yet as paintings done in America, images by Peto, along with those of other still-life artists, do bear aspects of a national style. Collectively, they have a character on an artistic genetic chart, so to speak, marking both place and time. First of all, historians have often called attention to the American artist's penchant for rendering the palpable, real world, in which solid forms are naturalistically defined and purposefully placed.[1] However cramped Peto's tabletop compositions sometimes are (see figs. 100 and 126), they share with works by other important American still-life painters, like Raphaelle Peale and John F. Francis (figs. 26 and 28), an insistent physical realism and convincing spatial ambiance. These are down-to-earth impulses which might be thought of as traditional virtues in a democratic country.

American painting, including its history of still life, has also expressed a continuing concern for the practical and functional. This is particularly evident in the aims of the earliest explorer artists, such as John White, coming to the New World in the late sixteenth century, when artistic images were primarily documentary records or scientific illustrations. The same motivation dominated the nineteenth-century ambitions of George Catlin's Indian and John James Audubon's bird paintings. This is a tradition Americans have valued because achievement is measurable, and it places a premium on technical ability. In this regard Harnett's painting has seemed readily accessible and admirable for its exquisite finish and polished illusionism. He appears to record a finite world of objects with precision and finesse, and this ability has been a clue to his high repute from the beginning. In comparison, Peto's roughness, non-illusionism, and mysteriousness have seemed alien, both somehow distant in spirit from the viewer and out of the American mainstream. The often melancholy deterioration of his imagery has additionally appeared to run counter to American assumptions of optimism and progress. Thus we can begin to perceive the ways in which Peto's art emerges from an American tradition at the same time as it is seen to represent something disturbing and new.

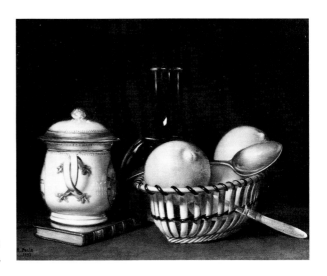

26. Raphaelle Peale. *Lemons and Sugar*, c. 1822.

Much of American still-life painting in the nineteenth century was indebted in fact or in spirit to Dutch seventeenth-century precedents. So, too, were aspects of genre and landscape subjects, not surprising since the cultures in the two countries in these respective centuries shared similar values. Both were nations grounded in Protestantism, giving rise to moralizing impulses; in commerce and mercantilism, investing value in material well-being; and in scientific exploration, finding expression in adventurous pioneering and technical ingenuity. Dutch pictures were collected by American patrons, copies were exhibited in the annual exhibitions at the Boston Athenaeum and elsewhere, and prints after Dutch compositions were widely familiar to aspiring American painters. Some images were thus known in original form, others indirectly through eighteenth-century English derivations. [2] In the cases of Peto and Harnett we can see that certain German and Dutch baroque models underlie their own versions of tabletop and rack picture compositions (see figs. 195 and 196).

As Ingvar Bergstrom has pointed out in his book *Dutch Still-Life Painting in the Seventeenth Century,* the interest in still life for artists reflected a larger emerging fascination with the things and activities of everyday life. Even earlier these interests coincided with the rise of naturalism at the beginning of the Renaissance (about 1400). We are familiar with the development of perspective at this time as a methodology for bringing intellectual order to our perception of both pictorial and actual space. Similarly, this period saw the first modern flourishing of the natural and biological sciences. These new disciplines encouraged the impulses to categorize and specialize. Concurrently in painting artists also more rigorously devoted themselves to a clear hierarchy of subdivisions in subject matter, from history and mythology to landscape and portrait painting. Although long considered the least significant of types, still life itself was increasingly subdivided. By the seventeenth century there were clear categories of food, fruit, flower, and so-called *vanitas* still lifes, for example—each with its own elaborate, specific iconographic symbolism. [3] Many of these types were in turn inherited by the American tradition, although seldom without highly particularized symbolic formulations or references. One obvious instance where Peto adapts associational details from Dutch prototypes is in his treatment of candlesticks and oil lamps as

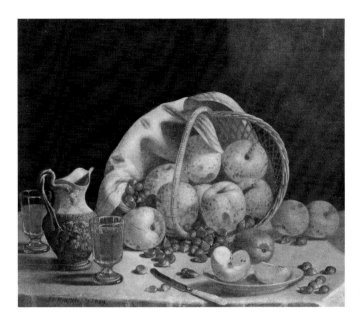

28. John F. Francis. *Still Life with Apples and Chestnuts*, 1859.

metaphors of worldly transience (see figs. 32 and 126).

If the background of Dutch art provides one perspective on the character of American still-life painting, comparison with the French school suggests other considerations. Although certain aspects of Chardin's work may well have had an effect on Peto (compare figs. 69 and 70), in general the refinements of touch and artifice in eighteenth-century French painting do not find counterparts in the more businesslike realism of American images. Likewise, American painting rarely concentrates on the formal values of pure paint, brushwork, or color which characterize the still lifes of Edouard Manet and Auguste Renoir. Paul Cézanne's aesthetic issues of how the mind's eye perceives masses and spatial relationships exist at some distance from the American preference to hold to image-making as illustration, decoration, or storytelling.

Theodore Stebbins has drawn a revealing comparison between the flower paintings of Martin Johnson Heade and Henri Fantin-Latour. While he makes a case for Heade's likely having been influenced by his French counterpart, he shows significantly how for the French artist

energy and enthusiasm are conveyed through brushwork, a rich sense of color, and swiftly painted highlights, and while Heade's composition resembles it superficially, his painting belongs to a quite different tradition. Muting any sense of the artist's presence, eliminating visible brushstrokes, his painting is truly *about* the flowers themselves. . . . Heade seems almost fearful of his medium. . . . the rich surface of the French painting gives it a quality of immediacy.[4]

A similar self-effacement is apparent in most American still-life paintings, from Raphaelle Peale to Severin Roesen to Harnett (figs. 26, 30, and 200). But in Peto we face a more unexpected handling of paint textures, color, and pure shapes for their expressive and aesthetic values. Such concern for the components of art for their own sake is infrequent in the history of American art, and this helps to explain why Peto has gained only partial favor with American taste.

But we need to do more than appreciate American still-life painting in a national context, for it is also possible to examine artists as exemplars of particular stylistic periods. There is no reason why we should not be able to see still life in relation both to other subjects painted in the same period and to the broader cultural attitudes of that moment. The following observation is characteristic of the blurring of the very stylistic distinctions needing clarification:

Place a Harnett still life of the middle 1870's next to a Raphaelle Peale of 1815 and it is impossible to believe that they are separated by two generations, that the one belongs to the era of James Madison and the other to that of U. S. Grant.[5]

Possibly at first glance the two artists may appear to share concerns with intimately scaled tabletop compositions, carefully highlighted details, and meticulously polished surface textures. But if in fact we compare closely representative works by Peale and Harnett (figs. 26 and 35), we find overriding differences in subject matter which suggest quite separate cultural visions. Indeed, these two still lifes are as different stylistically as the Federal architecture of Thomas Jefferson is from the Romanesque idiom of Henry Hobson Richardson. Surely in Peale's still life as in Jefferson's Monticello, for example, a stylistic expression of certain ideas of perfection and order in the early Republic is to be seen just as the somber, weighty arrangements of Harnett and Richardson offer clues to the materialistic period following the Civil War called the "Brown Decades" by Lewis Mumford.

We need no more confuse these still lifes just because of their nominal similarities of subject and finish any more than we should fail to distinguish between the respective classical forms in the two styles of American architecture. Narrowing the point further, we can make distinctions in building form and aspiration between periods so close as the Federal and Greek revival; concomitantly, there is an intellectual world of difference between the images of Peale and those of John F. Francis or Severin Roesen only a generation later (compare figs. 26, 28, and 30). Architecture may seem a surprising stylistic analogue in this discussion, but it is a useful one. For although one medium is two-dimensional and nonfunctional, and the other solid, spatial, and practical, both rely on the conceptual arrangement of solid volumes and ultimately reveal parallel cultural expressions.

More obvious, perhaps, are the associations one might draw between still life and, say, landscape or figure painting of the same period. It is a short distance aesthetically from Raphaelle Peale's still-life to Charles Willson Peale's portrait compositions (figs. 26 and 147); both share a refined calculation of design and illusion which marks much painting of the Federal period generally. By extension, the brooding darkness in a Harnett or Peto finds affinities in the lone figures painted by Thomas Dewing and Thomas Eakins (figs. 131, 178, and 218). But it is in architectural examples, initially so apart from still life in the world they occupy, where comparisons may help to frame this specialized subject matter of painters in a broader cultural background. A sequence of pairings will indicate the ways in which the imagery of painting and architecture can together illuminate key moments throughout the nineteenth century.

Raphaelle Peale's painting *Lemons and Sugar* of 1822 is an archetype of Federal period style.[6] Beginning about 1815 and continuing up to his death a decade later, Peale painted a

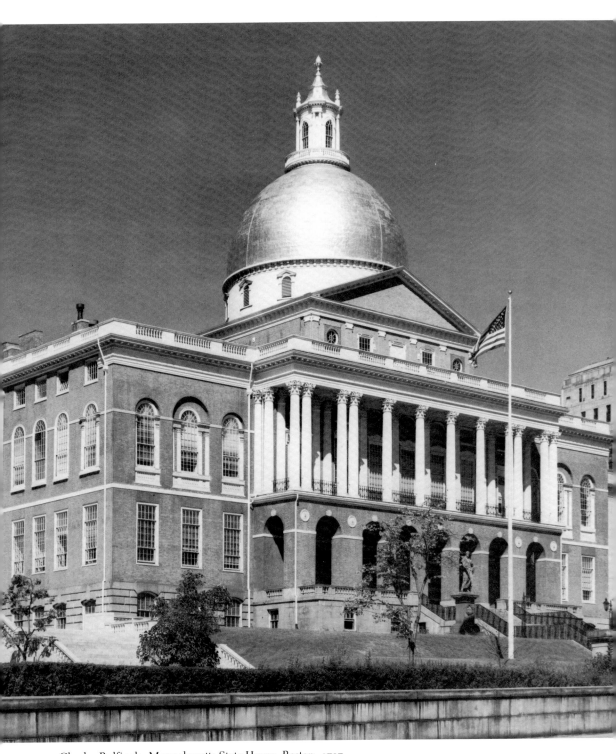

27. Charles Bulfinch. Massachusetts State House, Boston, 1797.

series of similar food compositions in this delicate, tight manner. As the eye begins to clarify Peale's discrete objects, the mind comes to realize how much the artist is engaged in the play of pure forms held in graceful and economic balance. The work savors the elevated tastes of Federalist society in the young Republic but also the aesthetic sense of ideal, abstract relationships. This latter concern for art itself was partially an inheritance from the artist's father, Charles Willson Peale (1741-1827), who gave to his several children both the talents and names of artists.

The senior Peale was a figure of protean abilities and achievements. Well known as an inventor, scientist, patriot, museum founder, and artist, he led a life shaped by the spirit of the eighteenth-century encyclopedists and philosophes. With his friends Thomas Jefferson and Benjamin Franklin, Peale embodied in America the aspirations of Europe's Enlightenment. His works were among the first by an American artist to essay a comprehensive variety of subjects from history and portrait to landscape and still-life painting. In addition, he adapted and transformed often traditional modes and formulas of subject matter by creating fresh combinations better suited to the generally more informal and practical needs of his countrymen. This encyclopedic vision became a stimulating legacy to the many members of Peale's family who took up careers as artists and scientists over several succeeding generations. In his own work he left precedents for virtually all the specialized subjects taken up in the paintings of his children and grandchildren.

Many of Peale's major canvases, for example, depicted himself or various members of the family. An early group portrait, *The Peale Family* of 1773 (New-York Historical Society), is a conventional figural image, but also one that includes references to other works of art and to the practice of art itself. One member holds palette and brushes in hand; a second is actually drawing; nearby are a canvas depicting the muses and a row of sculpted busts; on the table sits an elaborate still life; and the family dog poses in the foreground. This enumeration shows how Peale has infused his portraiture with family history and elements of genre and still life. In various, occasionally whimsical combinations he continued to make aspects of his professional life part of his art. Peale himself stands close to center stage in his *Exhumation of the Mastodon*, 1806 (Peale Museum, Baltimore) and *The Artist in His Museum*, 1822 (Pennsylvania Academy of the Fine Arts), while two of his painting sons constitute the subject of *The Staircase Group*, 1795 (fig. 147).

Perhaps it is not surprising that Raphaelle, who stands in the foreground of *The Staircase Group* as an artist, gave his attention in his own still lifes to lovingly arranged and finely wrought objects. Instead of two balanced figures at ease on a set of steps, in *Lemons and Sugar* dining room objects gracefully rest together on a table surface. They appeal equally to our senses of taste and sight, for throughout we may savor the efforts to render unblemished surfaces and essential geometries and to achieve a right order among the elements. Peale's technical dexterity is capable of a mirror-sharp illusionism. The result is a glowing clarity of light within this close dark space which evokes an almost devotional attention to the objects. This attention is paid equally to their reality as art and to their reality as things.

The care given to this arrangement is everywhere evident, as juxtapositions and echoes of forms carry throughout. At each lower corner the eye is led in by the complementary diagonals of book and knife; in turn, the entwined handle of the sugar pot matches the spiral

motif circling the basket opposite. Silver contrasts with china, china with leather, and glass with each of them. The organic nestles with the manufactured. The linear, the planar, and the spherical are in tangent with one another, and so are concave and convex forms. Soft rough textures play against hard gleaming ones, light falls on dark, and translucent materials reflect antiphonally with opaque counterparts.

Austere yet elegant beauty such as that in *Lemons and Sugar* may also be said to characterize the design of America's best Federal architecture; this comparison carries our analysis onto a larger stage. Consider, for example, the Massachusetts State House (1797) by Charles Bulfinch (fig. 27). Immediately visible are the same aspirations for clear relationships, hierarchical order, and equilibrium among the disparate parts. Planar and cubic geometries intersect logically and gracefully. Stone, brick, white-painted wood, and gold leaf are distinctly separate yet proportionately balanced within the whole. In his eloquent examination of early American architecture William Pierson has pointed out the important introduction of complex curved shapes in the Federal style, most particularly its favoring of repeated circular and elliptical forms.[7] Such elements of design are apparent here in Bulfinch's dome and tower—as they are in Peale's grouping—and even more so in interior details of the State House.

Similar qualities are to be found in the contemporary buildings of Samuel McIntire and Thomas Jefferson, qualities Pierson has described as controlled reserve and chaste serenity. If to him a Bulfinch structure is "an experience of proportions,"[8] then McIntire's Pingree House (1805) in Salem, Massachusetts, represents a "system of sharply defined self-contained and independent parts, rhythmically joined in a coherent decisive whole."[9] And Jefferson's Monticello (1793-1809) in Virginia can be characterized as

disarmingly simple at the same time that it is intricate; it is practical at the same time that it is easy, flowing, and gracious; it is dignified and yet is filled with charming informality.[10]

What the Federal era in all its forms gives us is an almost aristocratic refinement of taste, a natural consequence of Federalist ideas themselves, especially in New England, derived from inherited English manners. Certainly in architecture the graceful precedents of the Adamesque style abroad shaped American ambitions. It is in this spirit we can appreciate the shared language of style relating Peale's designs with the world of McIntire's carved fireplace mantles, Bulfinch's oval drawing rooms, and Jefferson's central rotundas. But theirs was also an age which valued the practical in combination with the ideal.

Intellectually, the philosophical cast of the eighteenth-century Enlightenment had stamped the very conception of the new Republic and consequently the taste and thought of Americans in the years before and after the Revolution. Scottish and French thinkers especially had stimulated the pursuit of systematic methods of inquiry, which led most notably to the reasoned shaping of America's founding political documents.[11] Declarative, calculated, orderly, Jefferson's list of grievances accumulated rhythmically within the total structure of the Declaration of Independence. The authors of the Constitution sought to translate vision into reality as they shaped the larger framework of a new government, while in the Federalist Papers James Madison, Alexander Hamilton, and John Jay conducted an elevated dialogue on the Constitution's provisions and operation. In so doing, this generation

drafted its own design for political order, in which the rights of citizens were placed—*E pluribus unum*—in equilibrium with the social whole.

Looking again at the pyramidal massing of both Peale's and Bulfinch's forms, we are not far from the spirit of political phrases linking America's great ideas in triadic sequence. Recall how the Declaration at the outset asserts the rights of "life, liberty and the pursuit of happiness," and closes by pledging "our lives, our fortunes and our sacred honour." In its turn, through checks and balances, the Constitution delineated a tripartite system of government composed of the executive, legislative, and judicial. Seen in the context of such values, Peale's still life is a small-scaled but legible index of this noble period in American history.

Where Peale's work can provide some insight into a cultural vision of the first quarter of the nineteenth century, the still lifes of John F. Francis (1808-1886) present a very different style belonging to the next generation at work through the second quarter of the century. Having begun his career as a portraitist who arranged his solidly modeled figures in clearly defined spaces, Francis turned almost entirely to still-life subjects about 1850. As a native Philadelphian, he well knew the painting tradition established by the Peales, and his own compositions initially strike us as similar. *Still Life with Apples and Chestnuts,* 1859 (fig. 28) depicts a familiar compact gathering of foods, strongly illuminated on a table surface, all seen close up and set off by a screen of darkness behind. There is the continuing delight in a calculated positioning of varying rounded volumes and an enlivening play of differing surface textures.

Sustained inspection, however, reveals crucial dissimilarities in content, technical handling, and overall feeling between the work of Peale and Francis. Peale's colors, limited mainly to yellows and whites, seem delicate and refined, whereas Francis manipulates a much stronger palette of the same hues but with denser patterns and contrasts of color complementaries. His yellow apples and basket, for example, are partly framed by the strong blue lines bordering the draped napkin. The bright blue and white pitcher at the left sits adjacent to the warm yellow of the cider-filled glasses. Spots of red and green mottle the surfaces of the central group of apples, while the tone of the background shifts from warm reddish brown at the left to a dark green on the right.

Francis' brushwork and rendering of textures are correspondingly more vigorous as well. The paint has a more plastic and rougher density, in contrast to the creamy smoothness of Peale's pigment. In addition, Francis has selected objects of a different taste, both in the sense of flavor and of style. Not Peale's sugar and lemons suggesting a quiet tea, nor his leather-bound book perhaps of poems, decanter possibly of sherry, gleaming silver, and imported china—instead Francis assembles a market basket and plain tablecloth, heavy glass goblets, and sturdy serviceable pitcher. Replacing Peale's calm reserve are food and drink about to be eaten: the cider is poured, an apple cut apart. But there is also a greater clutter in Francis' work, intensified by the basket tipped on its side, pouring apples and nuts out toward us. Even his composition is physically larger than Peale's standard scale of painting, as if we have now entered a more expansive and energetic world. In contrast to Peale's perfect fruits serenely in place, the richer textures and coloring and the blemished surfaces in the work of Francis enhance our awareness of a robust and ripe immediacy. No longer viewing

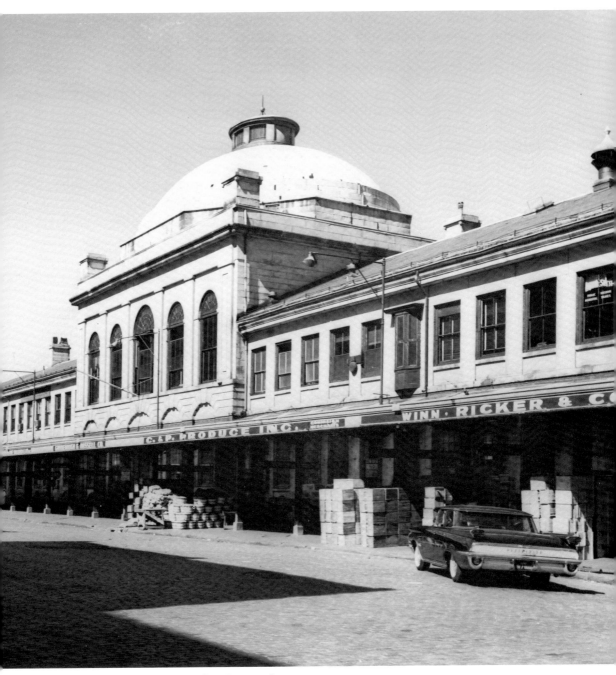

29. Alexander Parris. Quincy Market, Boston, 1825.

a chaste grouping on some Hepplewhite sideboard, we now face a more workaday kitchen setting in Victorian America.

In this instance the appropriate architectural analogy is the Greek revival movement, which dominates American building modes from the late 1820s well into the 1860s. Though as much derived ultimately from classical sources as the previous Federal manner of Bulfinch, the pure neoclassic style looked beyond English Adamesque translations to the original masses of Greek and Roman precedents. Alexander Parris' Quincy Market in Boston (fig. 29) was one of the first and most powerful examples of this new taste. Completed in 1825 as part of the active expansion in commerce during Josiah Quincy's mayoralty, it represented the first flourishing of Greek forms to pervade all types of public and domestic architecture in America. During the 1840s and fifties columned temples and grand rotundas came to house everything from courthouses and banks to college halls and private dwellings. This was an intentionally bold and impressive style of building, suited to the nation's newfound strength and optimistic pride in its sense of collective promise.

Unlike the thin planar qualities of Bulfinch's brick surfaces, his attenuated wooden columns, and elegant but fragile-looking dome, Quincy Market suggests a striking clarity of cubic mass, partly created by the use of sharply chiseled granite blocks, thickly proportioned forms, and a solid interlocking of all the parts. The whole effect is more muscular and monumental, one characterized by Pierson as "sharply in tune with the everyday working world of America."

Nothing could have been more expressive of the broad common strength of the new nation than the primitivism of Neoclassical forms.[12]

With a similar language of analysis he describes Robert Mills' Monumental Church (1812) in Richmond, Virginia, "with all essentials stripped away and only the bare bones of the geometry to define the spaces," and the same architect's Treasury Building in Washington (1836-1842) with its "bold articulation of the masonry construction," stylistic elements having a direct appeal "to the ordered taste of a pragmatic society."[13]

In larger political terms Jefferson's intellectual and aesthetic sensibility had yielded to the physical energies and emotional populism embodied in the presidency of Andrew Jackson. Though Jackson had left the White House by 1845, his personality initiated a celebration of the common man and an expansionist sense of democracy's triumphant self-reliance. The age of Jackson defined a new popular faith which continued to fire the American imagination up to the Civil War. One phrase above all proclaimed for that moment

The right of our manifest destiny to overspread and to possess the whole of the continent which Providence has given us for the . . . great experiment of liberty.[14]

Hopefully such political vocabulary will not now seem so distant from its cognate expressions in the architecture of Parris and painting of Francis. The dense central massing of forms in both is but one index of an almost aggressive amplitude and down-to-earth assurance shared in the golden years of ante-bellum America.

Emerging not long after the neoclassic style and flourishing during the third quarter of

30. Severin Roesen. *Still Life: Flowers,* 1860s.

the nineteenth century were art forms inspired foremost by nature. In still-life painting this meant a new concentration on botanical and floral subjects, while in architecture the gothic revival style reflected the organic complexity and variety of the natural world. The work of Severin Roesen (active c. 1841-c. 1871) depicts an earthly abundance (fig. 30) much in the same spirit as Francis' painting, but with an even more lavish and extensive enumeration of nature's bounty. Roesen was a German-born artist who emigrated to New York just before mid-century and then settled about a decade later in rural Pennsylvania for the rest of his career. He obviously brought with him a style of meticulous coloring and jewellike detail indebted to the prevailing manner taught in the Düsseldorf school. This approach well suited the aspirations of Americans to chronicle the details of their landscape with a fervor as much scientific as it was romantic.

Among the principal influences shaping this vision in still-life painting after mid-century were the writings of John Ruskin and Charles Darwin. In their respective ways both called attention to the specific identity of living things, Ruskin through his *Modern Painters* (published in London in 1844 and in New York in 1847) and *Elements of Drawing,* 1857, Darwin through his *On the Origin of Species,* which appeared in 1859. For all of nature's components Ruskin argued that "we have to show the individual character and liberty."[15]

More specifically, he proclaimed that "the flower exists for its own sake—not for the fruit's sake. . . . A flower is to be watched as it grows."[16] Darwin in turn stimulated a widespread popular consciousness of the scientific method and more particularly an appreciation of the processes of organic life.

In this climate artists turned with fervor to painting floral arrangements indoors and out. Roesen never went so far as others to render flowers, leaves, or grasses in their natural environment, though occasionally he sketched in vistas of open landscape behind corners of his still-life compositions. His *Still Life: Flowers* of the mid-1850s (fig. 30) is a typical assemblage, in which we confront almost an inventory of nature's lushness. Across this pair of shelves are settled three different containers—large glass bowl, basket, and bird's nest—in which rest a profusion of spherical forms to nourish our senses of sight, touch, and taste. We are invited to indulge in a rich variety of colors, textures, and shapes from the wide range of flowers at the left to the several fruits and eggs on the right, with smaller berries and grapes as transition in the center. There is a comparable breadth of floral species extending from the exotic orchid to the common daisy, but with each of nature's creations exuberant in its individuality.

Clearly, nature was deserving at once of study and of praise. Scientific examination led to a more accurate and comprehensive understanding of the natural world, while celebration served to reveal an ultimate divine presence. Thus, a flower had both an objective and an expressive reality. Roesen addressed the former through the precision of his scrutiny and the latter through the ideal artifice of his arrangement.

There are illuminating parallels in thought and observation to be found in the contemporary writings of Henry David Thoreau, and almost at random one can come across similar verbal descriptions of nature throughout his essays. Take, for example, this lengthy but evocative passage on hazel blossoms recorded in his journal for 28 March 1858:

I go down to the railroad, turning off in the cut. I notice the hazel stigmas in the warm hollow on the right there, just beginning to peep forth. This is an unobserved but very pretty and interesting evidence of the progress of the season. I should not have noticed it if I had not carefully examined the fertile buds. It is like a crimson star first dimly detected in the twilight. The warmth of the day, in this sunny hollow above the withered sedge, has caused the stigmas to show their lips through their scaly shield. They do not project more than the thirtieth of an inch, some not the sixtieth. The staminate catkins are also considerably loosened. Just as the turtles put forth their heads, so these put forth their stigmas in the spring. How many accurate thermometers there are on every hill and in every valley! Measure the length of the hazel stigmas, and you can tell how much warmth there has been this spring. How fitly and exactly any season of the year may be described by indicating the condition of some flower![16]

Although Roesen depicts his floral group on an interior tabletop, while Thoreau looks at his blossoms in their actual habitat, both take us into a private corner of nature and measure the component organisms with comparable accuracy. Thoreau's first sentences repeatedly express a stance of noticing, observing, and examining. He seeks to locate things in place by taking their measurement, at one point citing exact numbers and at another mentioning a thermometer in both a literal and metaphorical sense. He perceives analogous relationships with these blossoms in the laws of the cosmos (the "crimson star" at twilight) and in the evolution of organic life ("the turtles put forth their heads"). Tempering such abstract

31. Alexander Jackson Davis. Residence of Henry Delamater, Rhinebeck, New York, 1844.

associations is the technical scientific nomenclature ("staminate catkins"). But above all Thoreau asserts the equation of nature's growth with the "progress of the season." As with Roesen's painting, we are in the presence of an imagery of promise and fruition.

The architectural parallel here is the gothic revival style, especially as it flourished in the country villa and cottage. Among the most influential theorists and practitioners of the type were the architect Alexander Jackson Davis and the landscape gardener and architectural critic Andrew Jackson Downing. Together they set aside the concept of the marble-white purity and volumetric clarity of neoclassicism to design structures in relationship to their natural settings. Pronounced Downing in his first book, *The Fruits and Fruit Trees of America* (1845): "architectural beauty must be considered conjointly with the beauty of the landscape or situation."[17] To this end he argued for colors, textures, and detailing that would harmonize with a building's surroundings. Like nature herself this was to be an architecture of variety, surprise, irregularity, and dynamic relationships. Instead of the stable balances of discreet parts in the Greek revival, the gothic aspired to fluid organic rhythms, asymmetrical tensions, and lively contrasts consistent with the terrain and foliage nearby. Thus, re-

placing the solid masses and cleanly enclosed spaces of neoclassic structures was the imaginative introduction of trellises and airy balconies, verandas and porches, cupolas and turrets.

Davis' residence for Henry Delamater (1844) in Rhinebeck, New York (fig. 31), is typical of the gothic-revival manner, whose picturesque nature has been well summarized by William H. Pierson:

Its fragmented irregular shapes, its lofty tapered profiles, its constantly shifting surfaces, its interlacing proliferous forms [are] all so reminiscent of the world of natural growth. . . .[18]

Like Roesen's still life this is an artificial composition drawn from but not belonging to nature. Pierson's description of Lyndhurst (1865), Davis' great masterpiece in Tarrytown, New York, is equally apropos here:

each arch, each molding, each tracery bar conveys the impression of being there as a result of natural growth. . . . the later windows of Lyndhurst seem to emerge from the substance of older parts as living organisms, capable of perpetual renewal, and appear more as blossoms on a flowering tree than as cut flowers arranged for a special occasion.[19]

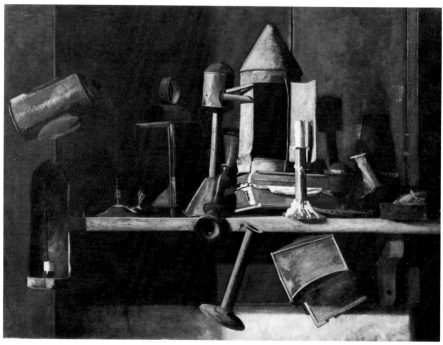

32. Peto. *Lamps of Other Days*, c. 1900.

This Darwinian sensibility animates the foliate vitality of both Roesen's and Davis' work. In addition, the gothic revival reminds us of its ultimate derivation from church architecture of the middle ages. In this regard its spiritual function and expressiveness also seemed especially suited to mid-nineteenth-century American ideas about the Edenic purity of new world geography and the divinity of nature. Indeed, most contemporary landscape painting—witness Frederic Edwin Church's triumphant *Twilight in the Wilderness*

of 1860 (Cleveland Museum of Art)—presents us with a similar fusion of religion, art, and science. Roesen's still life marks a burst of glory before the romance of science and the immortality of the spirit yielded to a darker, more worldly vision.

That shift in sentiment becomes apparent by the last quarter of the century, and brings us in this sequence at last to the still-life subject matter of Peto and the work of Henry Hobson Richardson (1836-1886) as its architectural counterpart. It should now be evident that when we turn to the work of Peto and Harnett, we are indeed in a different intellectual and stylistic generation from that of Raphaelle Peale and the contemporaries of James Madison. With Peto's *Lamps of Other Days* (fig. 32)—one of a series begun in the 1890s (see figs. 124 through 126)—the still life returns indoors to the darkened tabletop setting favored previously by Peale. The visions of immortal freshness and the bursting optimism in praise of the present seen in Darwinian flower painting now give way to a world of objects visibly subject to mortal wear and tear.

Peto belonged to a generation who came to maturity during the post-Civil War years of the 1870s, that unsettled, turbulent, and transitional period of Reconstruction. Industrialism and technology, in an earlier time agents of romance, were increasingly intruders and

33. Henry Hobson Richardson. Crane Memorial Library, Quincy, Massachusetts, 1880-1883.

disturbers of nature's peace. The planting of the golden spike at Promontory Point in Utah in 1869 marked the triumphant bridging of the continent by the railroad, but it also signaled new strains for the country, engendered by territorial expansion and regionalism. Corruption marred political life at the local and national levels. Above all, this was a time in America of great accumulations and expenditures of wealth. Still-life painting not least mirrored the obsession with a world of things. Personal property and possessions, whether the gathered objects of one's library den or collected antiques and artifacts, emerged to claim the private tabletop stages painted by Harnett and Peto. Similarly, they along with their colleague John Haberle (1853-1933) delighted in rendering acquisitions of personal value and illusions of paper currency (see figs. 102, 128, and 157).

It borders on oversimplification to assert a change in national life from innocence and optimism to complexity and cynicism, yet unquestionably the tone of America's self-perception and of artistic expression was different. Speaking of the earlier nineteenth century, Henry James talked about Nathaniel Hawthorne's career as being "passed, for the most part, in a small and homogenous society."[20] And in reference to Franklin Pierce and the same period James described "our hero" as

an American of the earlier and simpler type—the type of which it is doubtless premature to say that it has wholly passed away, but of which it may at least be said that the circumstances that produced it have been greatly modified. The generation to which he belonged, that generation which grew up with the century, witnessed during a period of fifty years the immense, uninterrupted material development of the young Republic; and when one thinks of the scale on which it took place, of the prosperity that walked in its train and waited on its course, of the hopes it fostered and the blessings it conferred—of the broad morning sunshine, in a word, in which it all went forward—there seems to be little room for surprise that it should have implanted a kind of superstitious faith in the grandeur of the country, its duration, its immunity for the usual troubles of earthly empires. This faith was a simple and uncritical one, enlivened with an element of genial optimism, in the light of which it appeared that the great American state was not as other human institutions are, that a special Providence watched over it, that it would go on joyously forever, and that a country whose vast and blooming bosom offered a refuge to the strugglers and seekers of all the rest of the world, must come off easily, in the battle of the ages. From this conception of the American future the sense of its having problems to solve was blissfully absent; there were no difficulties in the programme, no looming complications, no rocks ahead.[21]

James went on to argue, in sentences often quoted, that

the Civil War marks an era in the history of the American mind. It introduced into the national consciousness a certain sense of proportion and relation, of the world being a more complicated place than it had hitherto seemed, the future more treacherous, success more difficult.[22]

In poetry we may note the shift from the exuberant celebrations of self, country, and art by Walt Whitman in the 1850s to the private and solemn musings of Emily Dickinson in the seventies. When we return to Peto's painting and the comparison with Richardsonian architecture (figs. 32 and 33), it is significant that we enter the enclosures of a library. Here we are in the presence of knowledge assembled and arranged in books, with Richardson providing an impressive shelter for their public use and Peto piling them up for private contemplation. Despite the differences in medium, there are several formal similarities between Peto's work and the neo-Romanesque Crane Memorial Library (1880-1883) in Quincy, Massachusetts. Both painter and architect indulge in expressive surface textures, dark

earthbound forms massed on a solid platform, and bold cubic volumes held together in an asymmetrical design.

More interesting is the notion that for both Peto and Richardson the library was a kindred place to the artist's studio, where resided creativity and the stuff of culture. With Peto's imagery before us let us listen to one of Richardson's assistants describe the architect's private study:

The skylight. . . . was concealed by a curtain of soft India silk, diffusing its rosy light over the bewildering mass of riches. . . . A huge table was filled with the rarest volumes, bric-a-brac and choice bits generally; bookcases and couches ranged along the walls; casts and vases showed off beautifully in the subdued light against deep maroon walls. . . . There were stupendous volumes in sumptuous bindings inviting study. Away off in a quiet corner lay some happy pupil in blissful repose, reveling in the resources of the land of plenty. . . . This room was a magic source of inspiration.[23]

In this mood and context of late Victorian America we may begin to appreciate the shape of Peto's vision.

What remains before addressing his work in greater detail are some observations on the distinctive nature of still-life painting itself. Ingvar Bergström has provided a working definition of the subject useful for initial attention: "a representation of objects which lack the ability to move . . . and which are for artistic purposes grouped into a composition."[24] The operative phrase here is *for artistic purposes grouped*, reminding us that still life is perhaps the most artificial of all artistic subjects and the one most concerned with the making of art. Before actually painting, an artist has crucial preliminary decisions to make regarding his selection and arrangement of forms. Unlike other subjects, such as landscapes or portraits, still lifes do not preexist around us, so besides the acts of choice and interpretation there is that of invention, itself an aesthetic process. In composing a still life in his mind or in physical actuality the painter must address such formal properties as shapes, textures, colors, or sensuous associations. Thus the foremost concern of still-life painting is pure artistic form.

In this regard it is not accidental that the great cubist breakthrough from the analytic to synthetic phases during 1912-1913 took place via still-life components. As a revolutionary innovative style dealing with fundamental issues of artistic form and perception, cubism in the hands of Pablo Picasso and Georges Braque sought to reconcile the illusion of three-dimensional objects with the reality of a two-dimensional surface, the surface and the interior of forms, multiple sources of light, and different vantage points assumed simultaneously. To this end ordinary objects from the kitchen and café tables provided neutral and unsentimental shapes of particular formal power. Bottles, playing cards, fragments of newspapers, mandolins, and pipes variously possessed expressive contours or insistently flat surfaces, whereby their juxtaposition or overlapping could create provocative ambiguities between opacity and transparency (see figs. 136 and 193). In such ways cubism was successfully able to examine afresh the nature of illusion and representation in art. Its achievement would not have been possible to the same degree with the associations of personality or demands of likeness in portraiture or with the spatial assumptions of a landscape view. Rather, the centripetal aspect of still life has always drawn special attention to its inherently abstract and conceptual character.

A still life refers both to itself and to its creator. The artist stamps his presence through an overlay of roles: as conceiver, selector, arranger, transformer, and finally as painter. As John F. Peto's still-life paintings offer an index, respectively, to his culture, his time, and himself, we discover that his work is indeed about America, autobiography, and art.

Notes

1. The most extensive argument for this realist clarity as an American tradition is made by Barbara Novak, *American Painting of the Nineteenth Century: Realism, Idealism, and the American Experience* (New York, 1969). See also John Wilmerding, *The Genius of American Painting* (New York and London, 1973), 13-23.

2. To take one typical example, see the discussion of sources in George Caleb Bingham's work in E. Maurice Bloch, *George Caleb Bingham, The Evolution of an Artist*, 2 vols. (Berkeley and Los Angeles, 1967), 1: 91-92, 129. See also Denis R. O'Neill, "Dutch Influences in American Painting," *Antiques* 104 (December 1973), 1076-1079; and Bartlett Cowdrey and Hermann Warner Williams, Jr., *William Sidney Mount, 1807-1868, An American Painter* (New York, 1944), 4. With regard to still life specifically see Wolfgang Born, *Still-Life Painting in America* (New York, 1947), 5-9.

3. See Ingvar Bergstrom, *Dutch Still-Life Painting in the Seventeenth Century* (London, 1956), 1-10, 154-155.

4. Theodore E. Stebbins, Jr., *The Life and Works of Martin Johnson Heade* (New Haven and London, 1975), 115.

5. Alfred Frankenstein, *After the Hunt: William Harnett and Other American Still Life Painters, 1870-1900*, rev. ed., (Berkeley and Los Angeles, 1969), 31.

6. This picture is spuriously inscribed 1847 at the lower left. See Charles H. Elam, ed., *The Peale Family: Three Generations of American Artists* [exh. cat., Detroit Institute of Arts] (Detroit, 1967), 98.

7. William H. Pierson, Jr., *American Buildings and Their Architects: The Colonial and Neoclassical Styles* (Garden City, New York, 1970), 221.

8. Pierson, *American Buildings: Colonial and Neoclassical Styles*, 264.

9. Pierson, *American Buildings: Colonial and Neoclassical Styles*, 224.

10. Pierson, *American Buildings: Colonial and Neoclassical Styles*, 314.

11. See Garry Wills, *Inventing America, Jefferson's Declaration of Independence* (Garden City, New York, 1978).

12. Pierson, *American Buildings: Colonial and Neoclassical Styles*, 413 and 385-386.

13. Pierson, *American Buildings: Colonial and Neoclassical Styles*, 382, 412-413, and 376.

14. John L. O'Sullivan, 1845, quoted in Arthur M. Schlesinger, Jr., *The Age of Jackson* (Boston, 1945), 427.

15. John Ruskin, *The Elements of Drawing; in Three Letters to Beginners* (London and New York, 1857), 164; "Proserpina," in *Complete Works of John Ruskin*, ed. E. J. Cook and Alexander Wedderburn (London, 1905), 25: 249; and *Praeterita* (London, 1899), 2: 300. See also Ella Milbank Foshay, "Nineteenth Century American Flower Painting and the Botanical Sciences" (Ph.D. diss., Columbia University, 1979).

16. *The Writings of Henry David Thoreau* (Boston, 1906), 10: 325.

17. Quoted in William H. Pierson, Jr., *American Buildings and Their Architects: Technology and the Picturesque, The Corporate and the Early Gothic Styles* (Garden City, New York, 1978), 350.

18. Pierson, *American Buildings: Technology and the Picturesque*, 270.

19. Pierson, *American Buildings: Technology and the Picturesque*, 343.

20. Henry James, Jr., *Hawthorne* (Ithaca, New York, 1966), 1.

21. James, *Hawthorne*, 112.

22. James, *Hawthorne*, 114.

23. Quoted in James F. O'Gorman, *H. H. Richardson and His Office: Selected Drawings* [exh. cat., Fogg Art Museum, Harvard University] (Cambridge, Massachusetts, 1974), 8.

24. Bergstrom, *Dutch Still-Life Painting*, 3. This chapter is an expansion of an earlier essay which set forth these ideas in preliminary and summary form; see John Wilmerding, "The American Object," in *An American Perspective: Nineteenth-Century Art from the Collection of Jo Ann and Julian Ganz, Jr.*, [exh. cat., National Gallery of Art, Amon Carter Museum, Fort Worth, and Los Angeles County Museum of Art] (Washington, D.C., and Hanover, New Hampshire, 1981), 84-111.

46. Peto. *Fruit, Vase and Statuette*, February 1875.

3

HELP YOURSELF

The Parlor and Kitchen Still Life

Because so few of Peto's paintings are dated—about a quarter of the more than two hundred known (about half the total are signed)—establishing any firm chronology or clear evolution of his work is an open-ended process. At the same time there do appear to be certain recognizable themes and developments within the basic subjects which preoccupied him for particular periods of his career. When punctuated with the occasionally dated picture, these sequences of images fall in logical, if overlapping, groups and together begin to illuminate how Peto generally moved from rather conventional to more original arrangements over the three decades of his working career.

Newspaper and food subjects in compact tabletop groupings, for example, were the first types of still life he began painting in the mid-1870s. He remained interested in this material through the mid-eighties, with a few late variations coming in the early nineties. Almost all his paintings of bookshelves are undated, though his more complicated gatherings set off by an inkwell, pewter mug, or lard oil lamp bear infrequent dates from 1885 to 1906. Likewise, the images of violins tend to be a later series: the earliest on a tabletop is dated 1880, while the later ones seen hanging on a wall are closer to the turn of the century. For the most part, the inventive letter rack works date from 1879 to 1894, with the highly individual office board compositions dating from the late nineties through the early 1900s.

At least three interlocking factors shaped the emergence of Peto's early artistic style: the still-life tradition strongly established in Philadelphia since the period of the Peale family at the beginning of the nineteenth century; the new academic curriculum at the Pennsylvania Academy of the Fine Arts under the emerging leadership of Thomas Eakins; and the first artistic accomplishments of Peto's slightly older colleague, William M. Harnett. Both Charles Willson Peale and his son Raphaelle had left ingenious examples of illusionist still-life painting (see figs. 26 and 147), and at mid-century we have already seen the finely finished tabletop assemblages by John F. Francis and Severin Roesen (figs. 28 and 30), also well known in Philadelphia. Growing up in that city and enrolling in the academy, both Harnett and Peto would have been familiar with such examples, although their Victorian sensibilities would lead them to prefer such different subjects as the daily newspaper and one's favorite pipe and mug.

Harnett entered the Pennsylvania Academy in 1867. Eakins had left as a student just two years before, but returned from his years in Paris to settle in Philadelphia in 1870, and began his teaching career at the academy in 1876. The following year Peto enrolled there as a student, and remained close to the institution through the mid-eighties, the same years as Eakins' instructorship and celebrated resignation. Even before Peto went to study at the

34. Peto. *Pipe, Mug and Newspaper*, 1887.

academy, Harnett had commenced his painting career in the mid-seventies with a sequence of polished and very respectable still-life paintings. These included arrangements of fruit and vegetables, as well as pipes with mugs and newspapers or books with inkwells. If Eakins dominated the newer teaching methods stressing objective scrutiny and straightforward realism, Harnett brought these practices to bear on his familiar and commonplace subjects. In proximity to these personalities and in the context of their work at this time, the young Peto undertook his own first efforts at art.

Of the subjects initially engaging his interest, the still life combining a folded newspaper, pipe, and beer mug was closest to Harnett's examples. Like the various simple foods and cooking vessels Peto also essayed at the same time, these objects belong to the comfortable and familiar environment of the modest Victorian parlor or kitchen. Items and utensils in everyday use, they breathe an air of quiet temporality. Within the newspaper group of still lifes, as would so often be the case later, Peto fashioned numerous variations on his basic format. Here a paper folded with its edges fanning upward rests toward the back of a small table (fig. 34). Usually occupying the center of the composition, it serves as a screen in front of which stand the basic mug, pipe, and matches. Peto most frequently used a sturdy tan mug with a mottled surface and two broad blue stripes around it, though occasionally he painted ones with a single stripe, or six thin green stripes, or totally plain surfaces. The original models for all of these still hang on his studio wall in the Island Heights house today.

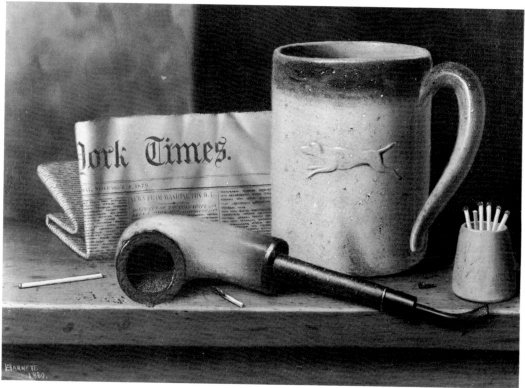

35. William M. Harnett. *His Pipe and His Mug*, 1880.

To this standard repertoire Peto from time to time added other elements, such as the creased tablecloth here or the hint of some drapery in the background. Almost always the wall behind is dark and indeterminate, though in anticipation of his large mature canvases there is sometimes visible the rare single nail or patch on the wall. In a number of this group are also added a biscuit and crumbs, mostly in the left foreground corner of the table, or a book off to one side of the mug. We always see the table parallel to the picture surface; if a corner is shown, it is close to the frame's edge. In the more prosaic and presumably derivative of these works Peto's components follow this essentially lateral displacement, suggesting an effect of studied balance. What is interesting to observe is how he gradually introduces diagonal tensions, asymmetrical juxtapositions, and disquieting crowdings into his compositions—signs of his independent stylistic identity asserting itself. Finally, this series is intimate in feeling and small in size: whether on canvas or academy board, these paintings fairly consistently measure six by nine inches, with a couple as small as four by six. By far the most frequent format is horizontal, although Peto attained striking and strong results with his occasional vertical compositions.

A comparison of this standard early Peto with a similar work by Harnett of 1880, *His Pipe and His Mug* (fig. 35), will quickly demonstrate the close, yet distinct, natures of the two painters' styles. Harnett first tried this subject in 1875 and perfected his designs over the next five years. The debt owed by Peto's versions of the early and mid-1880s is obvious. Aside from the similarity of composition, Peto has taken up Harnett's technique of painting

certain textures, notably the surface of the mug, with a thick, rough impasto. In general Harnett achieved a more polished illusion of different surface textures, at his best creating refined visual deceptions with his brush, while Peto preferred materials with a gritty expressiveness. Harnett's perfected illusionism as a rule led him to be quite precise and legible about the letters and dates on his newspapers, letters, or documents—to the extent that they directly confirm the orderly chronology of his works. By contrast, Peto's painted type is always illegible, a blurred pattern of abstract lines, and a dated, identifiable paper very rare. Because of Peto's derivative aspects here and his less sophisticated ability at illusionist details at this time, his reputation has struggled ever since with the perceived mantle of a pupil. Yet as his career evolved, we come to discover that he deliberately stopped short of pure trompe l'oeil—not out of relative inability but by conscious intention.

Even though his borrowing of Harnett's motifs continued into other later examples, Peto consistently probed the possibilities of modifying and transforming the formulas he began with. Among his most successful devices was simplification. Not only did this freshen his designs with a new clarity and boldness, but it also led him to invest objects literally modest in size with a disproportionate largeness of presence. Above all, his impulse toward simplicity and reduction brought to his art a distinctive quality of abstract power. In one instance he played off two mugs against each other (fig. 36), and placed a straight corncob pipe leaning against the one on its side. With the elimination of the newspaper and the stress on sparer surfaces throughout, this work gains in formal strength. While the overturned mug may have a touch of contrivance, its unusual foreshortened form establishes a compelling central focus to the design. Its open top finds an echo in the mouth of the adjacent pipe, and these circles lead our attention in turn to the other ovals and half circles nearby. At the same time this mug's horizontal axis also reinforces the diagonal line running from the match at the lower right back to the standing mug behind at the left. Peto had little interest in returning to the double mug arrangement again, but this one exercise did show his unpretentious concern with pure, almost abstracted, shapes and designs.

As a general principle, whenever Peto eliminated distracting or unnecessary details and reduced the number of objects in a composition, the results were most effective. Such is the case with this early series in the subgroup Peto painted without newspaper or biscuits, concentrating just on the single mug, pipe, and book (figs. 37 and 39 through 42); perhaps even stronger were his pairings of a pipe and mug only (figs. 43 and 44). These are still essentially horizontal arrangements, but the sparer handling of form gives more subtle visual interest to the occasional diagonal elements. Note in *Book, Pipe and Mug* (fig. 37), for example, how a few unobtrusive diagonal lines pull away from the frontal plane of the table edge like tidal forces, in particular the angle of the book, the mug's handle in relation to its body, the used matchstick, the gleam of light on the pipestem, and the shadow edges at each side of the table. Yet everything appears to rest in place together, held down as much by the gravity of light as of mass. Finally, Peto carries the tone of reserve and isolation here to the single match and nailhead, miniaturized notes of the stately geometries gathered above.

Because Peto painted variants of this subject for well over a decade, there were bound to be differing results in terms of quality. Since scholars have given relatively little attention to details of connoisseurship within his oeuvre, virtually no effort has gone to identifying

36. Peto. *Mugs, Pipe and Matches*, probably 1880s.

37. Peto. *Book, Pipe and Mug*, probably 1880s.

38. Attributed to Adolphe Ancker.
*Still Life with Cigarettes, Matches,
Book and Mug*, 1880s or 1890s.

and separating works by others, whether students, followers, or copyists. In some cases we now know that the recognizable hand of Claude Raguet Hirst has been confused with Peto's; the still-life paintings of his relative Thomas Hope also bear a definite stylistic closeness to Peto's models (see figs. 208 and 209). A more enigmatic personality is that of Adolphe Ancker, believed to have been an Island Heights neighbor and sometime student of Peto. From his business card (fig. 205) we know Peto gave instructions in painting to friends. For services rendered he occasionally presented a small painting in return, and he may also have given lessons as payment in kind.

Whatever Ancker's connection to the artist, he was capable of very competent work which, unsigned, might mistakenly be attributed to Peto. For example, the *Still Life with Cigarettes, Matches, Book and Mug* inscribed by Ancker (fig. 38) has all the familiar hallmarks discussed above. Its subject, arrangement, and textures all appear typical of Peto, though two details are clues to a hand more imitative than original. The juncture of the handle with the mug appears obvious and awkward, and the match extending forward over the table edge lies at an unconvincing angle. While Peto himself sometimes had problems with such tasks of foreshortening, they were demonstrably more difficult and noticeable for Ancker, careful as he was otherwise in following Peto's composition.

Peto played with other devices to simplify, including a more plain surfaced mug and a straight corncob pipe (fig. 39). In this case the thin pipestem is the only forceful and commanding diagonal motif, holding our attention to the center of the design. The mug not only rests solidly on the book, but its form is anchored by the white strip below of the volume's exposed binding. Coming deftly together here—an intersection of horizontal and vertical—are the balanced masses of book and mug. In the unassertive asymmetries of the whole Peto achieves an expressive fusion of tension and stability. The final element giving the whole a slightly more abstracted character than we have previously seen is the table edge now brought to the immediate foreground.

This last aspect is even more effective in the still life entitled *Salt Glazed Mug, Book, Pipe and Match* (fig. 40). In the previous example Peto selected a vantage point more traditionally above the table, looking obliquely down on its surface and close to the objects. Neither the bottom edge of the tabletop nor a corner at one side or the other is visible. In this

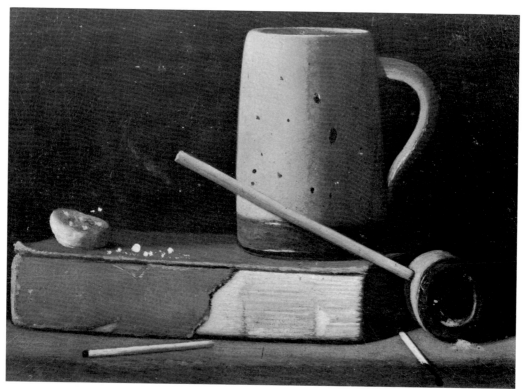

39. Peto. *Pipe and Mug*, probably 1880s.

40. Peto. *Salt Glazed Mug, Book, Pipe and Match*, probably 1880s.

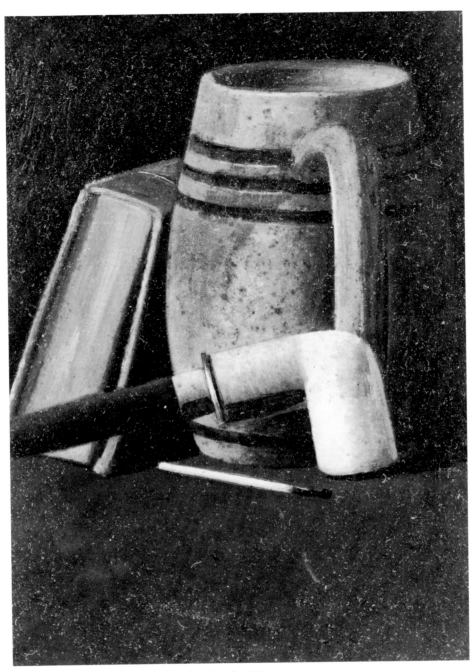

41. Peto. *Book, Mug, Pipe and Match*, probably 1880s.

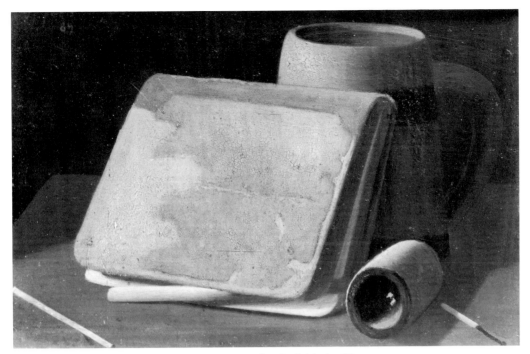

42. Peto. *Book Leaning against Mug with Pipe Used as Book Mark,* 1889.

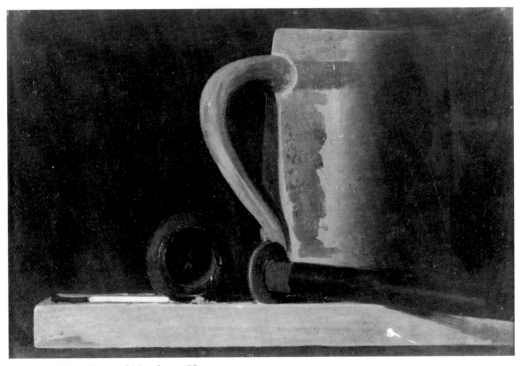

44. Peto. Mug, *Pipe and Match,* c. 1887.

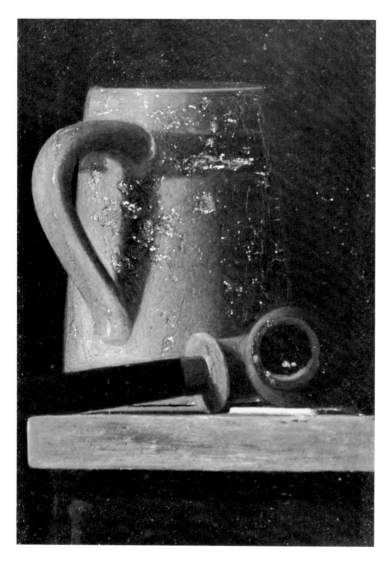

43. Peto. *Pipe, Mug and Match*, 1899.

picture, the cropping is even more severe, and the viewer now faces both table and objects from directly in front. The same four components are here, except that the mug is a more ample one lined with six thin bluish-green stripes. Again, lines, planes, volumes, and contours quietly echo one another. Peto's color scheme is equally restrained, his palette reduced to shades of green (the stripes, the table, and the background wall) contrasting with neutral tans (darker brown on the book, a grayish tan for the mug). Both because the forms all press so close to the surface of the picture and because the brushwork is so rich in suggesting textures, Peto leads us to contemplate his paint, color, and design for their initially descriptive but ultimately expressive roles.

The same mug appears in a relatively rare vertical composition (fig. 41), now enlivened by other means as well. By not defining the front edge of the table below the objects, Peto introduces a new ambiguity between foreground surface and background space. The book, now standing on its side, shows an awkwardness not seen before. In other examples

the inclining book assumes a dominant importance (fig. 42), bringing us to the threshold of one of Peto's central artistic obsessions in his mature work, the haunting densities and accumulations of books on shelves or in boxes (see figs. 109 through 126).

Following the observation that Peto's work tends to gain in strength as it reduces distracting forms, we may conclude discussion of this still-life type with examples depicting just two of the basic objects—mug and pipe (figs. 43 and 44). Counterpointed by a single matchstick aligned parallel to the table edge, these forms are viewed straight on, with our eye level raised only slightly above the table's plane. Now juxtaposed to each other in austere isolation, the dissimilar geometries of pipe and mug begin to assert their underlying kinship of form and function. Although different in size, both are tapered cylinders, striped in light and dark, with circular openings; both are hand-held and carry pleasures of taste to the mouth; both rest in proximity for an act of realistic transcription and of aesthetic meditation.

In this latter regard we might well return to the possible influence of Eakins on the shaping of Peto's style. It is often overlooked that as part of his program of instruction at the Pennsylvania Academy, Eakins in fact taught still life in his classes. To a friend he wrote in 1884:

We have at least our still life class going in the little room. There is solid work going on there all day. I am glad to say the oldest and best pupils patronize it largely and they are painting from eggs to learn nicely of drawing and from pure colored ribbons and muslins the range of their colors.[1]

45. Thomas Eakins. *Three Wooden Forms, Painted Red, White, and Black*, probably 1879-1886.

Another student quoted Eakins as saying

Paint three eggs—one red, one black, one white. Paint the white and black ones first, then paint all three together. I turned myself some wooden ones, this shape and I painted these in sunlight, in twilight, indoors,—- working with the light, and the light just skimming across them. These simple studies make strong painters.[2]

Eakins apparently made several sets of these egg-shaped wood forms (fig. 45), some of which may have been partly made by students. Sets survive in the Eakins collections at the Philadelphia Museum, the Hirshhorn Museum in Washington, and the Joslyn Art Museum in Omaha, Nebraska. Along with the latter are oil studies of these and similar forms, namely, colored balls of yarn and a human knee, all exercises in scrutinizing, defining, and

modeling objects.[3] That such efforts had to do with the careful examination of pure forms, colors, textures, and lighting is directly relevant both to the subject and process of Peto's art.

If the foregoing group of Peto's paintings owe an observable debt to Harnett and a more speculative one to Eakins, then his other early still lifes of food subjects are clearly closer to the tradition of Francis and Roesen. Indeed, Peto's first dated work known is an elaborate assemblage of fruits finished in February 1875 (fig. 46) and especially reminiscent of the so-called luncheon pieces by Francis. However, Francis at most counterpointed his dishes of food with large goblets, baskets, or bottles, whereas the prominent vase and statuette in Peto's composition suggest a foreign source, perhaps through engravings, such as the major series of canvases called *Attributes of the Arts* by Jean-Baptiste-Siméon Chardin. Some awareness of Chardin's art would not have been impossible in nineteenth-century Philadelphia, and Peto elsewhere gives indication that he may have been exposed to such French images (see figs. 68 through 71).

In any case, *Fruit, Vase and Statuette* is on several counts a singular work for Peto. It is one of the largest from his early career, and one of the most colorful. Reds, greens, and yellows dominate the whole, with smaller areas of gray for the fruit bowl, table surface, and background wall at the left. Down the center behind the table falls a broad red curtain, complementing the dish of red grapes and peaches in the center of the foreground. For contrast a couple of green apples and the massive bunch of green grapes have been set on the left side. Shades of golden yellow in turn draw our attention to other apples at either corner, the bronze figure, and the towering carved vase. The rather spacious interior for Peto is obviously derived from existing American conventions and gives little hint of the dark, hermetic spaces he would prefer to manipulate later. The relative uniformity of surface favored here was soon to yield to Peto's enjoyment of rougher more varied textures. This picture is the competent, assured achievement of an aspiring artist testing his wish to paint still lifes foremost. Its gathering of quaint bric-a-brac has a tone of contrivance, which Peto almost immediately abandoned. But it did mark the determined beginning of a professional career, and introduced a category of subjects Peto would explore in unusual and personal ways well into his maturity.[4]

Paralleling his group of newspaper, pipe, and mug subjects on tabletops was a similar, though more diverse, series depicting objects loosely belonging to the kitchen. Some items had genre overtones in alluding to the humble activities of daily marketing or preparing foods with ordinary utensils. Other images Peto constantly rearranged were fruits and vegetables, characteristically seen alone or in small compact gatherings, and colorful candies having an appeal of whimsical delight and innocence. But running throughout is the artist's probing attention to formal properties of shape, color, texture, and light. Upon occasion he pushed to one extreme of clever humor by painting a plucked chicken (fig. 82), or the other extreme of serene elegance by including wine bottles or crystal goblets (fig. 77). Yet for all the sensory associations of these various subjects, Peto always sought and stimulated the aesthetic pleasures of contemplating things for themselves.

In one separate sequence of some half dozen versions he arranged a market basket, straw hat, and furled umbrella. Half of the paintings in this group viewed these items close up on the familiar tabletop (fig. 47). This variant includes a folded wallet projecting into the

46. Peto. *Fruit, Vase and Statuette*, February 1875.

foreground much as matches did elsewhere. In other canvases Peto showed the same objects turned in the opposite direction or without the wallet. Though usually limited in range to reds, yellows, and blues or dark greens, these are fairly colorful compositions. Drawings of similar subjects bearing a Peto signature have infrequently appeared on the market (fig. 48), but comparison makes clear they have little connection with the Peto style. In fact, there is virtually no evidence that Peto worked as a draftsman; instead he preferred to paint and repaint directly on canvas. Beyond his childhood album sketches and watercolors (figs.

47. Peto. *Market Basket, Hat and Umbrella,* after 1890.

48. Attributed to Claude
Raguet Hirst. *Hat,
Gloves, Shoe and Umbrella,*
possibly 1904.

7 and 8), any mature drawings by him are not known to be extant. Several pencil and char-
coal drawings, such as the *Still Life with Hat, Gloves, Shoe and Umbrella* mentioned
above, have been recorded with his name (see also fig. 53), but almost certainly these can
now be attributed to Claude Raguet Hirst (see fig. 52).[5] Further comments about the per-
sonality and work of Hirst might better wait until the context of Peto's dinner table images
discussed below. Suffice it here to say that gloves, top hat, and overshoe are alien to the feel-

49. Peto. *Straw Hat, Bag and Umbrella,* 1890s/early 1900s.

ing and technique of Peto's painting.

The other half of this small group shows for Peto a radical shift in locating and viewing his subject. In this series he hangs the straw hat and umbrella from a hook on the wall, joined by a darkly patterned carpet bag (fig. 49). The choice of a vertical composition against a flat surface of course makes the picture space conspicuously shallow and, more importantly, focuses attention on the abstracted silhouettes of the objects. This concern

50. Peto. *Crumbs of Comfort*, November 1881.

with abstraction is further evident when we note Peto's changes from version to version. As with other subjects, he adjusted slightly in each case the placement of hat, umbrella, and bag in relation to each other—widening the hat's brim in one, for example, lowering the bag to align with the hat in another, emphasizing the spokes of the umbrella in a third. But of equal significance were his modifications to the top and side of the composition. In the variant illustrated here we see the lower edge of a green shelf at the top, while a shadow of similar width runs down the left side. These help at once to frame the central elements and to confirm the shallowness of the illusionary depth. With other variants Peto removed the shelf, placing the hook directly on the wall, and in one painting he eliminated both shelf and shadow, flattening even more the overall arrangement. Such a transformation of his original tabletop motifs to portions of walls found fuller expression in the extensive office board, fish house door, and letter rack canvases occupying his later years (see figs. 201 through 211).

On his familiar tabletop Peto set out some of the foods brought home in the daily marketing. There are a couple of canvases from his earlier career which will serve as a transition from the parlor to kitchen subject matter. One of these is *Crumbs of Comfort* of 1881 (fig. 50), a rare work that is signed and dated on the front and titled on the reverse. The rather large, plain forms and generally even, opaque surfaces are reminiscent of his youthful

Fruit, Vase and Statuette from six years before (fig. 46). A newspaper and pipe assume their established positions, but now a thick bottle and half-filled glass occupy the central area of the painting. Eleven years later Peto painted another such still life combining the pleasures of the library and the pantry. As its title prosaically informs us, *Mugs, Bottle and Pipe* (fig. 51) reintroduces the sociable beer mugs, along with the pipe and book. From the earlier combination the bottle remains in its prominent position, though here in more colorful and elegant form. The brushwork is more controlled, both tighter and more varied, than in the earlier painting, and the coloring especially well orchestrated. Oranges and reds are concentrated at the lower center, on the pipe stem, book binding, and bottle label; cool gray-blues animate the periphery, in the stripes on the mugs, ash of the cigar butt, matchbox interior, tobacco package, and foil and light reflection on the bottle. Peto toys with balances that are almost fussy: the inclining matchbox echoes the tobacco package, the single matches and cigar fan out evenly like spokes from the composition's center. He may have felt when done that his displacement of things here was overly careful and studied, for he showed no interest in this particular combination again.

The manner and substance, however, did appeal to his contemporary, Claude Raguet Hirst (1855-1942), the most talented woman painter working in the trompe l'oeil still-life tradition during the later nineteenth century. When she came to New York from Cincin-

51. Peto. *Mugs, Bottle and Pipe*, 1890.

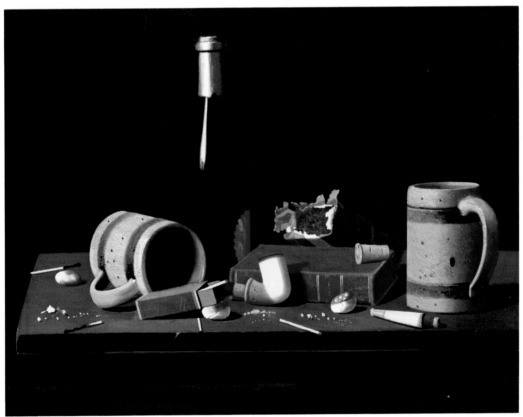

52. *Claude Raguet Hirst. Pipe and Tobacco,* late 1880s/early 1890s.

53. Attributed to Claude Raguet Hirst. *Library Table,* late 1880s/early 1890s *(right)*.

nati in the mid-1880s, she was painting flower and fruit still lifes, but after Harnett's return from Europe in 1886, she soon adapted his standard motifs. Expectedly, typical pictures like *Pipe and Tobacco* (fig. 52) immediately recall Harnett, but because her technique of painting tended to be looser than his, and her draftsmanship less meticulous, she calls to mind Peto's style even more. For this reason, and because she preferred painting in watercolor, occasional pencil and wash drawings have appeared with Peto signatures, such as *Library Table* (fig. 53), but they are far more logically attributable to Hirst.

An equally problematic relationship exists between Peto and Thomas H. Hope, another Philadelphia painter of similar subject matter. At the end of his final chapter in *After the Hunt* Alfred Frankenstein mentions a number of the lesser painters working in the cir-

54. Thomas H. Hope. *Still Life on Newspaper,* probably 1880s.

cle of Harnett and Peto, and on the last page he takes note in passing of Hope as "an uninteresting artist whom I shall not mention further."[6] Yet Hope turns out to have been a painter of quite competent pictures and even an occasional work of superior merit (see fig. 209). He is interesting for our purposes because he appears to have had probable artistic and familial connections with Peto.

Hope (1832-1926) was born in Sussex County, England, and came to the United States at the age of thirty-two with his wife and infant daughter. Almost immediately he enlisted with the Union Army from Connecticut, serving out the last year of the Civil War with the rank of sergeant. He also had an interest in music, an avocation he continued in later years as a bandmaster. After the war he moved to Philadelphia, took up the study of art, and graduated from the Pennsylvania Academy in 1881. Then after moving back to Connecticut, Hope pursued a long-lived career as a well-regarded painter of trompe l'oeil still-life subjects in the manner of Harnett and Peto.[7] Looking at a characteristic tabletop picture by Hope (fig. 54), we can readily pick out familiar objects from the Peto repertoire: the newspaper, mustard jar, overturned brass bucket, and ordinary wine bottle. And from contemporary comments on exhibited Hope paintings, there are additional descriptions of subjects in the Peto mold:

The old rule that in the best painting the least paint is seen holds true for these specimens, for we see on canvas papers of tobacco, newspapers, coins and bank notes so real in treatment that we feel like grasping.[8]

Two other canvases by Hope are recorded as follows:

One represents a bag of tobacco with the contents partly visible; a meerschaum pipe with smoke issuing from the bowl, an old ink stand, box of matches lying loosely about, the whole jumbled together on a table leaf in that careless way so often seen in a gentleman's smoking room. The other presents an earthen mug, copy of Weekly Ledger, account book, much work, pipe and matches.[9]

Though Hope's style is harder and drier than Peto's, and his arrangements somewhat more obvious and static, the resemblance in subject is understandable, given Hope's presence at the academy in the very years Harnett was exhibiting and Peto studying there. In addition, there are other shared interests, as well as a possible family relationship, which suggest a link between Hope and Peto. We know that both were accomplished cornet players; more intriguing is the recognition that Peto's father's name was Thomas Hope Peto and his brother Thomas Hope, Jr. Genealogical searches have still to pin this down; but meanwhile Hope's name and work are close enough to Peto to warrant more than summary dismissal.

Harnett's work at this time also takes up similar food subjects, although he seems not to have had the same interest as Peto in pursuing his arrangements through multiple versions. As happened on a number of occasions over the years, Harnett would venture into a relatively new subject, only to try it once and then discard it, returning to his preferred pipe and mug combinations. But it was precisely these different subjects, such as *Just Dessert* (fig. 55), which had an impact on his colleagues like Hirst, Hope, and Peto. The latter especially took up Harnett's singular themes and made them his own by exploring them in depth through multiple variations.[11]

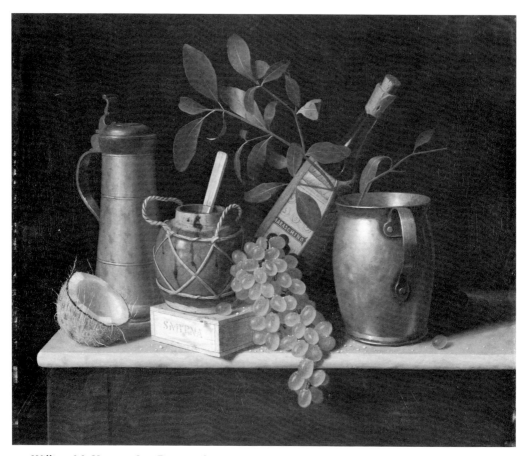

55. William M. Harnett. *Just Dessert*, 1891.

57. Peto. *Still Life with Box*, probably 1890s.

56. Peto. *Bottle, Candlestick and Oranges*, probably 1890s.

58. Peto. *Miniature Still Life*, possibly 1890s.

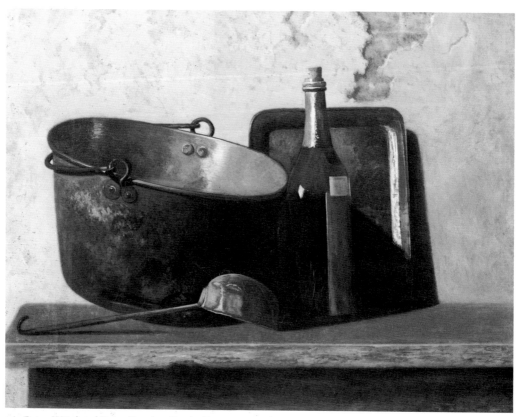

59. Peto. *Wine and Brass Stewing Kettle (Preparation of French Potage)*, probably 1890s.

Here Harnett paints a fairly unusual gathering for him of fruit and food pieces in his cool and polished style. A similar mustard jar, wine bottle, and box appear in a number of paintings Peto completed in this period (figs. 56 and 57). The stylistic differences between the two artists are instructive. Where Harnett's edges are sharp, his light gleaming as it models all the forms, Peto's lines and surfaces are softer, his light source mysterious and diffuse. The result for Peto was a concentration on color, tone, and texture with an almost independent evocative effect. Among the variations he experimented with was a small panel unusual in its square format (fig. 57) and the rare oil sketch of a similar grouping (fig. 58). The

60. Elihu Vedder. *Old Pail and Tree Trunk*, 1865.

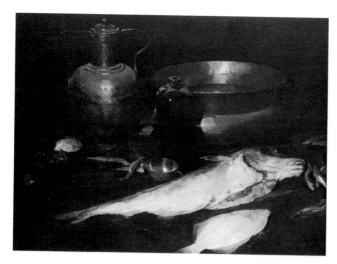

61. Emil Carlsen. *Still Life with Fish*, 1882.

65. Peto. *Battered Pot*, probably 1890s.

square design shows Peto's particular attention to how his picture shape might reinforce the subject matter arranged within it, in this case echoing the cubic cigar box in contrast to the adjacent geometries of bottle and orange. The oil sketch, one of the very few known by Peto, gives an idea of how he began blocking out the broad masses of his forms in terms of the texture of his paint and brushwork. It also demonstrates why the drawings which have appeared with his signature are so unlike his approach, for his basic method was to work directly on academy boards, repainting and overpainting in later stages when necessary, and pursuing alternative compositions on larger canvases as he proceeded. Thus, this little sketch is revealing both of Peto's techniques and of the energy shaping his abstracted forms.

Among the kitchen objects providing notably strong compositions was a group built around an old brass bucket and tin tray, to which were variously added a wine bottle, copper ladle, salt shaker, cream pitcher, or candlestick (figs. 59, 62, 64, 65). To one of these he gave an explicit title, inscribed on the painting's stretcher—*Wine and Brass Stewing Kettle (Preparation of French Potage)*—suggesting the sensory resonances of taste and smell as well as sight. As usual, Peto's quietly nestled forms juxtapose different basic geometries, and also in this case four types of containers or carrying utensils. While we recognize his personal touch stressing simplification, isolation, and wear, his treatment of the subject is not totally

63. Stuart Davis. *Egg Beater No. 1*, 1927.

idiosyncratic, but rather does have its place in the larger context of still-life paintings being undertaken by other American artists during the later decades of the nineteenth century. For example, Peto may be usefully, if unexpectedly, compared with painters as diverse as the mystical Elihu Vedder (1836-1923) and the Chardinesque Emil Carlsen (1853-1932). With the former (fig. 60), Peto shares a contemplation of ordinary, used things and with the latter (fig. 61), a love of painterly textures and diffusely lit solid masses.

The close-up concentration of objects on a tabletop corner inspires an even more distant, though applicable, comparison with the *Egg Beater* series by Stuart Davis (1894-1964) in the twentieth century. Brought up in the realist tradition of Robert Henri and John Sloan of the Ash Can School at the beginning of the century, Davis turned under the catalyst of the Armory Show of 1913 to the abstract directions of European modernism, most particularly the intersecting planes and flat color surfaces of cubism. With *Egg Beater No. 1* in 1927 (fig. 63) he began a sequence of pictures based on the shapes of an eggbeater, fan, and pair of rubber gloves set upon a table. His own description of the circumstances leading to this work is revealing of his process and intentions:

One day I set up an eggbeater in my studio and got so interested in it that I nailed it on the table and kept it there to paint. . . . [The] subject is an invented series of planes which was interesting to the artist. They were drawn in perspective and light and shade in the same way another artist draws the planes of a human head or a landscape. . . . I got away from naturalistic forms. I invented these geometrical elements. Gradually through this concentration I focused on the logical elements. They became the foremost interest. . . I felt that a subject had its emotional reality fundamentally through our awareness of . . . planes and their spatial relationships. . . . My aim was not to establish a self-sufficient system to take the place of the immediate and the accidental, but to . . . strip a subject down to the real physical source of its stimulus.[12]

From Matisse's fauvism came the bright colors, from Léger's cubism the mechanical utensils, and from Picasso's collages the overlapping textured planes. In his own terms Davis explored the pictorial interaction of solid and void, negative and positive planes, lines as edges and as free-floating elements, forms open and closed, color descriptive and abstract. Obvi-

62. Peto. *Pots and Pans*, c. 1880.

64. Peto. *Brass Kettle and Candlestick*, probably 1890s.

66. Peto. *Brass Kettle*, probably 1890s.

ously, Peto never pursued to the same degree such an analytic dissection of forms or reduction of object and surface to the verge of independent abstraction and nonrepresentation. But from the vantage point of Davis' experiments we can appreciate the foretaste of modernism in Peto's attention to formal matters of pure shape, texture, and design.

67. Peto. *Wine Bottle, Raisins and Box,* 1894.

In this group, as elsewhere, when Peto narrowed his focus of attention to the simplest possible arrangement or major single object alone, he achieved a heightened power. This is evident in the effective tensions he creates between the two forms in *Brass Kettle and Candlestick* (fig. 64) and in their compressed relation to the framing edges of the painting. Even more dramatic is his isolation of the *Battered Pot* or *Brass Kettle* (figs. 65 and 66), where the dented contours and glowing highlighted edges accentuate these familiar but idiosyncratic shapes. Although physically small images, the objects here acquire a primitive strength and stature through the obscured lighting and setting. They are wonderful examples of Peto's ability to invest the ordinary and humble with a touch of poetry and mystery.

Various types of wine bottles, jugs, and jars also anchored a number of compositions he filled just with fruits. These are some of Peto's least well-known works, yet among his most colorful and graceful. With only a small fig box reinforcing the planar severity of the table edge, these designs are otherwise replete with the bulging forms of oranges, lemons, figs, or grapes (figs. 67 and 68). Their colors are ruddy and hearty tans, yellows, and greens. In sum, they convey a mood of amplitude tempered by reserve, vital warmth held in balance, and things which might be taken for granted taken seriously.

In this regard Peto's art from time to time recalls that of the eighteenth-century French

68. Peto. *Oranges, Lemons, Nuts, Pitcher and Honey Pot on Box,* probably 1890s.

69. Jean-Baptiste-Siméon Chardin. *Still Life,* c.1755.

70. Jean-Baptiste-Siméon Chardin. *Still Life with a White Mug*, c.1756.

master, Jean-Baptiste-Siméon Chardin (1699-1779), enough so that we have to wonder if the American painter was somehow familiar with the images of his rococo predecessor. After Jean-Antoine Watteau's early death in 1721, Chardin emerged as one of France's greatest painters of the century, and above all one of the most eloquent painters ever of still-life subjects. Quiet, timeless, luminous, and restful, his canvases of commonplace kitchen objects and foods draw our attention equally with their mysterious aura and the sensuous presence of paint. Chardin depicts a world of social, natural, and artistic order. Yet his images are not inert abstract reductions, but rather radiate an implied human presence and an idealism shaped by a sense for the rightness of things.[13]

Several aspects of Chardin's typical still lifes (figs. 69 and 70) suggest comparison with Peto: the pervasive attitude of meditation, celebration of the quotidian, somber colors and rich textures, austere compositions including details such as objects projecting diagonally across the foreground table edge. The subjects themselves—simply arranged mugs or pitchers alongside a few ample forms of ripe fruit, at rest in a gravity of mood as well as weight, glowing with light as much emanative as objective—bear an affinity of spirit with much of Peto's work.

While no documentary evidence is known confirming a first-hand familiarity by Peto with such French precedents, a number of contextual factors are worth noting. From 1855 for more than a decade the chief instructors and shaping influences at the Pennsylvania

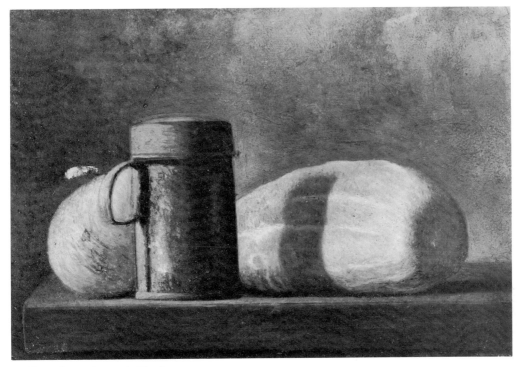

71. Peto. *Cucumber*, probably 1890s.

Academy were Frenchmen, Christian Schussele and Joseph A. Bailly. By the time of Eakins' arrival there in the early 1860s the academy's classical training solidly reflected the model of the Ecole des Beaux-Arts in Paris.[14] Beyond this American orientation toward French academic taste, a strong revival of interest in Chardin's art occurred in the middle of the nineteenth century. This began in France during the 1840s, and in the following decades the Louvre began acquiring his still lifes. By the 1860s articles were published on Chardin, his paintings appeared in exhibitions, and his influence extended to numerous nineteenth-century followers.[15] By the last quarter of the century his canvases were entering American collections; two of his still lifes were acquired by the Museum of Fine Arts, Boston, in 1880 and 1883, respectively.[16] But more importantly many engravings after his work contributed to making his images widely familiar and popular outside France, especially in England and America.

Engravings after Chardin were well known in Philadelphia, and Peto was certainly familiar with various types of prints and illustrations, as we can see from the graphic images he often incorporated into his later rack paintings. In particular, he was acquainted with the mezzotints of the influential John Sartain (see figs. 159 and 160), the wood engravings in *Harper's* magazine by his contemporary Winslow Homer (figs. 144 and 145), and other popular illustrations (see fig. 208). Certainly in these circumstances his awareness of Chardin's work in some form seems a genuine likelihood. Both Peto's more elegant food compositions already discussed (figs. 67 and 68) as well as more prosaic subjects such as his *Cucumber* (fig. 71) suggest a Chardinesque influence. In this last picture one notes the off-center placement of the kitchen salt-shaker and the monumentalizing of forms through

their isolation in a shadowy space. Indeed, the scale of Peto's cucumber in one reading might seem to suggest a watermelon instead. As might be expected, within the same format Peto went on to paint more personal, sometimes whimsical, variants of this subject, as in his unusual treatment of *Banana and Orange* (fig. 72). Again, limited in the number of pieces on the table, it plays off those familiar geometries to him of the linear and spherical. But its special effect derives even more from the nuances of texture, contour, and hue which he exploits within the limited range of yellow-orange.

Yet other modifications led Peto to give predominant importance to a large green ginger jar, seen in differing juxtapositions with oranges, nuts, or pieces of cake. Among the subtlest of these are *Ginger Jar and Orange* (fig. 73), with its close contrasts of green-blues and orange-yellows, and the slightly larger canvas of a similar subject (fig. 74), with its setting side by side of a whole and opened orange. The former demonstrates other gentle tensions of design in the fig box obliquely resting on a pit and in the encircling lines of twine on the ginger jar continuing in the rim and level of red wine in the glass to its left. Uncommon for Peto in the latter is the inclusion of a table cloth, although its creases nicely complement the light and dark sections of the orange and the figs in light and shadow nearby. Elsewhere he painted just the jar and a piece of cake together or the jar and cake set beside half a lemon and glass of water. These last two elements would reappear in one of his most refined food paintings (fig. 78). Equally charming and unexpected for him are two works devoted to a delicate white and blue teacup and saucer (figs. 75 and 76). Both view the object straight on and close up, one against an impenetrable dark background and the other a bright textured

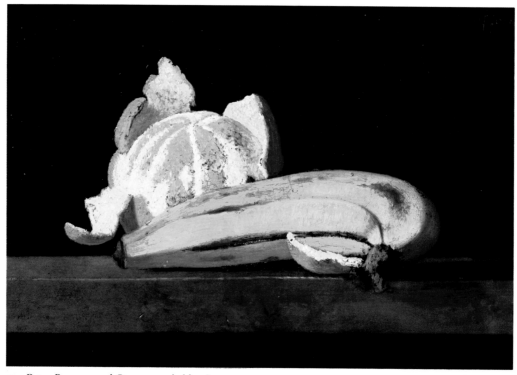

72. Peto. *Banana and Orange*, probably 1890s.

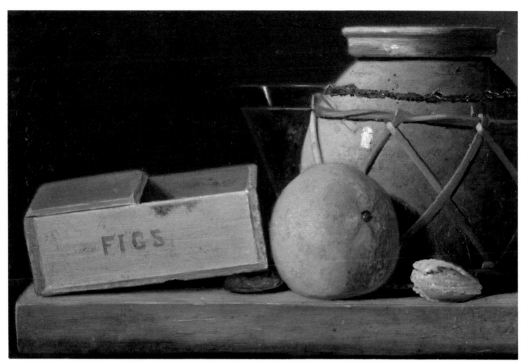

73. Peto. *Ginger Jar and Orange*, probably 1890s.

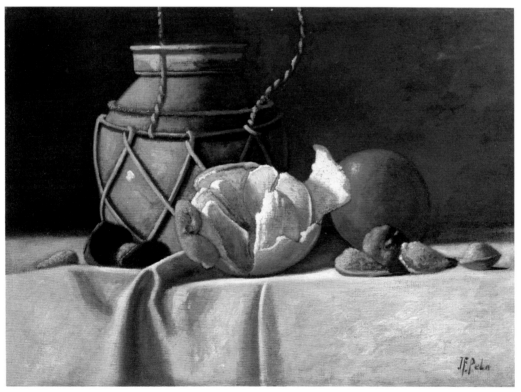

74. Peto. *Ginger Jar and Oranges*, probably 1890s.

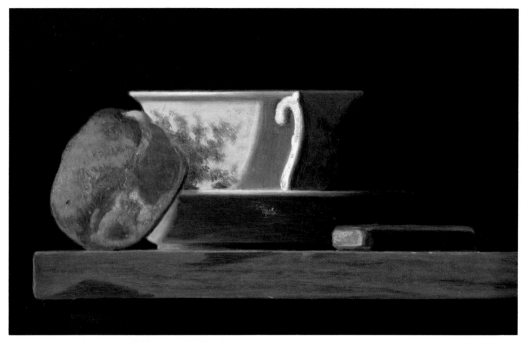

75. Peto. *Cup, Biscuit and Fruit*, probably 1890s.

77. Peto. *Oranges and Goblet of Wine*, 1880-1890s.

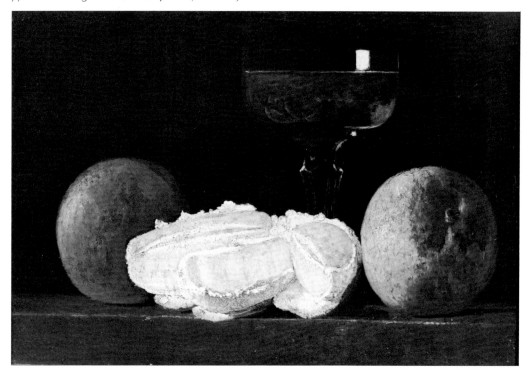

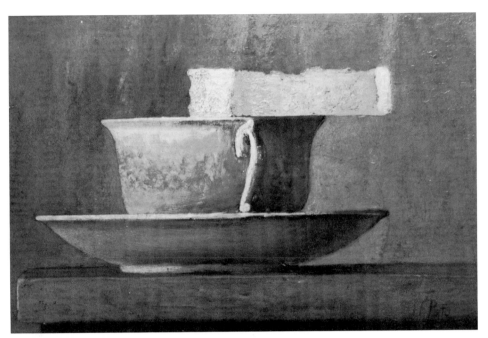

76. Peto. *Teacup and Slice of Cake*, probably 1890s.

green wall. The teacup was another of those rounded shapes Peto loved to render, like the ginger jar, kettle, beer mug, tobacco canister, inkwell, or lantern; with the teacup a biscuit replaces the orange or pipe resting to one side. Even more daring in effect is the slice of cake resting across the teacup's rim, for it introduces at once a heightened sense of sequential convex and concave surfaces, a taut pull on the image's symmetry, and a lively set of silhouetted steps across the picture surface.

Some of Peto's most intimate and beautifully finished food pictures concentrated on simple combinations of fruits seen whole and cut in sections. Replacing the ginger jar used in another arrangement (fig. 74), he set a delicate crystal goblet just behind a trio of oranges (fig. 77), all richly textured and dramatically glowing in light. In contrast to the lush, almost sensuous, character of this work is another of equal but quite different appeal. *Cake, Lemon, Strawberries and Glass* (fig. 78) is rare for Peto on several counts. It is one of the few pictures he dated—1890; its selection of strawberries and the lemon with a slice seen through the transparent liquid in the glass was a subject he treated seldom and with special care; and the relatively tight handling of paint and detail results in an unusual jewellike elegance. Paintings of this sort by Peto have heretofore been virtually overlooked, but they reveal an intensity and virtuosity exceptional in the history of American still-life painting.

On at least one other occasion Peto painted strawberries, this time in a small wooden carton (fig. 79) and rendered with a much softer touch. Instead of the precise contours and bright red coloring in the previous example, now the berries are more impressionistically suggested. The warmer, grayer tones and more powdery surfaces create an effect of ripeness on the edge of decay. This hint of mortality is enriched by the dense brushwork of the background and the muted, mysterious lighting. Thus Peto paradoxically fused alternating sen-

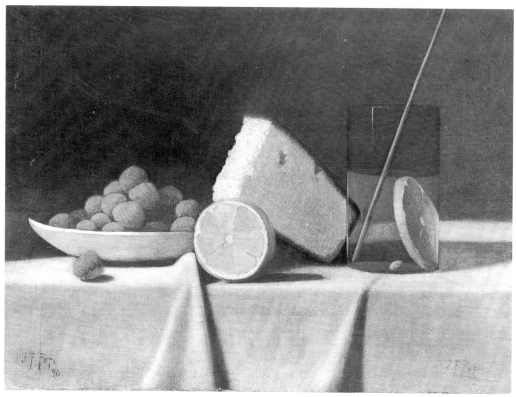

78. Peto. *Cake, Lemon, Strawberries and Glass,* 1890.

79. Peto. *Basket of Strawberries,* 1887.

sations of the humble and the ravishing, the vital and the timeless. In a quite different marvel of ambiguous illusion and visual wit he painted another singular subject for him, *Peanuts—Fresh Roasted, Well Toasted* (fig. 80). Here we look at and through several layers of trompe l'oeil: the outer wooden frame with its lettering, imitation graining, and opened peanut shells; cut within that is the off-center opening and a second painting attached behind showing a drawer or shelf; beyond is the dark space receding into depth with an array of peanuts, their container, and an apple. The eye is never entirely certain of how surface and space are to be read here. Although the two pairs of peanuts in the foreground have believably spilled from the lot inside, where do they sit spatially and how do they observe gravity? They appear to float above the floor logically beneath the interior shelf of peanuts, yet they also cling to the brown and green wood panels, casting small shadows beside them, as if in these instances we are looking down on a table top while at the center looking into depth. Such a playful manipulation of forms seen against a flat surface and in space was to be a central and continuing artistic concern in many of Peto's later sequences of paintings.

80. Peto. *Peanuts—Fresh Roasted, Well Toasted*, probably 1900s.

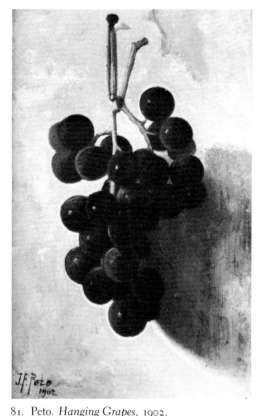

81. Peto. *Hanging Grapes*, 1902.
83. William M. Harnett. *Plucked Clean*, 1882 *(right)*.

That very transition which he made in his work of the 1890s and 1900s is readily apparent in his depictions of fruit or foods hung against walls and door panels. In 1902 he painted a bunch of grapes hanging from a nail in a rough plaster wall (fig. 81). Presumably in preparation he made a small oil sketch of this bunch, looser in handling, against his familiar dark green wall,[17] while here he intensified the tonal contrast between the dark blue grapes and lighter wall surface behind. This accentuates the intricate circular rhythms of the silhouetted grapes, at the same time that the decisive shift from a tabletop situation to a flat vertical plane gives new visual emphasis to the subject's abstract two-dimensional design.

We have already seen a similar process at work in Peto's market basket series (figs. 47 and 49), and will again in a group devoted to candies (figs. 84 through 86). As a more amusing aside, in 1890 he painted a comparably hung plucked chicken suspended on a door (fig. 82). This picture had its inspiration in an earlier tour de force called *Plucked Clean*, 1882, by Harnett (fig. 83). Although Peto has again followed his friend's example, he treats his image with both a different manner and attitude. Where Harnett indulges in his bravura ability to render illusionistically these peculiar textures, Peto heightens both the humanity and humor of his subject. The fallen keyhole latch, bent nails, and gouged wood surface all hint of life's pathos and loss; the splattered blood beneath the chicken's head stands out against the complementary hue of the green door and introduces a wry sense of immediacy. *For a*

82. Peto. *For a Sunday Dinner*, 1893.

Sunday Dinner is at once ironic and poignant, toying with the art of nature and the nature of art.

The completed picture must have drawn a certain amount of attention, for the Island Heights newspaper made note of its display at a local shop:

John F. Peto the artist of Island Heights, has just completed a handsome oil painting representing a rooster hanging on an old door, the chicken had just been picked and presents a very natural appearance. It can be seen at C. B. Mathis' drug store.[18]

The contents of this local meeting place may well have inspired Peto to attempt other store case items, such as the colorful canvases of candies which serve as the metaphorical and literal dessert to this chapter.

In 1878 Peto painted *Peppermint Candy* (fig. 84), which displays on the familiar table-top corner a white paper bag, out of which tumble red and white striped and orange candies. The combination of cluttered shapes with a sense of serene refinement is a note we shall see explored more extensively in Peto's later series depicting books piled on shelves (figs. 108, 117, and 122). This work above all remains a delightful indulgence in bright colors both for their own sake and for their sensory associations. The vibrating white and red motifs find a particularly clever echo in the pink string which delicately lies across the paper bag and falls first to the table surface and then over its foreground edge.

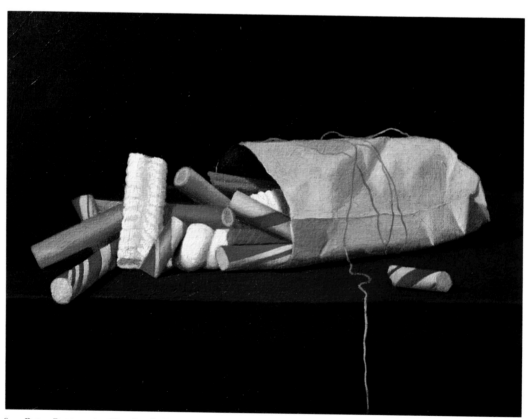

84. Peto. *Peppermint Candy*, 1878.

Three years later Peto did another version, slightly smaller in size and rougher in finish. Were both canvases not dated, our expectation might be that *Help Yourself* (fig. 85)—proudly inscribed on the reverse "John F. Peto/Artist/Phila/7.81"—was possibly a finished study for the larger work. Instead this is a characteristic instance of Peto's returning to an earlier image he enjoyed, readjusting its components for a different effect. Besides reversing the bag and candies on the table and viewing the whole ensemble closer up and cut off at the sides, he also gives greater attention here to the complicated interlocking candy forms and to their reflections on the now polished table surface.

The theme received its most ambitious and inventive treatment in one of Peto's summary works, *The Poor Man's Store* (fig. 86), executed in 1885. Now the tabletop has become a shelf in a display window, and the composition, as we have seen elsewhere, has shifted from one of volumetric organization in depth to a vertical and planar arrangement. Familiar presences from earlier pictures are the cakes and oranges, the containers of peanuts, and the candycanes. The smaller candy pictures were clearly a part of his working out the subject, for as early as 1880 Peto was painting his first canvas with this title. Its location now unknown, the work was submitted by the artist for exhibition in Philadelphia, where it received favorable notice in the newspapers:

Mr. John F. Peto contributes to the present annual exhibition of the Pennsylvania Academy of the Fine Arts a study of still life, entitled the "Poor Man's Store," which cleverly illustrates a familiar phase of our street life, and presents upon canvas one of the most prominent of Philadelphia's distinctive features. A rough, ill-constructed

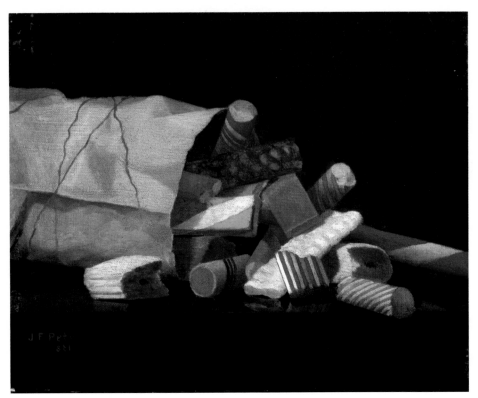

85. Peto. *Help Yourself,* 1881.

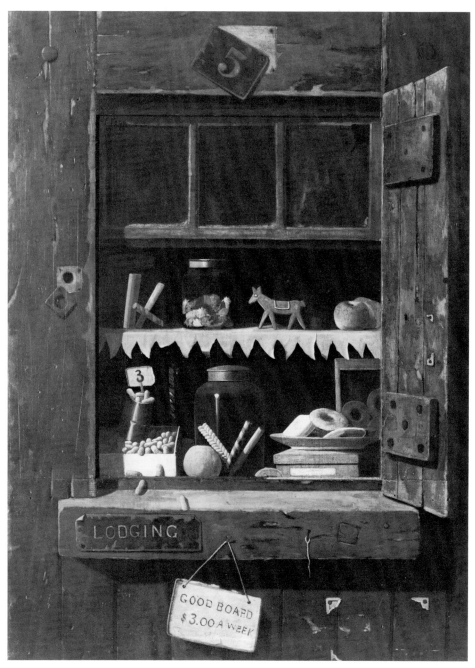

86. Peto. *The Poor Man's Store*, 1885.

board shelf holds the "Poor Man's Store"—a half dozen rosy-cheeked apples, some antique gingerbread, a few jars of cheap confectionery "Gibraltars" and the like, and, to give all a proper finish and lend naturalness to the decorative surroundings of the goods, a copy of *The Record* has been spread beneath. Mr. Peto's work has been well done, and is no less attractive from its artistic merit than for its fidelity to truth. The picture is No. 159 in Gallery F.[19]

From this description it is evident that Peto made some minor changes in the 1885 ver-

87. Walker Evans. *Bedroom Fireplace, Tenant Farmhouse, Hale County, Alabama,* 1936.

sion reproduced here, the most notable being the replacement of the newspaper with the two lodging signs at the bottom. In many of his later works Peto loved to paint numbers, signs, addresses, and other references both identifiable and obscure. These in part were clues to the world of objects he was painting but equally were lexical elements having their own verbal and visual power. Here the title, the decrepit state of the wooden boards, the simple goods, and the pointedly inexpensive prices all suggest a humble yet cheerful humanity. The bright details and even good humor of this world etched by decay eloquently reveal Peto's constant personal balancing of the forces of pessimism and optimism. No doubt intentional is his ironic punning in the sign "GOOD BOARD," referring at once to the foods above and to the construction of his painting.

Peto's image of this gentle corner of humanity, with its casual yet careful record of individual presence, calls to mind strikingly similar arrangements isolated by the camera of Walker Evans in the 1930s. His *Bedroom Fireplace, Tenant Farmhouse, Hale County, Alabama* (fig. 87) captures a comparable locus of daily human activity. Evans, one of the foremost photographers of his generation, joined many of his colleagues during the great Depression in working for the Farm Security Administration to document the conditions of rural poverty in America. Like Peto, Evans brought an eye to his subject matter that cared as much for the reality of things as for the aesthetics of abstract form. Instead of store shelves, a crude table and shallow mantle serve the same effect of turning this plain Alabama fireplace into a secular altar. With reverence objects of use are placed on these boards; the mantlepiece is given simple decoration by the cut paper strip; and on the nearby wall planking are affixed the visual signs of peoples' passing lives. The scratched sentences, child's palm

print, magazine photographs, and torn-away paper call attention, as do their counterparts in Peto's art, to the basic elements of art and biography.

Evans' concern for formal order and organization is also an aspect fundamental to Peto's painting. Both artists play with the tensions of visual symmetry and asymmetry in their compositions, suggesting a taut pull between the impulses toward clarity and chaos. In this regard we can also cite the writing of James Agee, who collaborated with Evans in the famous project of documentation that resulted in the publication of *Let Us Now Praise Famous Men*. In his prose meditations Agee took inventory of the plain and worn truths of sheer endurance, the accumulated details of individual activities and surroundings. Describing the parts of a tenant farmhouse, he noted:

> Most naive, most massive symmetry and simpleness. Enough lines, enough off-true, that this symmetry is strongly yet most subtly sprained against its centers, into something more powerful than either full symmetry or deliberate breaking and balancing of 'monotonies' can hope to be. A look of being most earnestly hand-made, as a child's drawing, a thing created out of need, love, patience, and strained skill in the innocence of a race. Nowhere one ounce or inch spent with ornament, not one trace of relief or of disguise: a matchless monotony, and in it a matchless variety: and this again throughout restrained, held rigid.[20]

It is one of the rich fascinations of Peto's art that it gives such a broad range of hints of coming aesthetic concerns in modern art, from the treatment of subjects in cubism, dada, and pop art to the spare yet poetic realism seen here. But not only do the accidents of theme and composition bring Peto and Evans together for comparison. We also gain insight through their respective images into two periods of American life when the nation and the age were "sprained against [their] centers."

Notes

1. Quoted in Theodor Siegl, *The Thomas Eakins Collection*, Philadelphia Museum of Art, Handbooks in American Art, 1 (Philadelphia, 1978), 109.

2. Quoted in Siegl, *Eakins Collection*, 109. In a comprehensive doctoral dissertation, uncovering numerous unknown records and much new material, "Thomas Eakins as a Teacher" (Columbia University, 1981), Maria Chamberlin-Hellman now shows Peto to have been an enrolled student at the Pennsylvania Academy one year earlier then previously thought, from 1877 through 1879. In 1877 Eakins assisted Christian Schussele in teaching the life studies classes, and the following year Eakins began to teach anatomy and perspective as well. In the fall of 1878 he had the additional responsibility of supervising the modeling classes; that year, too, the directors of the academy gave him the title of Assistant Professor of Painting and Chief Demonstrator of Anatomy.

Under Eakins' leadership most entering students took the antique classes first, drawing from casts after classical and Renaissance sculptures. In this regard it is important to note the presence of the small statuette in Peto's first dated still life of 1875 (fig. 46). 1877 is the one year in which Peto and Harnett were both attending the academy, the former in the beginning antique class, the latter in the life class. Registrar records indicate that an antique class ticket was issued to "Peto, John F.—245 Spruce."

Schussele first formed a class in still-life instruction in the late 1870s, which Eakins operated during the eighties. His best known pupil, Thomas Anshutz, completed a rough oil sketch, *Still Life with an Orange*, c. 1883 (Hirshhorn Museum and Sculpture Garden, Washington, D.C.). One of Eakins' own most intimate group portraits includes a still life: *Chess Players*, 1876 (Metropolitan Museum of Art, New York), depicts wine

glasses and a decanter on a table to the side, details which occasionally appear in some of Peto's tabletop still lifes of the next few years (see figs. 50 and 51).

In sum, while we cannot exactingly place Peto in the very same room at the academy with Eakins, so close is their proximity as teacher and student during Peto's formative years, that we clearly have both strong stylistic and personal evidence to indicate a connection. For the preceding information on Eakins' teaching years I am much indebted to Maria Chamberlin-Hellman, and specifically to her dissertation, Chapter 3.

3. See Phyllis D. Rosenzweig, *The Thomas Eakins Collection of the Hirshhorn Museum and Sculpture Garden* (Washington, D.C., 1977), 225.

4. Periodically, superficially similar food and fruit compositions bearing spurious Peto signatures have surfaced on the market. A photograph of one such picture with fruit surrounding a large painted vase is in the files of Chapellier Galleries, New York. Another once owned by Victor Spark, New York, is a circular canvas depicting apples and nuts before an overturned market basket. Neither the handling nor format of this work bears a relation to Peto's style of any period. But because Peto's oeuvre has been so less clearly established than Harnett's, it is easy to see why such attributions and signatures appear.

5. Photographs of two other spuriously signed drawings are on microfilm among the Alfred Frankenstein Papers in the Archives of American Art, Washington, D.C., roll 1377, frames 0142 and 0190. One is a fruit still life; the other, game with a wine bottle.

6. Alfred Frankenstein, *After the Hunt: William Harnett and Other American Still Life Painters, 1870-1900*, rev. ed. (Berkeley and Los Angeles, 1969), 160.

7. Chronology of Thomas H. Hope on file in the Inventory of American Paintings, Smithsonian Institution, Washington, D.C.

8. Hope chronology, Inventory of American Paintings.

9. Hope chronology, Inventory of American Paintings.

10. Letter from Raissa Fomerand, Post Road Gallery, Tarrytown, New York, to Abigail Booth Gerdts, Inventory of American Paintings, Smithsonian Institution, Washington, D.C., 9 January 1977. Since Hope was a generation older than Peto, he may have been a first cousin or an uncle.

11. The most interesting and important cases of Peto's taking over a particular subject Harnett tried only once or so are the boxes of books and the rack pictures (see figs. 118, 119, 200, and 201, which Peto explored with deep personal feeling and expressiveness through his last years.

12. Quoted in E. C. Goosen, *Stuart Davis* (New York, 1959), 21. See also John R. Lane, *Stuart Davis: Art and Art Theory* [exh. cat., The Brooklyn Museum] (Brooklyn, New York, 1978).

13. See Pierre Schneider and the Editors of Time-Life Books, *The World of Watteau, 1684-1721* (New York, 1967), 146-161; Michael Schwarz, *The Age of the Rococo* (New York, 1971), 127-143; Michael Levey, *Rococo to Revolution, Major Trends in Eighteenth-Century Painting* (New York, 1966), 140-146; and Pierre Rosenberg, *Chardin, 1699-1779* [exh. cat., Cleveland Museum of Art] (Cleveland, Ohio, 1979).

14. See David Sellin, "1876: Turning Point in American Art," in *The First Pose* (New York, 1976), 10.

15. See John McCoubrey, "Revival of Chardin in French Still-Life Painting, 1850-1870," *Art Bulletin* 46 (March 1965), 39-53; and Gabriel P. Weisberg with William S. Talbot, *Chardin and the Still-Life Tradition in France* [exh. cat., Cleveland Museum of Art] (Cleveland, Ohio, 1979).

16. Mrs. Peter C. Brooks gave *Kitchen Still Life* to the Boston Museum in 1880, followed three years later by the gift of *White Tea Pot* from Martin Brimmer. See Eric C. Francis, "Chardin and His Engravers," *Print Collectors Quarterly* 21 (July 1934), 228-248; and Esther Singleton, *Old World Masters in New World Collections* (New York, 1929). I am also indebted to the research of Linda Ayres of the National Gallery of Art and Harry A. Brooks of Wildenstein & Co., New York.

17. Collection of the Peto family, at The Studio, the artist's house at Island Heights, New Jersey. As already noted, such oil sketches by Peto are fairly rare. Along with the one broadly outlining a mug and cigar box (fig. 58), note should also be taken of a similar preliminary sketch of *Raspberries in a Basket*, sold at auction at Christie's, New York, Lot 72, on Friday, 24 April 1981.

18. Undated newspaper clipping in the family albums, The Studio, Island Heights, New Jersey.

19. Unidentified newspaper clipping, 8 April 1880, in the family albums, The Studio, Island Heights, New Jersey. X-rays taken by the Boston Museum in November 1964 revealed that Peto painted his picture on an underlying composition of a letter rack, never completed. I am grateful to Trevor J. Fairbrother, Research Fellow, American Paintings, Museum of Fine Arts, Boston, for bringing this information to my attention.

20. James Agee and Walker Evans, *Let Us Now Praise Famous Men* (Boston, 1969), 143.

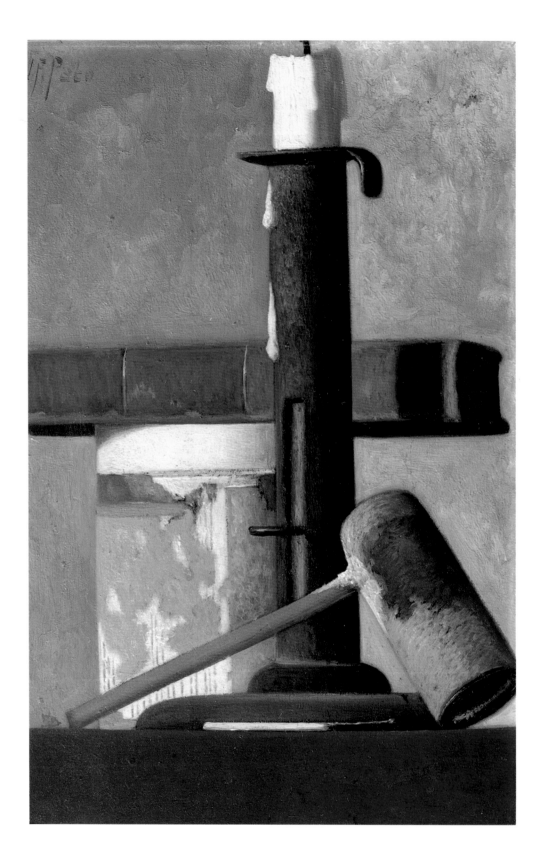

4

JOB LOT CHEAP
The Library Still Life

THE QUIET WORLD OF THE LIBRARY was always a compelling theme for Peto. Along with his occasional diversions into subjects of food and related household containers, he maintained an abiding attachment to those inanimate objects which in other ways nurtured physical and spiritual well-being. Among the items giving such pleasure were the tobacco canister, the inkwell, and the book, each an agent of sorts in enriching the human condition. On a formal level these were shapes which derived from Peto's first still lifes of newspaper, pipe, and mug composed under Harnett's influence. But as with his concentration on the single teacup or cooking pot, Peto here too sought to give these common things new life. Again largely by a process of isolation, enlargement, and simplification he drew attention to elements which go beyond Harnett's conventions. We become witness once more to Peto's mode of transforming familiar tabletop precedents into his own expressive statements.

The tobacco canister must have had an appeal similar to the brass pot, beer mug, or tin lantern in its strong cylindrical presence. As might be expected, Peto undertook several variations (figs. 88 through 90). Together these explore shifting nuances in arrangement, balance, texture, and color. Generally, they show a bright container surrounded by the darker forms of a pipe, book, and occasionally a candle. Some dozen in this series are now known, with the canister appearing in several to the left of center. In one its lid rests to the side with a thick-stemmed pipe placed across its open top (fig. 88). Possibly Peto felt this arrangement slightly contrived, for in most of the other compositions he has the pipe lying across a book or the table surface itself. At least one other version shows the canister lid leaning against the container, but this also may have seemed too unstable, for elsewhere we find the lid perched just off the open top at an angle more in harmony with the few other sloping diagonals in the design (fig. 89). Just one of the known variants depicts the canister placed at the right side of the table; coincidentally this canvas has been given a false Harnett signature.[1] Several in the group do bear Peto's name, though only a couple are dated. Interestingly, these happen to be the most nearly identical in composition, as if having completed one particular composition in 1888, Peto wished to differentiate it and a later slightly dissimilar treatment of the same subject.[2]

Playing as usual with contrasting kinds of cylindrical geometries, Peto introduces different shapes of pipes in these pictures, either a plain thin-stemmed corncob pipe or thicker meerschaum variants. While he takes note of certain textural details and highlights on the

90. Peto. *Candlestick, Pipe and Mug*, 1880s–1890s.

peripheral objects, he indulges most in manipulating the rich surface of the tobacco container, with its combinations of labels and torn paper stripping. Likewise, he concentrates his warmest colors on this central form, usually a mustard yellow body with an orange base and pieces of blue or green paper around the top edge. We are very much aware that these are items in use: the lid just removed, a match lit and blown out, a hint of glowing embers in the pipe, and the occasional candle recently extinguished and dripping bits of wax.

Paralleling his practice in other series, Peto here too ventured into the alternative vertical format (fig. 90). This resulted in a striking rearrangement of the objects, now seen even closer to the picture plane and locked together in a shallow but subtle spatial ambiance. Typically, the artist tested this solution in another vertical panel, slightly less successful in setting the still life against a door panel behind and more conventionally leaning the book beside the tobacco canister. With the version illustrated here we see Peto pushing toward the more daring formal tensions in his work at its best: the stark crossing of book and candle forms, the precariously upturned pipe, the ambiguously plain background wall, and the pressing of each object against the picture edges.

Closely related for Peto were his still lifes with inkwells, a couple being cylindrical like the tobacco containers, but most in the more familiar conical form (figs. 91 through 97). We recognize the books that are worn, the envelope recently torn open and a letter removed, and the quill pen just replaced in the inkwell or set down nearby, with ink dribbling down its side. Both the sense of things in everyday use and the slight but restless shifting in their placement impart an immediacy and vitality which make the human presence seem

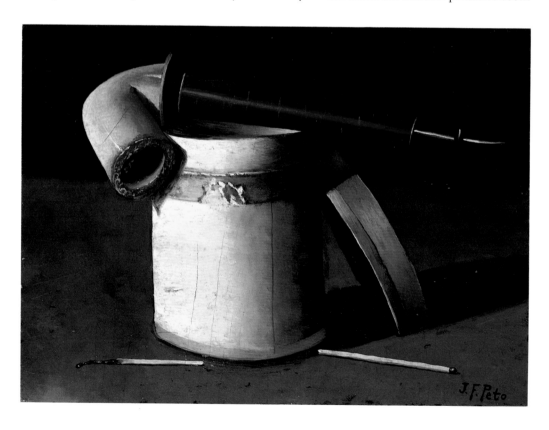

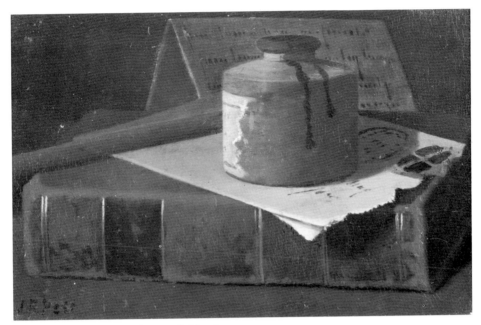

91. Peto. *The Green Envelope*, probably 1890s.

89. Peto. *Tobacco Canister, Book and Pipe*, 1888.

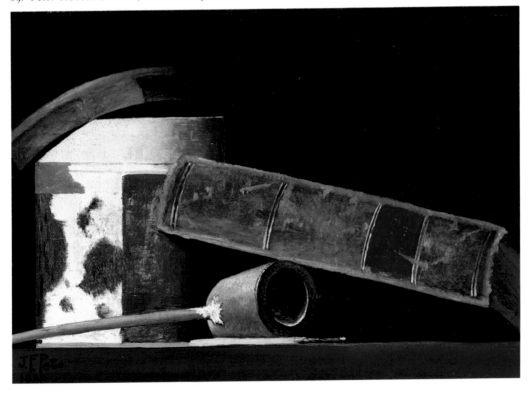

At left: 88. Peto. *Still Life with a Pipe*, 1880s-1890s.

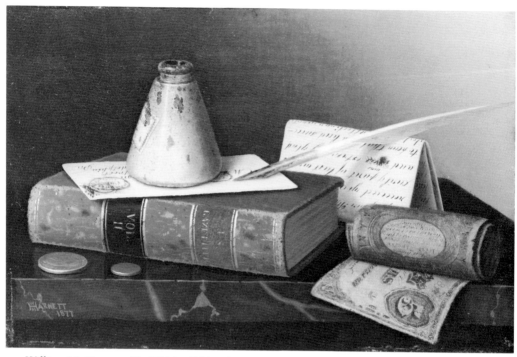

92. William M. Harnett. *The Writing Table*, 1877.

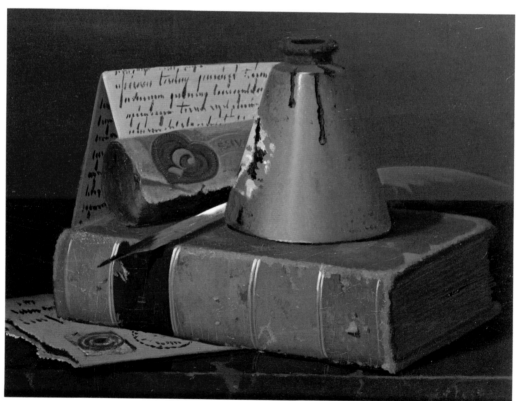

93. Peto. *Inkwell and Plume on Old Book*, probably 1880s.

so close in Peto's art. This subtlety is better appreciated when his work stands alongside that of Harnett, from whom Peto took the precedent of his more standard inkwell compositions. Harnett's *Writing Table* of 1877 (fig. 92) has a characteristic coolness of feeling and precision of detail which convey his particular visual interests in rendering the exact illusion of things. This more detached and dispassionate approach contrasts with Peto's slightly later handling of the same subject (fig. 93), in which the words on the book, envelope, and letter remain imprecise. Even the number on the five dollar bill appears to interest Peto mostly for its lively shape read upside down, in contrast to Harnett's methodical literalness of record.

As with his other efforts initially inspired by Harnett, Peto explored this subject on his own, increasingly concentrating on his richer textures, brooding sense of decay, and warmer coloristic schemes. By the 1890s he had produced a dozen or more variants of this combination, and in turn it became the basis for copies by at least one of his able students in Island Heights. But Adolphe Ancker's *Ink Pot, Book and Copper Ewer* (fig. 94) possesses certain prosaic and awkward details which mark it as the work of a follower. Where Peto himself was capable of exploring new interpretations of established subjects, Ancker remained a borrower, however accomplished. Aside from the ewer, which appears nowhere else in Peto's work, we become conscious of the minor discrepancies in the way the pitcher, coin, envelope, and book rest on the plane of the table. Turning to examples by Peto (figs. 95 and 96), we note the almost disquieting enlargement and confinement of forms, colors on the edge of acidity, and things pressing upon one another in unstable but always legible positions.

Within the book-and-inkwell group were some compositions which differed only in the placement of the conical inkpot. Usually it appeared atop one or two books in generally small pyramidal groupings, but its setting here (fig. 95) on the tabletop itself, off to the side

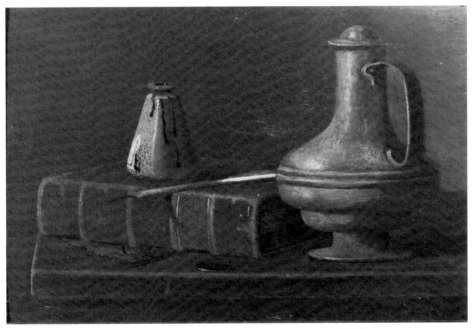

94. Attributed to Adolphe Ancker. *Ink Pot, Book and Copper Ewer,* probably 1890s.

and pushed to the foreground edge, strengthens the contrast with the odd piling of books on the right. [3] Now, the silhouetted left edges of the three top books descend in a jagged diagonal cleverly echoing the inkpot's contours. One massing of these forms is known in a vertical panel (fig. 96), more brightly colored than most of the others. It also differs in playing off broad areas of light and dark as well as planes and lines intersecting at near-right angles, all parallel or perpendicular to the surface of the picture. What is interesting to watch in these series by Peto is how certain elements come to dominate his attention, as he explores their permutations. For example here, both for formal and symbolic reasons, he appears to find some of his most touching and understated solutions in arrangements dominated almost totally by books. In *Books* (fig. 97) and images like it the presence of the inkwell is subdued: its size is relatively smaller, and Peto now pushes it back in the space or off to one side, allotting it a duller green on the edge of a shadow. Somehow, the environment of the library table that we have seen before, and will again with other components, has gradually given way in the artist's mind to the repeated thick planes of books, geometric units which Peto obviously enjoyed independent of their descriptive role. At the same time his interest in books for their own sake was also intellectual. A shelf of worn volumes bespoke the pleasures of constant reading—the old masters made familiar. Within these broken bindings and frayed pages reposed the muse of literature. Peto's books stand as embodiments of culture as diverse as the shapes and colors of the volumes themselves. For him books were more than inert things lying around on tables or shelves; they were unexpected but accessible incarnations of art.

But before Peto was to give himself over fully to his painted shelves of books, he made

95. Peto. *Old Books*, 1890.

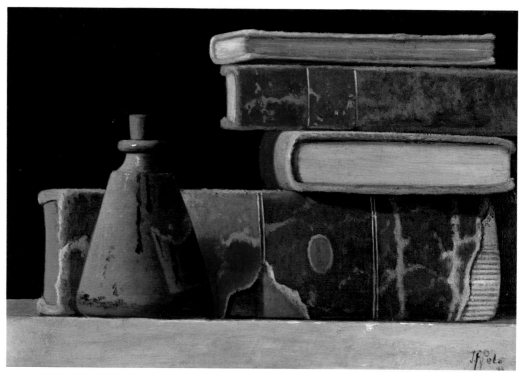

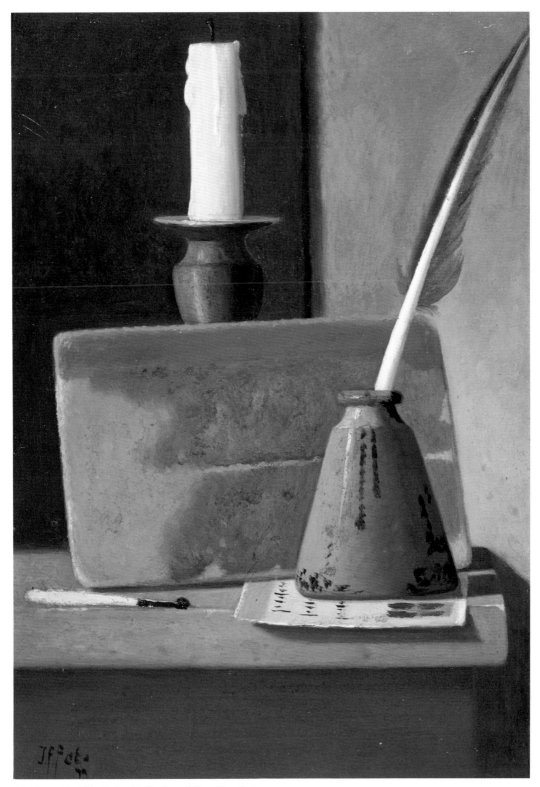

96. Peto. *Quill in Inkwell, Book and Candle,* 1894.

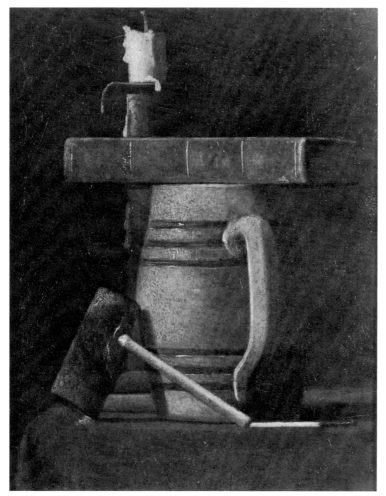

98. Peto. *Candle, Book, Jug and Pipe*, probably 1890s.

certain to explore multiple combinations with other objects in shifting stances on table surfaces. In some instances he simply substituted forms of similar geometries in virtually unchanged compositions: this was the case with *Candle, Book, Jug and Pipe* (fig. 98), in which a striped mug takes the place of the tobacco can in an obviously related work (fig. 90). For some reason, there are many more vertical paintings of this subject matter, with books, pipe, mug, and candlestick in various array now quite frequently occupying the front corner of a table. This congestion of shapes lends a heightened air of unease and precariousness to Peto's works of this period. Increasingly, too, papers or pamphlets bend or hang over the front edges of his tables (figs. 99 through 101), hinting further at impending chaos and collapse. As usual, Peto appears to have pursued two modes of composing at the same time, one moving toward greater density of objects (figs. 106 and 109), the other toward severe reductionism (figs. 107 and 108). Together, these approaches provided him with all the permutations of both formal solutions and expressions of mood he needed. His colors varied accordingly, from the bright and crisp to the dark and suffused, while his generally thick

97. Peto. *Books*, probably 1890s.

99. Peto. *The Writer's Table:*
A Precarious Moment,
probably 1890s.

brushwork ranged from tight and smooth detailing to a loose, plastic handling elsewhere (compare figs. 101 and 103).

One of Peto's most fully realized works in this group is the large canvas known as *The Writer's Table: A Precarious Moment* (fig. 99). For him the color is rather strong and the detailing clear, yet the overall effect remains subdued and engrossing. The bright blue is a familiar color of his palette, and here it dominates the lower third of the composition, echoed gently in the paler blue on the tattered pamphlet hanging in front. In contrast are the nearly complementary hues of the red book and orange inkwell above, which in turn find a muted continuation in the grayish-purple candle snuffer to the right. Despite the relative spareness of objects gathered here and the clarity particularly in defining the edges of forms, there are hints of tension throughout. The leather-bound book to the left bends its covers slightly from carrying its weight in this arbitrary position; an interior page is bent back unnaturally. The candle, inkwell, and beer stein all tilt in nicely repeated but precariously acute angles. And the intense blue table cloth bunches up in smooth but overly compressed folds. In all respects this work evokes that special Peto expression of elegance and elegy.

Occasionally in these compositions Peto exploited canvas formats with more unusual dimensions. Such is the case with the painting known as *Forgotten Friends* (fig. 100).[4] Here, not only have the elements of candlestick and piled books been severely crowded on the front corner of the table, but also the narrow vertical orientation of the image has been augmented by the attenuated ratio of the canvas' height to width. Thus by the very shape of his painting, Peto frames his subject both in physical and expressive terms. This work is characteristic of his more crowded formulas, whereas in other studies from the same period he concentrated on sparer juxtapositions of just two or three items on the table corner.

As if constantly fine-tuning the possibilities for his props, Peto restlessly added to and subtracted from their number, smoothed out or roughened their surfaces, and juggled kindred shapes in the focal positions. When the candlestick did not hold center stage, he substituted a tin lantern or stone jug. The assemblage of a jug, pipe, books, and newspaper (fig. 101) provides a good reminder of Peto's modes of composition and paint handling as well as a sense of the meanings his forms held for him. We can see how his impulses toward density and compression create the feeling of impending instability. At the same time we can begin to appreciate such an obvious awkwardness as the placement of the pipe unconvincingly extending into the foreground across the table edge. The explanation in part lies in Peto's genuine occasional inability to situate and foreshorten objects perfectly, but in part he also appeared satisfied with these defiances of logical space and gravity as liberations from slavish illusionism. Such inconsistencies allowed him to examine pure shapes for their own sake and to express his vision of an unsettled world about him.

If we compare Peto's treatment with that of Harnett in a similar work, *My Gems* (fig. 102), we are immediately conscious of their usual differences in style. All Harnett's surfaces have a uniform smoothness, even a gloss; his light casts logical, consistent shadows; his objects, however artifically arranged, comfortably and solidly rest in their clearly allocated spaces. His painting, moreover, pursues an almost magical illusionism in the deceptive ren-

100. Peto. *Forgotten Friends*, probably 1890s.

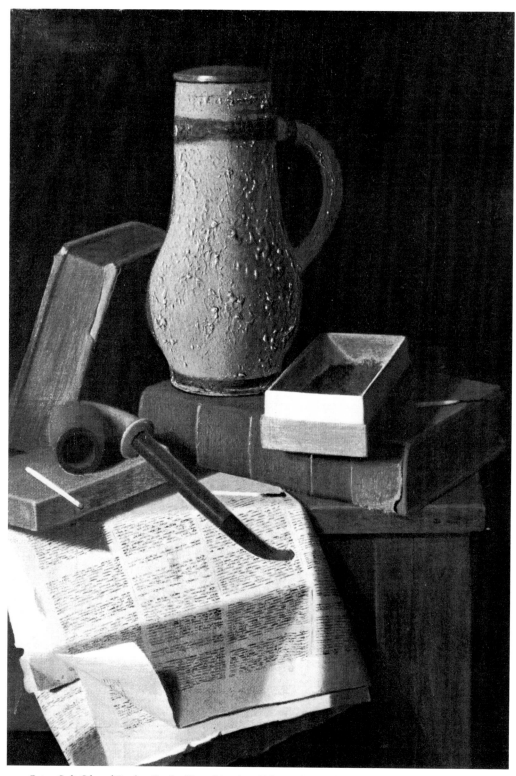

101. Peto. *Salt Glazed Beaker, Books, Pipe, Matches, Tobacco Box and Newspaper,* 1899.

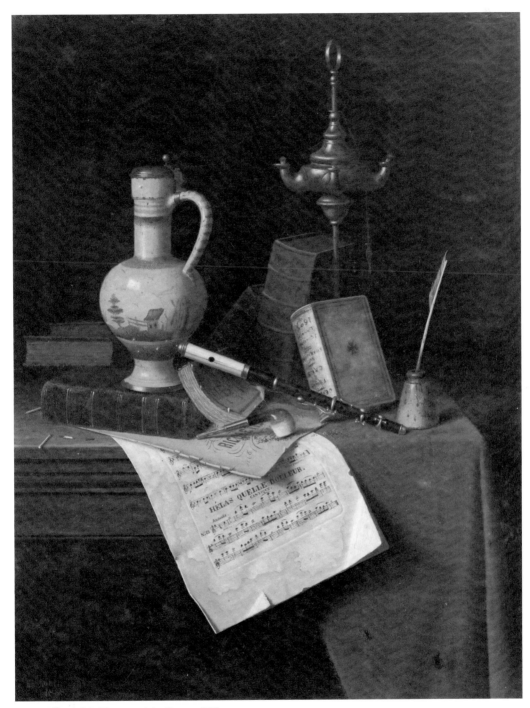

102. William M. Harnett. *My Gems*, 1888.

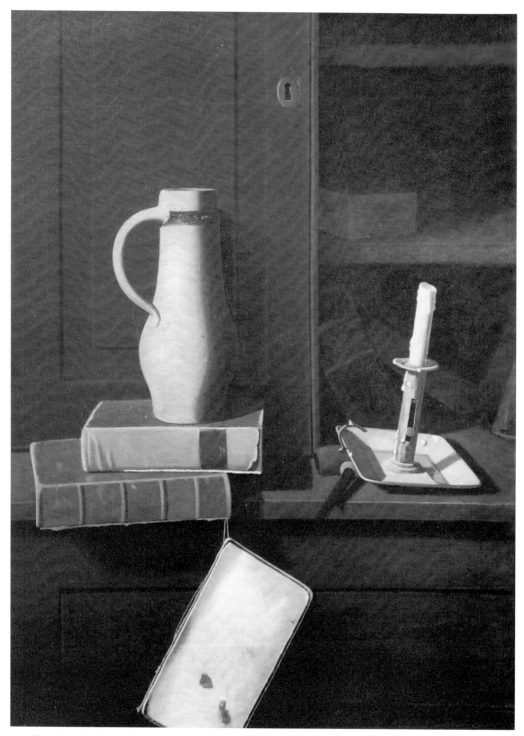

103. Peto. *Jug, Books and Candle on a Cupboard Shelf*, probably 1890s.

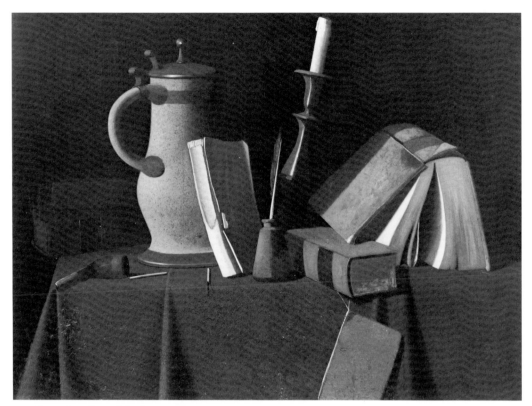

104. Peto. *Candle and Books*, c. 1900.

dering of three-dimensional things on his flat painted surface. In Peto's image, by contrast, the lines of the newspaper are illegible, present more as an abstracted pattern, while his pipe stem floats forward in space, casting no shadow beneath. Although his objects come from the immediate world before him, they take on a generic, detached air in his paintings.

The things in Harnett's world tend to be not only emphatically specific but almost literary in their identification. The blue Delft vessel to the left and the Roman lamp in the right background suggest aesthetic European origins. The inclining piccolo and sheet music allude to the refined talents of musical performance, and the very legible titles of the latter carry additional romantic associations. Both Verdi's emotional opera *Rigoletto* and the score for a flute solo, "Hélas Quelle Douleur" ("Alas What Sadness") are reminders of the transient pleasures of this world. Such allusions are matched by the serious titles of the bound volumes nearby: Dante's *Purgatory*, Shakespeare's *Troilus and Cressida*, and a book of Tasso's poetry. [5] All these details tell us about Harnett's sensibility for giving to his forms allegorical functions. Thus, the used matches, the cracked ivory head of the piccolo, and the stains on the torn sheet music are at once masterful details of illusion and of mortality. Harnett's collection of objects, then, reveals the instincts of an antiquarian and an intellectual. Things are gathered for their explicit associational values, and their significance as treasured possessions.

Peto's images are seldom so rarefied or particular, but rather tend to remain anony-

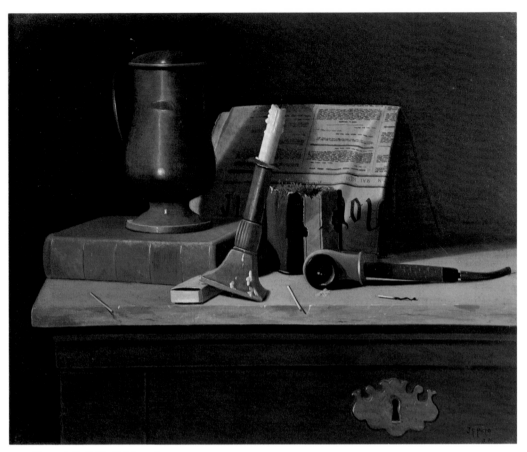

105. Peto. A *Full Shelf*, May 1891.

mous and mysterious. In one important vertical composition Peto hints of a more complex and personal direction for this still-life type (fig. 103). The familiar tall jug and candlestick stand close to the foreground again, but instead of a tabletop, the setting is the cramped space of a shallow cupboard. Two books rest on the narrow shelf in front, while the ghostly shapes of other volumes sit in the shadows behind. These modifications to Peto's heretofore relatively conventional tabletop motifs predict his more interesting and innovative later works, most notably the densely piled shelves or open boxes of books (figs. 124 through 126) and the totally flattened designs of his office boards and rack pictures (figs. 201 through 208).

Peto simultaneously pursued these designs in vertical and horizontal formats. In them he ultimately arrived at the austere and eloquent formalities of his later series. Something of the stark grandeur we associate with his best mature work is present in the large canvas *Candle and Books* (fig. 104). The bright blue tablecloth vividly commands attention as it did in *The Writer's Table* (fig. 99), a vertical counterpart to this painting. Although the handling of paint here is relatively smooth and tight for Peto, he especially engages our attention with colors that are slightly off from the normal or expected hues. Thus the blue borders on green, the orange tends toward brown, the yellow is more a mustard, and the pewter grays

are tinged with lavender. A *Full Shelf* (fig. 105) is painted with comparable precision and some of the same colors, although its more glossy finish overall brings it as close as Peto comes to the style of Harnett. Rare for Peto is the presence of the dated newspaper, May 1891, probably another indebtedness to Harnett, though characteristically personal are such calculated details as the candlestick half perched on the pink matchbox, the dented pewter mug, and the asymmetrically placed brass keyhold plate.

These last two paintings represent the broad middle ground in the spectrum of Peto's compositions. The extremes extending from this center took him respectively to the packed assemblage on a large scale of *Books* (fig. 106) and to the intimate, isolated image of *Pipe and Candle* (fig. 107). The first is one of his largest canvases, obviously an ambitious, intentionally summary effort. Aside from bringing together most of Peto's familiar props in one grand gathering—the tobacco canister, pipe, candlestick, tall jug, and inkwell, all embedded in a dense array of books—the painting exemplifies Peto's studied concern for repeated shapes and colors. On the one hand it seems to suggest the sense of careful arrangement we associate more with the manner of Harnett; yet on the other this order is tempered by the enveloping darkness and almost crushing compaction of all the forms. It is just this initial sense of clarity barely holding off a threatening compression which generates the aura of mystery at the heart of Peto's style.

Although the size of this canvas allows for a certain effect of grandeur, a current of unease is introduced by the elongated horizontal format, by the cropping of book and table-

107. Peto. *Pipe and Tray*, c. 1900.

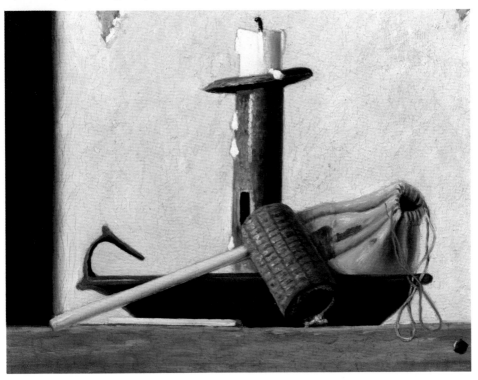

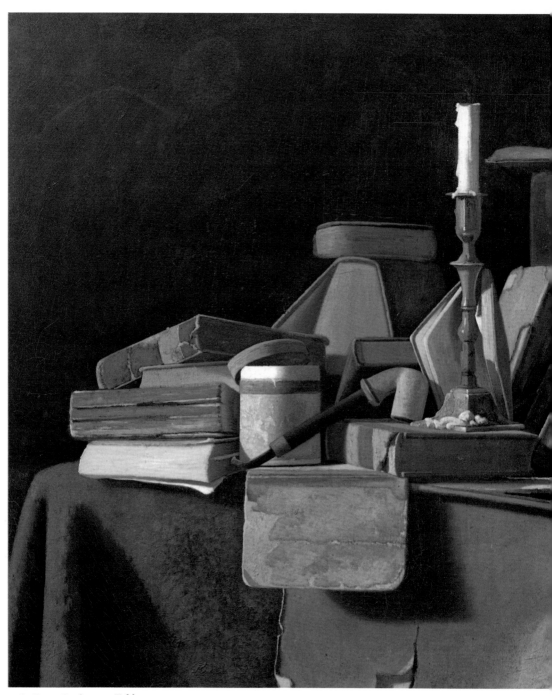

106. Peto. *Books on a Table*, c. 1900.

cloth at the bottom edge, and by the impenetrable background. Light falls on these stolid volumes, but it exists without a source and illuminates nothing beyond them. Peto's vision of the world at large is to be found in the one at hand: things in this world assert their existence even as they must bear the scars of their own mutability. This point of view is evident in the many variants of this subject Peto executed in other smaller-scaled canvases. In some

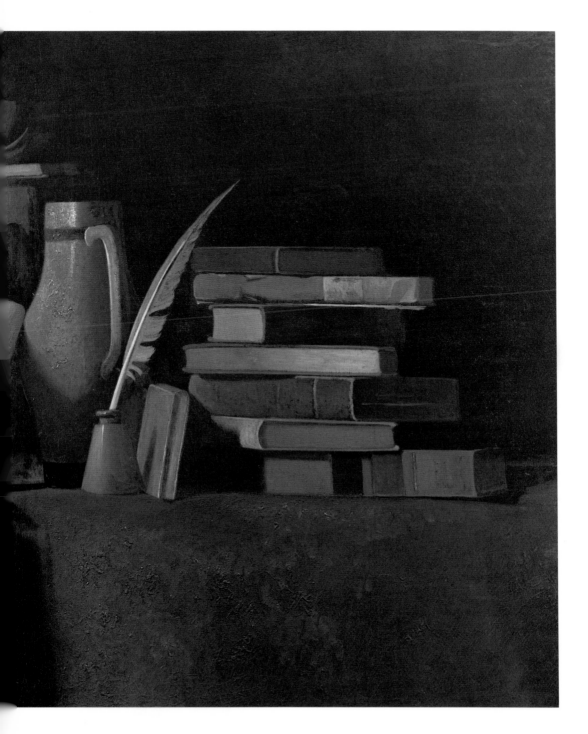

the beer mug reappears, or the candle snuffer, tin pitcher, or round inkwell. In others the viewpoint may close in, the tablecloth change from blue to green, a drawer open partly, or a keyhole be revealed.

At the other extreme Peto would set aside just one or two objects, closely viewed and nearly filling a small surface. He indulged in changing combinations, of candle and

108. Peto. *Pipe and Book*, c. 1900.

snuffer, or book and candle, some viewed from above, some straight on, as in *Pipe and Candle* (fig. 107).[6] In contrast to his usual preference for pervading dark tonalities, Peto has here worked largely in bright tans and yellows. This color scheme serves to set off the central candlestick in a dramatic silhouette, while the frontal, eye-level viewpoint enhances the formal play of the few interlocking vertical, horizontal, and diagonal shapes. Another painting in the category of simplified forms is *Pipe and Book* (fig. 108), a work especially

109. Peto. *Nine Books*, c. 1900.

110. Winthrop Chandler. *Shelf of Books*, c. 1769.

notable for its extended horizontal format, whose elongation directly reinforces the few linear elements of the composition. Such unity between a painting's internal design and outer physical structure is an aesthetic factor occasionally appearing in Peto's art which we much more readily associate with the formalist intentions of modern art.

In terms of subject alone, however, these experiments bring us at last to one of Peto's central and most interesting images—books. From the beginning of his career books were present as ancillary props, components in the larger context of library furnishings and the conventions of American still-life painting. But as books crowded the candlestick, mug, and inkwell off his shelves, they gained increasing attention for their own power, both as repeated shapes in a composition and as repositories of the literary arts. On a more immediate, personal level books were all about the Peto house; they were familiar parts of his interior landscape of living room and studio. Thus, his paintings of books (fig. 109) were acts of

111. Sol LeWitt. *Autobiography* (detail), 1979.

112 A. & B. Peto. *Shelf of Books* (two details), probably 1890s.

delineating his biography by recording the contents of his life and the spaces in which he worked.

Books have been of interest to American artists from the colonial period to our own day. In the eighteenth century Winthrop Chandler (1747-1790) executed a trompe l'oeil panel showing two shelves of books (fig. 110), which demonstrates his fascination with their rhythmic linear shapes and the slight variations in their alignment from section to section. Books were one signal of attained culture in the world of America's first patriots and merchants holding aspirations for prosperity and well-being in the early years of the Republic. Evidence of a library was commonplace in the backgrounds of Federal period portraits, including those by Chandler (see fig. 114). But here in a work intended as a decorative panel for a living room he shows special delight in the play of planes and lines of this illusionary grouping of books. Chandler was an untrained artist in the folk tradition best known for his portraits in bold patterns and bright colors. Born in Woodstock, Connecticut, he may have gained some early experience as a house and sign painter in Boston. He passed most of his later career painting portraits in the Woodstock area and Worcester, Massachusetts. His brother-in-law, General Samuel McClellan, built a house in South Woodstock in 1769, and for the downstairs parlor Chandler executed this overmantle, a clever study of books as a pictorial artifice.[7]

Where Chandler marks one end of the historical perspective on a subject of Peto's, a modern comparison is to be found improbably but aptly in the work of Sol LeWitt (born

112 B.

1928). Known foremost as a conceptual artist for his modular structures and serial images based on mathematical formulas, LeWitt has published his ideas primarily through books of drawings and photographs. On the one hand these are directly concerned with purely formal matters—repetitions of similar shapes, for example—and on the other with observed data of his surrounding environment. In this latter regard his accumulated images constitute a personal narrative, as confirmed in one of his most comprehensive projects, *Autobiography*, a series of photographs taken in the later 1970s and published in book form in 1980.[8] On page after page appear nine square photographs, set in ranks of geometric precision. In part these remind us of the dull factuality and regularization of our lives, but they also force us to look more carefully at small or ordinary things we take for granted. LeWitt's world may be more mechanized than Peto's, but both find art in humble, used objects. They are set aside for us to examine both for their forms and their contents.

Included among the photographs in LeWitt's *Autobiography* are numerous images with counterparts in Peto's work: old album snapshots of his family, professional trade signs, sections of wall and floor boards, old hooks and light fixtures, tools and utensils, cooking pots and pans, food containers, clothing hung on pegs, stamps and letters, pamphlets and fragments of papers, pages of newspapers, art reproductions and playing cards, photographs

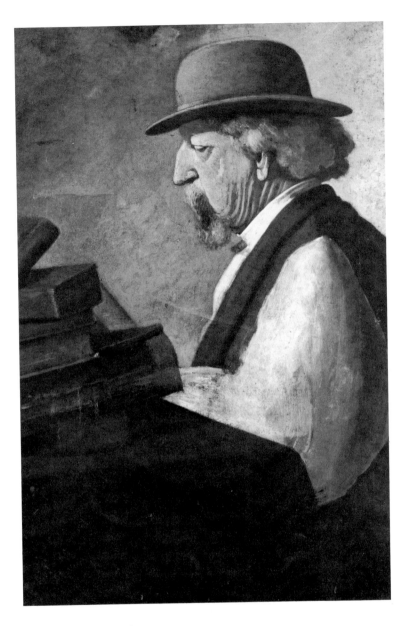

113. Peto.
Joseph Westray,
probably 1890s.

of his own art, close-ups of desk drawers and key latches—and books. The detailed photographs of LeWitt's bookshelves (fig. 111) have the casualness of cropped views and practical arrangements, though the prints are then transformed into strict artifice by the formula of his overall layout. Not only are disparate volumes given visual continuity, but LeWitt's calculated borders between the squared photographs function dually as abstract planar strips and as surrogate shelf dividers. That many of the titles on these shelves refer to other art books tells us about the artist's continuing meditation on the raw materials of his profession. But LeWitt is also at work in that provocatively ambiguous area between the random ordinariness of the world about us and the inventive powers of the artist's creative imagination. As with Peto, he shows us how unexpected things can enter within the frame of art.

114. Winthrop Chandler. *Mrs. Samuel Chandler,* c. 1780.

116. Thomas Eakins. *Professor William D. Marks,* 1886.

115. Eastman Johnson. *Boy Reading,* 1876.

Peto extended his fascination with the theme of books in one especially appealing and clever direction. Around a small upstairs room in his house he painted in oil on plaster an illusionary shelf of books (figs. 112a and b).[9] This was the ultimate play on the merger of his environment with his art. Now his actual books and shelves bordered his imaginary ones on the walls of his library. By moving from a single canvas or panel to the surrounding walls, Peto was both drawing on his immediate work for art and turning his still-life subject matter into a literal interior landscape. In fact, he was able to take the quite related step of painting an occasional outdoor scene, such as his late views of *Harper's Ferry* (fig. 20), in which the geometric volumes of buildings sit astride the hillside like so many books across a shelf.

But it was not just landscape that Peto saw in still-life terms; when he rarely painted the human figure, it, too, assumed the posed immobility and solidity of a large-scale still life. In the Island Heights house still hang two small figure compositions, which show Peto's infrequent attention to quasi-genre motifs. One is a small oil sketch of three dolls belonging to

117. Peto. *Discarded Treasures*, c. 1904.

his daughter Helen; expectedly, his primary interest is in their simple, inanimate forms. The other canvas, long known by the family as *Testing the Hat*, depicts a child pouring water into a top hat while a pet dog watches nearby. Behind these figures in profile stand a ladder-back chair and a wooden cabinet with a bowl and jug, all boldly silhouetted against the wall. The contrived air of the subject and broad patterns of all the forms affirm Peto's impulse to compose what he sees as a still life.

Joseph Westray (fig. 113) is one of the strongest figure paintings Peto completed. On the back of a photograph of this picture kept with the family albums at Island Heights the artist's daughter Helen Smiley noted: "One of the few portraits by my father, this old gentle Joseph Westray owned all this Island at one time." Despite the essential portrait features captured here—the hooked nose, bushy hair and mustache, and sagging chin—Peto generalizes and abstracts his forms, as is evident in the repeated folds of skin around the neck and in the rhythmic piping of books on the table opposite. Significantly, he is concerned with presenting Westray in profile, so as to allow a maximum effect in the bowler hat and contours of the head beneath, and with showing him immersed reading in his world of books. Thus we return to the artist's central and private cosmos of the library. This treatment invites the eye to see the human figure as a pure shape, and to join in the mood of thoughtful concentration.

The figure with books in a library setting was but one formulation of Peto's aesthetic vision. At the same time that it was a natural extension of his book still lifes, it also belonged to the larger conventions in the history of portraiture and American art. For example, Winthrop Chandler showed *Mrs. Samuel Chandler*, c. 1780 (fig. 114), wife of his older brother, seated in a library nook, framed by rows of books as evidence of elevated taste and social well-being. But their repeated verticals also partake in the painter's overall attention to contrasting linear patterns in the figure, tripod table, and swags of drapery. Closer in feeling and period to Peto's art is Eastman Johnson's affectionate rendering of a youth absorbed with a

118. William M. Harnett. *Job Lot Cheap*, 1878.

119. Peto. *Job Lot Cheap*, after 1900.

book in *Boy Reading*, 1876 (fig. 115). Johnson (1824-1906) was an accomplished portraitist before he went to Europe at mid-century for study in Düsseldorf, The Hague, and Paris. From the German school he gained a sense for strong draftsmanship and careful coloring,

while the old Dutch masters made him more conscious of evocative light effects, intimate interior scenes, and hints of an individual's inner life. Exhibited in Philadelphia in 1876, this picture evokes nostalgia for the past, suggested in the Chippendale chair and withdrawn engagement of the youth in his book. Johnson's quiet vignette and shadowy interior belong to the more somber outlook so prevalent in the later nineteenth century, a context already cited for the work of Peto and Thomas Eakins (figs. 130 and 218).

Eakins' name has come up in conjunction with Peto's time of study at the Pennsylvania Academy in the 1870s. The older master and preeminent teacher had firmly established his own style of painting portraits with a broad, often dark palette and keen psychological insight. Peto certainly had the opportunity of contact with Eakins both during his student days and later when he set up his own studio and contributed occasionally to academy exhibitions. It is quite possible that Peto not only learned certain elements of still-life painting from Eakins' methodology, but also acquired his feeling for dark, expressive colors and dense paint textures. In any case, relevant to the present series of comparisons are Eakins' own later portraits of individuals seated in their book-lined studies.

One of the most incisive examples dates from the culminating period of Eakins' academy years, the portrait of *Professor William D. Marks*, 1886 (fig. 116). The sitter was a scientist at the University of Pennsylvania who assisted Eakins in his motion photography experiments, an interesting fact in the light of Peto's work in photography at the same time. Eakins had earlier included a hint of books on shelves behind the figure of *Benjamin Howard Rand*, 1874 (Jefferson Medical College, Philadelphia), and about 1895 placed the seated form of Philadelphia newspaper critic *Riter Fitzgerald* (The Art Institute of Chicago) in front of a wall entirely lined with orderly rows of books. In his portrait, Marks leans forward with a glance of focused concentration; on the right sits his scientific measuring device, which helped Eakins in setting his exposure levels. Like the other sitters, Marks appears to be an intelligent, creative individual, a notion visually reinforced by the

120. William M. Harnett.
Memento Mori, 1880s.

comfortable arrangement of books nearby. Along with the scientific instruments, calipers, and working papers, these volumes are defined like elements in a still life, and they palpably signify the stuff of thought.

Beyond his one rare figure painting of Joseph Westray reading, in contrast, Peto found little need to depict the literal human presence. Consistent with his own evolving experimentation with the Philadelphia tabletop tradition, as maintained by Peale through Francis to Harnett, Peto developed his own modes of adaptation. Beginning in the later 1880s and extending through the nineties, he undertook more complicated groupings of objects, primarily books, on broader wall or cupboard shelves. This decisive break from the conventional tabletop of usually delicate and modest scale permitted Peto to treat his books as emblems of the larger studio environment. In place of a human figure he was able to gather books and occasional fragments of signs or cards to convey a sense of human activity and feeling.

In formal terms there are a few compositions of books spread out on tabletops, which appear so shallow and wide as to suggest shelves. Typical are *Books* and *Discarded Treasures* (figs. 106 and 117), in which the table edges are almost totally obscured or cut off. The latter is one of several pictures which are loosely indebted to an unusual Harnett precedent, *Job Lot Cheap*, painted in 1878 (fig. 118). The Harnett work is intriguing in its atypicality: the slanted signature in script unlike his usual block letters, the bright blond tonality, the torn label fragments, and the awkward tension in the pile of books. Indeed, without its recorded documentation of provenance going back to Harnett's possession, one might initially think it to be by Peto.[10] Only its precision of certain details, especially the glinting highlights of the bookbindings, reveal the Harnett touch. The suggestion of a few titles and the attention to labels announcing a second-hand book sale give to Harnett's image an implied ambiance of

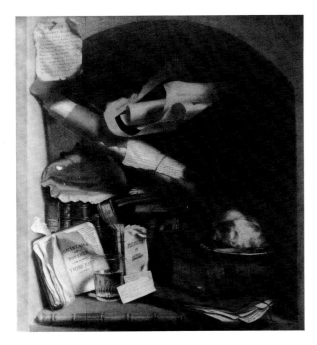

121. Charles Bird King. *Poor Artist's Cupboard*, c. 1815.

122. Peto. *Take Your Choice*, 1885.

genre. Although Peto has taken the same general scheme, *Discarded Treasures* retains little sense of a particular time, activity, or place, but rather turns the jumble of books into a study of time's erosions.

Where Harnett discarded this subject in favor of more refined displays of textural illusionism and contrasts of interesting objects, Peto reworked the idea in a series of variations which moved successively toward a very different mood and result. Peto's version of *Job Lot Cheap* (fig. 119) is much more somber in color than Harnett's books of brightly contrasting yellows, blues, reds, and greens. To be sure, the painted sign remains placed in the lower left, and Peto has added other fragments of personal existence in the signs at the right, reading in part, "Dealer in Books" and "To Let: 2 Rooms." But there are other touches of pure Peto ambiguity, most notably the number 7 just above the window. In Peto's later work these molecules, so to speak, of language and communication appear frequently, sometimes carrying associational meaning, other times standing as details on their own. Like *The Poor Man's Store* (fig. 86) Peto's *Job Lot Cheap* ventures beyond the Harnett precedent in setting his still life upon the shelves of a sidewalk bookstall. Here Peto concentrates on an ordinary corner of the world, made mysteriously private by the cropped close-up view of the open stall door and the shadowy hint of the inner bookshelf.

Given the knowledge that Peto seldom sold his pictures, and made little money on those few he did part with, it is not surprising that we should sense his personality and circumstances projected in these tired discards. By extension, Peto presents himself as a dealer in art, having perhaps to sell it cheap, but convinced of its beauty and power to move. His soiled and chaotic books stand as reminders of our mortality, affecting reformulations of the

memento mori convention. Harnett's treatment of the theme (fig. 120) employs the much more standard image, taken directly from Dutch precedents, of a skull, guttered candle, and torn book binding with its pointedly inscribed message: "Now get you to my lady's chamber, and tell her, let her paint an inch thick, to this favour she must come."

The hourglass and the skull are the most obvious symbols in Harnett's work referring to man's frailty and the brevity of life. Like the pipe so often included by both Peto and Harnett, they are emblems of this transient world: "For my days are consumed like smoke," says the Book of Psalms.[11] The moral notion of addressing the vanity of man is an old theme in the history of art, and one taken up early in the American tradition. One of the more notable treatments exists in the work of Charles Bird King (1785-1862) at the beginning of the nineteenth century. King painted several still-life arrangements across shallow shelves or niches which anticipate Harnett's *memento mori* subjects. The best known of these speak in their titles alone of the difficulties of the artist's life: *The Vanity of the Artist's Dream*, 1830 (Fogg Art Museum, Harvard University) and *Poor Artist's Cupboard*, c. 1815 (fig. 121). Born in Newport, Rhode Island, King studied just after the turn of the century with Benjamin West in London. His consciousness of history painting and of portraiture led him to make a highly successful career painting portraits of American Indians. Before settling in Washington, D.C., in 1816, King spent a few years in Philadelphia, where exposure to the

123. Henry Hobson Richardson. Interior, Winn Memorial Library, Woburn, Massachusetts, 1887-1888.

124. Peto. *Still Life with Lard Oil Lamp,* 1900s.

still-life productions of the various Peales may well have stimulated his own interest in such subjects. Indeed, his subsequent depictions of Indian heads and torsos suggest a continuing still-life sensibility in their attention to clear outlines, contrasting shapes, and striking surface patterns, as if his images were at once documentary portraits and figural still lifes.

Poor Artist's Cupboard is a capsule visual autobiography of a struggling artist in the young republic. Crammed into this shadowy niche are nostalgic memories of his youth in coastal Newport, conjured up by the pearly conch shell at the center. Title pages of books and newspaper fragments refer to his toiling aspirations: "Advantages of Poverty," "Pleasures of Hope" torn through, "The Art of Painting beter advanced by Critisism than Patronage," and "Sherrif's Sale: The Property of an Artist." The mundane glass of water and coarse loaf of bread allude to a humble existence and appeal to our senses of taste and smell.[12]

When we return from the perspective of this academic tradition to Peto's shelves of books, it is possible to see even more clearly his evolution away from the tabletop convention in both composition and content. In *Take Your Choice* (fig. 122) he has decisively shifted from a table surface to what looks like either a wooden box or a shelf attached to the wall. This canvas at one time had the Peto signature and date of 1885 (at the lower right) covered over with a forged Harnett signature. But cleaning removed the surface overpainting as well as an inscription on the reverse, also tampered with, which read: "Take Your Choice/John F. Peto Artist/Philadelphia, Pa."[13]

To Frankenstein this was "one of Peto's most careless productions," yet close looking reveals a richness of coloring and brushwork as subtle and evocative as that anywhere else in the artist's production.[14] Books, scribbled numbers, a sign fragment, and a magazine illustration all testify to the artist's fascination with acts of sight and perception. What seems to be near-chaos in the piling of books in fact possesses consistent rhythms of internal order

and patterning. The loose brushwork and evidently unfinished area—such as the suggestion of a window upper left—heighten the tactile presence and enigmatic mystery of the picture. The brightest tones of orange, blue, green, and white anchor the composition's center, with generally darker variations occupying the outer sections. Finally, even the apparent forces of disorder hold together in the quiet symmetries of balanced details: the two nails on either side of the wall above, the label fragment and dangling pamphlet below, the upended book at each side of the pile, the shadow of the "window" on the left and that cast by the standing book on the right, and the silhouetted angles of the open green volume, creating a culminating focal point for this would-be pyramidal mass. Surely the impression of carelessness gives way instead to an apprehension of artful intent.

It is this conscious arrangement of books which earlier brought our attention to the comparison with H. H. Richardson's architecture (figs. 32 and 33). In his small-town libraries especially Richardson responded to the growing suburban populations and expanding cultural aspirations of Victorian America in the decades following the Civil War. Such libraries (fig. 123) were usually designed as small-scale cultural centers, with not only book stacks and reading room but often exhibition areas and collections of prints, paintings, or copies after old masters as well. Above all, they served the growing reading needs of an American middle-class with increased leisure time and romantic sensibilities. In a day before swift communications by telephone, newspapers were numerous in all major cities and widely read for information. The advent of the paperback book and publishers of popular

125. Peto. *Old Companions*, 1904.

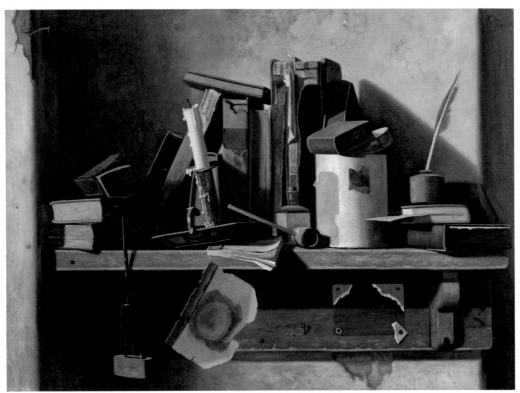

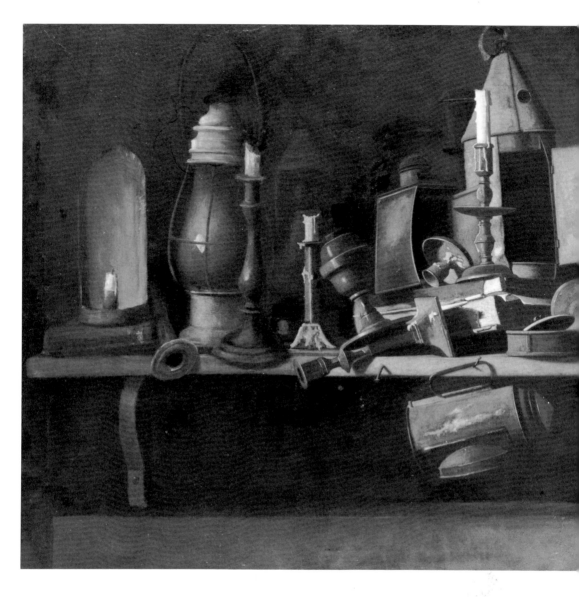

literature brought all manner of books into every family's parlor. The publisher of Mark Twain's stories, The American Publishing Company, for example, was located in Hartford, Connecticut, rather than highbrow Boston or financially powerful New York. Thus the phenomenon of Richardson's libraries makes an interesting point of comparison with Peto's concurrent passion for books. But it is a relationship we have seen to be both stylistic and intellectual. Richardson's structures and Peto's paintings share that context we have already noted of Lewis Mumford's Brown Decades, in their rough textures, earth tones, and heavy materialism. A library's shelves also served social needs; where Richardson provided practical solutions for this cultural function, Peto gazed upon books as metaphors of artistic experience.

The book as a private world for focusing inward and voyaging outward is an idea which links Peto's meditations in another direction to the poetry of Emily Dickinson (1830-1886).

127. Joseph Cornell. *The Hotel Eden*, 1945.

126. Peto. *Lights of Other Days*, 1906.

"There is no Frigate like a Book/To take us Lands away" read the opening lines of one of her most-quoted poems. She goes on to assert that "This Traverse may the poorest take" and marvels at this "Chariot/That bears the Human soul."[15] Although her life span was almost a generation earlier than Peto's, Dickinson created a reclusive art similar in several ways to his. Both spoke from a dark inner vision which had previously haunted the imaginations of Washington Allston and Nathaniel Hawthorne and which ran as a psychological undercurrent through American culture again at the end of the nineteenth century. The shelter, even confinement, of home was of primary significance to Dickinson, and certainly more fully than Peto ever did, she withdrew in midlife into the inner spaces of her house and herself.[16] But like his, her seclusion was as much psychological as physical.

Out of this isolation each seemed to craft in darkness small hermetic assemblages, hers of words and his of painted shapes. With both we often feel we are witnessing the struggle to

shape order out of a fragmented world.[17] Dickinson's privacy is frequently more impenetrable and obscure than Peto's, through it resembles his in mystery and introspection. Like his still lifes, her poems are usually compact and intimate; they turn and echo upon themselves. As his paintings dwell on pure shapes, colors, and textures for their own sake, her lines revereberate with repeated sounds, syllables, and consonants. Both poet and painter collect the building blocks of their respective art forms, using them to fashion metaphors of the self as maker.

With Peto's culminating series of large bookshelf pictures before us (figs. 124 through 126) we can listen for familiar strains in another Dickinson poem which makes an especially appropriate parallel:

> Unto my Books—so good to turn—
> Far ends of tired Days—
> It half endears the Abstinence—
> And Pain—is missed—in Praise—
>
> As Flavors—Cheer Retarded Guests
> With Banquetings to be—
> So Spices—stimulate the time
> Til my small Library—
>
> It may be Wilderness—without—
> Far feet of failing Men—
> But Holiday—excludes the night—
> And it is Bells—within—
>
> I thank these kinsmen of the Shelf—
> Their Countenances Kind
> Enamor—in Prospective—
> And satisfy—obtained—[18]

While we must refrain from assuming exact correlations between poet and painter, we can sense how both individuals see art and books as a retreat from exhaustion. Dickinson talks of the pleasure in contemplating her library, its alluring spices and flavors, its promises of stimulation and satisfaction. She finds joy in an attitude of expectation and anticipation, even endurance, because despite delays and discomfort there is ultimately the prospect of "bells within." For his part, Peto leads us to savor his sensuous colors and textures and to feel, despite the superficial disorder and injury to his books, a calming sense of respite. Each conducts a voyage of thought confident that within the outer pressures of impending chaos art reveals an inner power for us.

Books have had other specific associations in the history of art, though it is unlikely that Peto had any traditional iconography in mind. In the hands of the Virgin, books of hours carried allusions to piety. As a more secular symbol they variously recalled an earthly existence or warned against excessive pride in learning.[19] In American painting these conventions perhaps come closest to traditional realization in the still lifes of King and Harnett; Peto, however, personalizes and transforms their presence. We are still made mindful of the mutability of this world, but it is through an imagination more modern in spirit.

The most complicated and suggestive of Peto's book compositions were the shelf still lifes of his later years, and they were the logical conclusion to his preceding experiments with tabletops and cupboards. At least half a dozen are known in this group; they all tend to be fairly large, approaching life size. In fact, they depict an actual shelf once mounted on his library wall at Island Heights. Its dark green form contrasts with the lighter tan-gray wall behind. With almost no change in the framing and viewpoint from picture to picture, Peto arranged a few basic massings on this shallow surface: one type with an inkwell, lard-oil lamp, and book cover hanging in front (fig. 124); a second with a tobacco can and pamphlet cover overhanging the front edge (fig. 125); and a third with a tin sconce and two or more lanterns standing or hanging nearby (figs. 32 and 126).

Within these hermetic enclosures the artist collates the pieces of his creative life. A parallel is suggested in the magical boxes constructed in the twentieth century by Joseph Cornell (1903-1973). More explicitly influenced by surrealist currents in modern literature and art, Cornell on his own developed his small wooden stages, filling them with memorabilia and evocative found objects.[20] *The Hotel Eden*, 1945 (fig. 127) takes its title from a torn advertising flyer, and in so doing, conjures up both the idea of travel and a fancifully furnished room in the corner of the imagination. Like Peto, Cornell worked largely on his own, in or near New York City for most of his productive life. He drew on the objects collected in his studio and gave them a poetic life inviting contemplation. He was interested as much in the associational values of his objects as in their abstract properties and formal juxtapositions. In looking forward to Cornell's assemblages, Peto once again gives us a surprising hint of twentieth-century aesthetics. As celebrations of artifice and subjectivity, Peto's works, no less than Cornell's, come from the studio of the mind.

Painted toward the end of his life when he was suffering from Bright's disease and consumed with the lawsuit over family land, Peto's battered images do seem to bear an autobiographical burden. But they are also among the most subtly imaginative and lovingly painted works of his career. In transferring his tabletop still lifes, in effect, to the wall surface, he was moving his art into fresh considerations of two-dimensional design and surface illusion. These ideas animated the other general type of picture he pursued in multiple forms through his later career. This involved a wall panel, door, signboard, or letter rack, against which were hung, more conventionally, solid objects and later, more cleverly, flat items. With the painting of pages, cards, photographs, currency, or news clippings attached to a flat plane, the literal canvas and illusionary image virtually became one.

Notes

1. Collection Jeff Cooley, Weatogue, Connecticut.

2. The second variant to the one dated 1888 and illustrated here is titled *Evening At Home* and is in the collection of the Museum of Fine Arts, St. Petersburg, Florida (fig. 231). The figures in the date of this latter painting have been abraded, but appear to read 1902. In this alternate version more of the right side of the book is visible, the stem of the pipe is less sharply modeled, and the juncture of the book against the side of the canister is not as well defined.

3. A near-identical variation of the one discussed here is in the collection of the Newark Museum, Newark, New Jersey, but with a more conventional centralized massing of the same objects (fig. 236).

4. As Alfred Frankenstein has pointed out, only very few of the titles now given to Peto paintings are ones known certainly to have been his own. Among those bearing titles he could have provided or been aware of are the several he lent for exhibition at the Pennsylvania Academy in the 1880s, such as *Any Ornaments for Your Mantlepiece?*, *The Poor Man's Store*, and *For a Leisure Moment*. In other rare cases he painted a title on the reverse of a canvas, like *Help Yourself* (fig. 85). See Frankenstein, *After the Hunt: William Harnett and Other American Still Life Painters, 1870-1900*, rev. ed. (Berkeley and Los Angeles, 1969), 101-102. Other, often romanticized titles were apparently given to Peto's works as they were being discovered and identified in the 1930s and forties, presumably in an effort to characterize their moody style and to distinguish them from Harnett's better known and already documented work. Correspondence with the author, 9 June 1979.

5. See Frankenstein, *After the Hunt* (1969), 178-179. I am also indebted to the observations of Irvin M. Lippman, formerly of the Department of Education, National Gallery of Art.

6. This work has also carried the title *Pipe, Tray, and Candle* (Hirschl & Adler Galleries, New York, inventory no. APG 3077); but this is a misunderstood reading of the forms. What may seem to be a small tray seen from the side is in fact the bottom of the candlestand itself, a small holder variously seen as round and rectangular in other Peto paintings (see figs. 100 and 125).

7. See Nancy C. Muller, *Paintings and Drawings at the Shelburne Museum* (Shelburne, Vermont, 1971), 41.

8. Sol Lewitt, *Autobiography* (New York, 1980).

9. Unfortunately, during the 1960s the plaster mural was removed from this room and cut into eleven fragments measuring approximately 11 x 19 inches each. One remains framed in the Island Heights house, while the others have been offered for sale by Bernard & S. Dean Levy, Inc., New York.

10. Harnett sold his painting to Byron Nugent, owner of a prominent dry goods firm in St. Louis, and the picture descended in the Nugent family until its acquisition by Reynolda House, Winston-Salem, North Carolina. The artist also gave a photograph of the work to his friend and early biographer, E. T. Snow, with the inscription, "[T]hanks for the idea, Yours Truly, William M. Harnett." See Frankenstein, *After the Hunt* (1969), 45-47. My thanks also to Barbara Babcock Millhouse, president of Reynolda House, for a further summary of information on this painting; correspondence with the author, 3 March 1980. See also Barbara B. Lassiter, *Reynolda House American Paintings* [exh. cat., Hirschl & Adler Galleries] (New York, 1970), 40-41, 56.

11. Psalms 102:3. See Ingvar Bergstrom, *Dutch Still-Life Painting in the Seventeenth Century* (London, 1956), 10, 154-155.

12. In particular they suggest taste and smell, augmented by the associations respectively of the conch shell with sound and the several books about art with sight. See Andrew J. Cosentino, *The Paintings of Charles Bird King (1785-1862)* [exh. cat., National Collection of Fine Arts] (Washington, D.C., 1977), 27-28, 80-82.

13. See Frankenstein, *After the Hunt* (1969), 22.

14. Frankenstein, *After the Hunt* (1969), 22.

15. Emily Dickinson, *The Complete Poems of Emily Dickinson*, ed. Thomas H. Johnson (Boston, 1960), 553.

16. See Albert J. Gelpi, *Emily Dickinson: The Mind of the Poet* (Cambridge, Massachusetts, 1966), 9, 25, 162-163, 172.

17. Gelpi, *Dickinson: The Mind of the Poet*, 152.

18. Dickinson, *Poems*, 296-297. In some editions the transcription of the second line of the last verse reads instead: "Their Countenances bland."

19. See Bergstrom, *Dutch Still-Life Painting*, 13, 154-156.

20. See Dore Ashton, *A Joseph Cornell Album* (New York, 1974); and Kynaston McShine et al., *Joseph Cornell* [exh. cat., Museum of Modern Art] (New York, 1980).

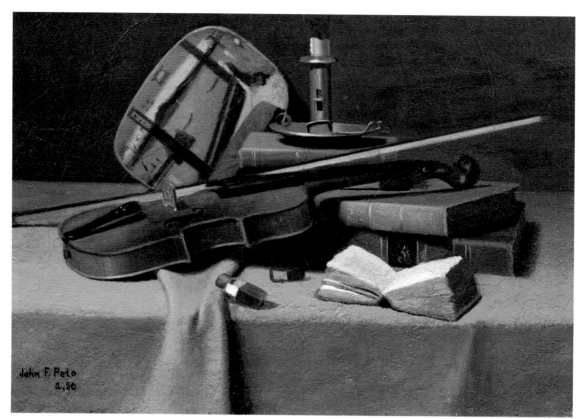

128. Peto. *Violin, Fan and Books*, 1880.

5

THE CUP WE ALL RACE 4
Objects on the Studio Wall

Pᴇᴛᴏ's sᴛɪʟʟ ʟɪꜰᴇs ᴏɴ sᴇᴄᴛɪᴏɴs ᴏꜰ ᴡᴀʟʟs or panels of doors began in an expected way as pieces of the artist's home and studio, set aside for their abstract interest and personal association. They are readily grouped according to objects constantly used or important in Peto's life. For example, many of his food pictures had their inspiration close at hand. Peanuts, candies, and cookies were everyday delights at the local country store, and around his Island Heights house Peto took special care of his fruit trees and grape orchard. These turned up respectively in such paintings as *The Poor Man's Store* and his studies of hanging bunches of grapes (figs. 81 and 86). The ubiquitous brass pots and pans around the house had such an appeal as subjects for him that he refused to allow his wife to polish them, so fond was he of their light green tarnish (see figs. 64 through 66). As a city boy who had moved to the country, Peto was enchanted with activities along the shore: he loved sailing and fishing and often took his family boating on the river at the foot of their hill or picnicking at the ocean beaches a few miles away (figs. 15 and 16). On weekends he drove them on long carriage rides to the lakes of nearby Lakewood and occasionally even further to picturesque Harper's Ferry, West Virginia (fig. 20). In a strongly Methodist town which disapproved of drinking, smoking, and gambling, Peto was endlessly intrigued with putting wine bottles, beer mugs, pipes, and playing cards into his compositions.[1]

One of the avocations in Peto's life we know to have been close to his heart was his music. From the time he was a young man he played the cornet and the violin (figs. 9 through 12); not surprisingly these and other instruments found their way comfortably into his paintings. But the violin above all proved to be an object with an arresting aesthetic character in different contexts. Whether lying flat on a table, reclining on adjacent props, or hanging flat against a wall, it offered challenging questions of foreshortening and shape. On a tabletop in a more traditional still-life arrangement the violin could serve as an interesting visual foil to the shapes of books or candleholders, while hung vertically, it caught the eye by its undulating symmetrical contour.

Among Peto's earliest still lifes to include this motif is *Violin, Fan and Books*, dated 1880 (fig. 128). As a gathering of items on a cloth-covered table, it is close to his standard library and food groups done at the same time (compare figs. 39, 56, and 84). The accumulated bric-a-brac may be indebted to Harnett's example, for this picture dates to early in Peto's career when he was just beginning to strike out on his own. The bright coloring of the top green book, maroon binding below, and yellow table cover is a familiar note of his youthful work, seen also in his first food still life of 1875 (fig. 46). Likewise, there is the attractive antiquarian touch in the Japanese fan, itself bearing a colorfully painted scenic

129. Jefferson David Chalfant. *Interrupted Musicale*, 1880s-1890s *(above)*.
131. Thomas Wilmer Dewing. *Lady with a Lute*, 1886.

view. This possibly unconscious attention to an image within an image was later to become a constant pictorial device in Peto's mature paintings of office boards and letter racks (figs. 159 through 165). At this point Peto appears satisfied with playing off contrasting linear and planar forms and with echoing his vibrant tones throughout the composition.[2] As an exotic item, the fan can be seen as an emblem of the new *japonisme* then in vogue in the United States; the orientalizing details in the work of Peto's contemporaries James Whistler, Mary Cassatt, Winslow Homer, and John LaFarge are well known. Peto took note of this foreign aesthetic only in passing, turning full attention instead to his favored violin.

The violin as a still-life object in a domestic setting occurs in the work of a number of American artists at this time. Usually it is seen in the hands of a musician or music lover, as for example the violinist J. G. Moulton drawn by Jefferson David Chalfant in *Interrupted Musicale* (fig. 129). Chalfant (1856-1931) spent most of his career in Wilmington, Delaware, where around 1880 he began to paint still lifes seriously. Called by some historians "perhaps the finest of all the followers of Harnett,"[3] he joined Peto in taking up the older Philadelphian's violin motifs (fig. 134) in his own smooth illusionistic manner. He was a much more refined draftsman than Peto, and he often made small, meticulously executed pencil studies for subsequent paintings. *Interrupted Musicale* is typical in its emphatic linear treatment of all the details, with just the barest hints of occasional shading or tonal modeling. As was often Chalfant's practice, he pressed the principal contours hard into the pa-

130. Thomas Eakins. *Mrs. William D. Frishmuth*, 1900.

per so that he might trace a sort of carbon image directly onto a like-sized canvas underneath. Like Peto, Chalfant knew how to play the violin and rendered the instrument with its correct stringing. This drawing makes a direct comparison with Peto's work in a number of concerns: the inclusion of pictures within a picture; the hanging muskets, powder horn, and trombone on the wall behind (compare figs. 143 and 144); and the central silhouetting of the violin.

Stringed instruments appear in several of Eakins' portraits, which Peto might well have seen first hand in Philadelphia. If music was ever sympathetically treated as a sister art, it was in the painting of Eakins. In the early 1870s he showed figures at the piano, and thereafter he portrayed others variously making music with pipes, horn, guitar, zither, or voice. Among his well-known images particularly relevant here are *The Cello Player*, 1896 (The Pennsylvania Academy of the Fine Arts, Philadelphia); *Music*, 1904 (Albright-Knox Art Gallery, Buffalo, New York); and *Major Manuel Waldteufel*, 1907 (French Benevolent Society of Philadelphia). The last two show the figure respectively playing and holding his vio-

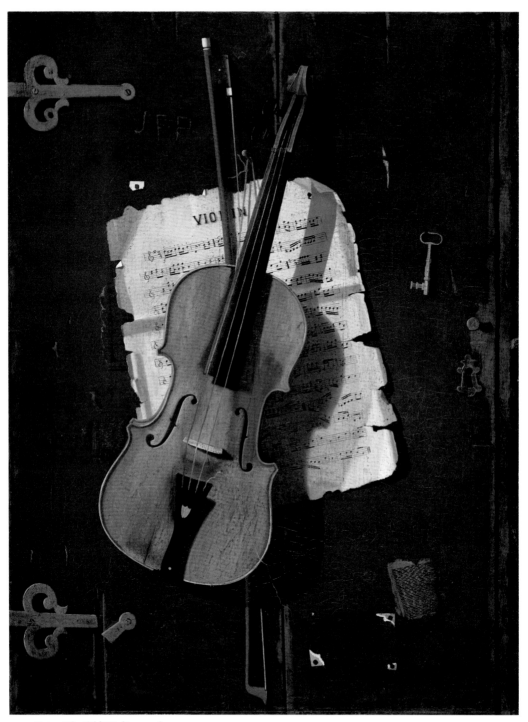

132. Peto. *The Old Violin*, c. 1890.

lin. Eakins' most impressive and commanding portrait in this genre was the large canvas of 1900 depicting Mrs. William D. Frishmuth (fig. 130). Aside from being an uncompromising portrayal of an imposing woman, a collector of musical instruments in the process of tuning the viola on her lap, it presents a complicated array of horns, pipes, and strings arranged around the figure like a still life. Indeed, Mrs. Frishmuth herself is so immobile in her preoccupation that we sense some enigmatic tension between discipline and passion, intellect and emotion, even silence and sound.[4] A correspondence in subject and interpretation with Peto's art in this period remains circumstantial yet close enough again to be worth noting.

For Eakins the figure holding a musical instrument was at once a portrait of someone making music and a salute to creativity. Many artists of this period turned to images with musical associations, for through them one entered a world of the private imagination. In fact, music acquired a pervasive importance in American culture at the end of the nineteenth century.[5] Like art and literature, it signified an alternative to the material world. Music invited contemplation; it was abstract, symbolic, mental, sensuous. This "obsession with mind," one historian has suggested, belonged to a "cult of intellect and imagination" having wide appeal to an age unsettled by civil conflict and scientific advances.[6]

That interior world was a frequent subject for Thomas Dewing (1851-1938), whose paintings of the 1880s and nineties depicted one or two women in undefined spaces absorbed with playing or listening to music. *Lady with a Lute*, 1886 (fig. 131) is a prototype of the series. With but variations of greens and echoing profile curves Dewing evokes a visual equivalent of the rhythms, textures, and harmonies of music. The synthesis of meticulous enamel surfaces and gauzy softness appropriately matches the sense of lovely sounds born out of discipline and feeling combined. A native of Boston, Dewing had studied in Paris and Munich, art centers which contributed to his subsequent style of elegant drawing and polished details. For much of his later career he limited himself to delicate and poetic paintings of figures situated as carefully as musical notations on a page. Although a painter of different taste and background from Peto, Dewing here shares a similarly self-contained aesthetic vision.

As with his handling of the reader of books, Peto was less interested in the musician than in his instruments. After his rare early depiction of the violin as one component in a conventional still-life accumulation, he focused his full concentration on the isolated instrument itself. Of course, musical instruments including the strings appear illustrated throughout Western art, from vases, frescoes, and sarcophagi in the ancient world to medieval manuscripts and Renaissance paintings.[7] At least two gods of mythology—Apollo and Orpheus—and three of the Muses—Erato, Euterpe, and Calliope—were associated with music. Many instruments held particular connotations, such as the heroic character of the trumpet and erotic symbolism of wind pieces generally. The violin was seen to be of a more elevated nature than, for instance, folk instruments like the bagpipe and hurdy-gurdy. Stringed pieces descended from the ancient lyre; hence they carried noble and humanist associations with the great poets among gods and men of the past. Above all, music was perceived to be at the center of the arts, linking poetry and science in the value it placed on order, harmony, and proportion.[8] Although Peto's artistic interest in the violin was born more

133. William M. Harnett. *Music and Good Luck*, 1888. 134. Jefferson David Chalfant. *Still Life*, 1889.

out of daily familiarity than any conscious allegiance to this iconographic tradition, it is obvious his imagery inherits the idea of music as an elevated symbol of pure art.

By the late 1880s Peto had transferred his violin from the foreshortened plane of a tabletop to the close surface of a door or wall. Here it hung usually with a bow and a single sheet of music or simple music book just behind. A number of versions are known of this type, of which *The Old Violin* (fig. 132) is the most resolved. In all respects it bears the essential Peto touch. The door itself is badly cracked, its paint peeling and lower hinge broken. Pieces of old newspaper and cards have worn away or been torn off. The sheet of music is shredded from use along its borders, and even the graceful instrument—the most interesting form and object closest to the viewer—bears a crack in its lower body echoing the larger one in the door panel. The texture of the paint in places approaches a rich impasto, intended to engage our sense of touch as well as of sight and hearing. But it is his total visual harmony of forms which best matches the satisfying power of making music. Yet for Peto there is also the strain of tensions tempering perfection, and the stress of relationships is a possible unwitting confession of his struggles to live and create despite the presence of pain.

Although we accept a generally central placement of forms, with the violin framed first by the music sheet and then by the door, the eye soon notes the pulls against symmetry. The vertical break in the door is just to the right of center, and all the hanging objects crisscross in slight diagonals. At the same time Peto unifies the whole through certain details echoing one another. For instance, the f-holes of the violin have visual cousins nearby in the key, keyhole plate, and iron hinges. And everything has suffered some small loss; the

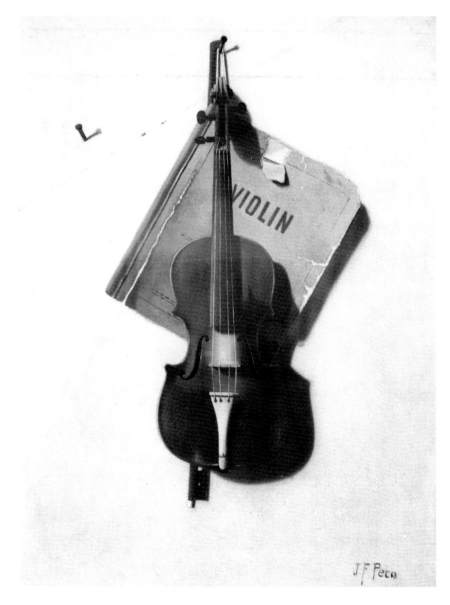

135. Peto. *Violin*, early 1890s.

door its splinters and rubbed paint, one hinge its tip, the newsprint its legibility, the papers either their edges or their interiors, even the violin one of its strings. But for all these assaults Peto ultimately asserts the endurance of art. His simulated carved initials are both a traditional signature and a statement of autobiography. At the top of the music sheet is the word *VIOLIN*, a typical Peto pun on the verbal versus visual perception of things. In this constant play on what we see, the artist's paint never reaches for total self-effacing illusionism, but rather calls us back to the objective presence of his stroke, his literal act as an artist.

Peto's painting probably dates from the period he was giving up residence in Philadelphia for coastal New Jersey, since its initial conception appears to have been stimulated by a similar composition painted by Harnett in 1888.[9] *Music and Good Luck* (fig. 133) highlights the distinctions in approach between the two artists: Harnett's trompe l'oeil effects are

magical, calm order and neatness dominate the arrangement, his geometries are principally stable right angles, and certain romantic touches are introduced by the identifiable song sheet and the horseshoe. In some respects Harnett is unsurpassed, especially in his technical finish as he models objects in a shallow plane or casts particularly convincing shadows. In other respects he is flawed; not a player of the violin himself, often he painted the instruments misstrung, as if formal effect was his principal end. It might be said that Harnett loved his instruments and books for their surfaces and textures, while Peto loved them for their souls.

It is well known that Harnett had a widespread influence on other still-life painters of his generation, and Chalfant was among the cleverest in essaying the violin motif. Within a year after Harnett's example he painted his own spare rendering of just the instrument and bow against a clean white door (fig. 134).[10] Its austerity and simplicity have an obvious appeal to modern tastes, but for all Chalfant's silvery delineation, he suffers as a Harnett *manqué*. Peto similarly tried a picture of a violin hung on a white ground (fig. 135), and while some may feel disappointed by his lesser finesse in brushwork, other compensating touches succeed in stimulating the imagination. First, one notes the primary conceit of the subject seen both as word and image; then the enigmatic whimsy of the nondescriptive lines and isolated nail at the top; finally, the ambiguous background itself—perhaps door or wall, but still recognizably canvas as well.[11]

To Peto the violin and the book were containers of art, in a sense microcosms of the studio. They are both enclosed and enclosures themselves. This idea combined with Peto's

136. Georges Braque. *The Blue Mandolin*, 1930.

devotion to formal purities is a principle brought to fruition in cubism two decades later. In particular, these aspects invite comparison with the French master Georges Braque (1882-1963), an artist engaged mostly in still-life painting throughout his career, one who loved the emotional and visual effects of black, a manipulator of textures and the literalness of paint. We know him especially as a reflective artist, concerned with the nature and perception of things, ultimately inventing his art out of the common raw materials to be found within the confines of his studio. More to the point here is the significant fascination of the cubists, and Braque for much of his life, with musical imagery. Repeatedly the guitar, clarinet, or mandolin is at the center of their still lifes (fig. 136). Peto also shared with the cubists an interest in the iconography of word fragments and playing cards.

Possibly the most telling correlation to be drawn between the work of Peto and Braque is the fusion of art and life which occurs in their making the studio landscape an autobiographical still life. Peto of course never abandoned perspective and the assumptions of illusionistic modeling, as Picasso and Braque did, but we have observed how he did move from the deeper space implied by tabletop assemblages to increasingly flatter and shallower still-life designs. Braque's *Blue Mandolin* is a mature distillation of the cubist aims to integrate space and solid, surface and interior, as well as tabletop and wall composition. The formal and intellectual realities of this picture saw a final expansive resolution in a last major series of paintings, occupying him from 1948 to 1956 and actually titled *Studio, I-IX*.[12] As in Peto,

137. Samuel van Hoogstraten. *Still Life,* 1655.

we encounter the incorporation within the image of other images, the shapes of the artist's palette, and those objects which refer to the making of art (see fig. 144).

If Peto's art looks forward in certain ways, it also fits into a long prior tradition in western European painting of trompe l'oeil pictures. Some examples of Renaissance and baroque illusionist work were known in America through print copies, occasional originals, or first-hand acquaintance for those like Harnett who had traveled abroad. Early examples of spatial deception are known in Roman fresco painting, and flourish again with the invention of perspective in Renaissance ceiling and wall decorations. During the seventeenth century the delight in naturalism and representation of the material world led the Dutch to

138. John Singleton Copley.
Corkscrew Hanging on a Nail,
c. 1766-1774.

practice visual trickery in various ways—perspective boxes, anamorphic projections, and above all illusionistic still lifes.[13] Among those who were the most inventive and most often cited as precedents for Peto and Harnett are Franciscus Gysbrechts (active c. 1674), Cornelis-Norbertus Gysbrechts (active c. 1659-1678), and Samuel van Hoogstraten (1627-1678). The Gysbrechts together executed a variety of cupboard, letter-rack, and *vanitas* arrangements.[14] Indeed, in their work and that of their contemporaries can be found almost the whole repertoire of subjects Peto would try for himself: the back of a canvas, a painter's palette, hanging game, violins on a door, and books in a cupboard. But it is hardly surprising that Peto and America in the late nineteenth century, strongly affected by the inroads of scientific naturalism and materialism, should have looked back to Dutch seventeenth-century culture with sympathetic interest.

Illustrative of the similar vision in the two periods is van Hoogstraten's *Still Life* of 1655 (fig. 137). Like many of Peto's more ambitious efforts, this is a large canvas suggesting actual size. Against a worn wooden door with old hinges and nails hang a few common domestic items, of interest for their differences in volume, contour, color, and texture. In out-

139. Peto. *Lock and Key,* 1890s.

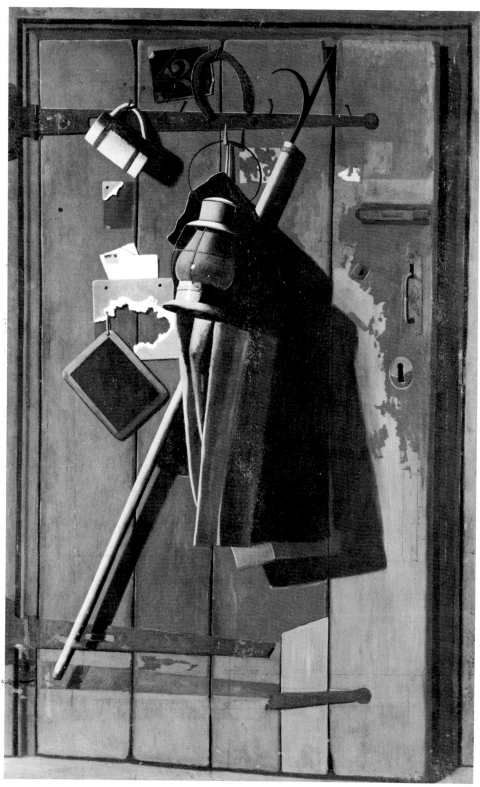

140. Peto. *The Fish House Door*, 1890s.

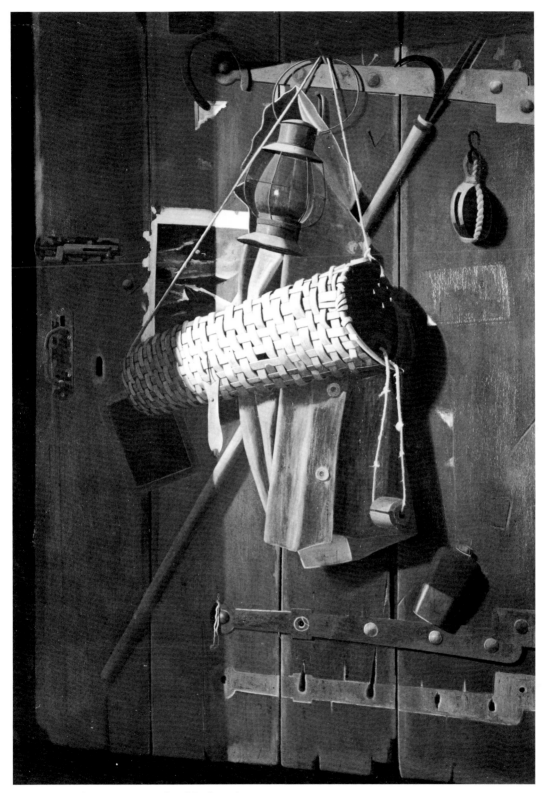

141. Peto. *Fish House Door with Eel Basket*, 1890s.

142. Peto. *Stag Saloon Commission*, 1885 (photograph).

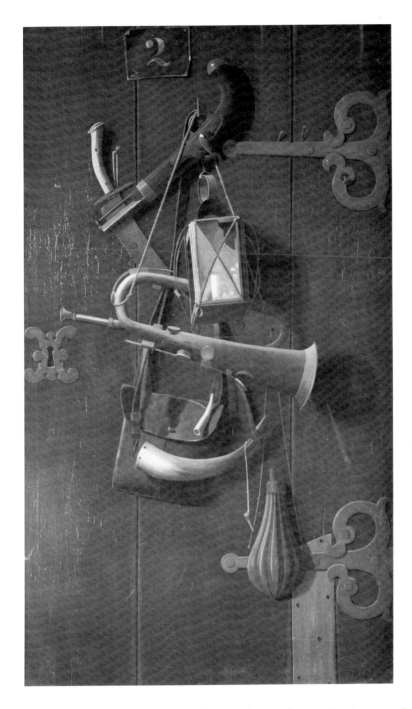

143. Peto. *Things to Adore: My Studio Door,* 1890s.

look, content, and execution, then, such a work provides the most direct antecedent for the development of American still-life painting. As we have seen, Raphaelle Peale and Charles Bird King were among the first to take up still-life subjects seriously in the young republic. Even earlier there are occasional examples of still lifes, some executed by folk artists as decorative details for overmantles and the like, others included as accessories in more formal figure or portrait painting.

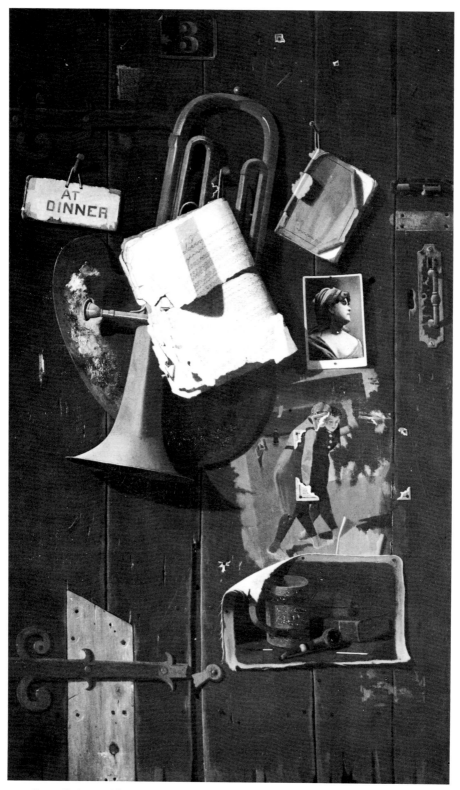

144. Peto. *Ordinary Objects in the Artist's Creative Mind*, 1887.

As one of America's first masters, John Singleton Copley (1738-1815) undertook his portraits with such care and precision that the clothing of his sitters and the surrounding furniture often had the studied polish of a large still life. In many instances he actually included finely wrought flowers or bowls of fruit which stand scrutiny on their own, and once he painted a small trompe l'oeil as a private joke. *Corkscrew Hanging on a Nail* (fig. 138) dates from sometime between 1766 and 1774 when the artist paid a visit to Dr. Charles Russell in Lincoln, Massachusetts. A family account relates that Copley's host offered him a drink but was unable to open a bottle because his corkscrew had been mislaid. In this witty gesture the artist then set to his painted illusion as a memento of the occasion.[15] It serves as a nice forecast of Peto's little oil sketch *Lock and Key* (fig. 139), in which each element extends to slightly different levels just out from the wall plane. Suitable to its modest size and composition is the restrained palette of grays and browns.

By contrast, on a much larger scale with multiple objects combined in more intricate ways Peto explored correspondingly richer nuances of color and texture. Just as the violin

145. Winslow Homer. *The Bathers,* 1873.

146. Peto. *Mug, Pipe and Book,* 1880s.

represented one activity he regularly enjoyed, so too did the fishing gear he used at the coast and lakes nearby. This material was the basis for a series of paintings mostly known as *The Fish House Door* (figs. 140 through 142). Their design loosely relates to Harnett's *After the Hunt* (fig. 24), a painting which Alfred Frankenstein has shown to have been pervasively influential for many of Peto's colleagues. Its door composition as borrowed from Adolphe Braun's photographs (fig. 25) turned up over and over again in variations by Chalfant, George Cope, Richard LaBarre Goodwin, Alexander Pope, and others.[16] Although Peto employs a similar vertical door as a background and the diagonal crossing of linear forms, he distances himself from the Harnett model with his more painterly stroke, denser shadows, and personalized subject matter.

In his most repeated arrangement Peto hung a lantern and yellow oil slicker on top of

the slanting fishing pike (fig. 140). Above and to the side appear a mug, slate, and envelopes. One of his most beautiful modifications of this formula involved adding a large eel basket at the center (fig. 141) and a fishing toggle and pulley just out of the strongest light. Tacked to the door in place of cards and envelopes is a torn reproduction of a moonlit marine in the manner of Albert Ryder (see fig. 212). But unquestionably Peto's most important tour-de-force in this group of pictures is one that has sadly been destroyed. This was the painting he was commissioned to do for the Stag Saloon in Lerado, Ohio, now known only from a glass plate photograph Peto took of it at the time (fig. 142). To judge from the scale of the frame, itself probably some ten inches wide, and the importance of the circumstances, the canvas must have been at least as large as the other versions. Its contents are certainly a summary of this particular repertoire, to which have been added an amusing photograph of a young boy, a reproduction showing an old barn, an old musket, and the extraordinary skeins of fish netting. These in fact hung in tangled bunches around Peto's studio (figs. 1 and 217), and they bring to his painting yet another item having both immediate practical use and a fascinating visual interest.

There were other artistic experiments with this corner of Peto's household. One related canvas (The Brooklyn Museum; fig. 238) depicts more than a half dozen differently shaped lamps and lanterns bunched down the center of the door panel. Another work, later romantically titled *Things to Adore: My Studio Door* (fig. 143), introduces several objects having a shared life as mementos of the Civil War.[17] Besides the large pistol at the top we note the bowie knife, bugle, ammunition pouch, and powder horn suspended below. These apparently held both antiquarian and personal associations for Peto. His father had died in 1895, and the loss seems to have stimulated his attention during this period to romantic agents of death. Moreover, some of Peto's descendants believe that his father-in-law, John Farrell Smith (1837-1918), who served as a drummer for General Grant in the Civil War, had picked up the bowie knife on the field of Gettysburg.[18] This reminder of the war might have prompted the reminiscence of Lincoln's death, which was part of a larger wave of nostalgia at the end of the century. Peto brought his imagery of the knife and Lincoln together in a related sequence of paintings underway concurrently (figs. 174 through 177).

Before turning to Peto's letter rack pictures and their flat geometries, we need to take account of his grandest accomplishment in displaying still-life objects on a door. *Ordinary Objects in the Artist's Creative Mind*, 1887 (fig. 144) at once summarizes previously covered ground and introduces new pictorial initiatives. From its imposing size, its careful balance between clutter and order, and its inclusive variety of objects, the work was obviously meant to encapsulate the essence of Peto's aesthetic landscape. More than any other single work this image elevates the studio into art. Superimposed at the very center and largest of all the forms are emblems of the two key, interrelated occupations of Peto's life, his cornet and his painting palette. Counterpointing the musical associations are the other references to verbal and visual expressions nearby: the small sign "AT DINNER" (as if the artist has briefly stepped away and left us to consider the nourishment of art), the tattered musical notebooks taken from the violin paintings (see figs. 132 and 135), and the reproductions of other works of art.

Among the latter, seen to the right one above another, are a postcard of a French salon

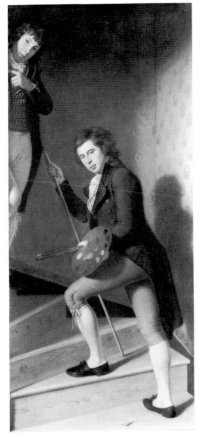

147. Charles Willson Peale. *The Stair-case Group*, 1795.

148. Peto. *Still Life on a Palette*, c. 1890.

figure painting, a wood engraving of *The Bathers* by Winslow Homer from *Harper's Weekly* of 2 August 1873 (fig. 145), and one of Peto's own small canvases of the type he frequently did at the start of his career (fig. 146). Together these represent photography, engraving, and oil painting, and they juxtapose a foreign artist, an American contemporary, and Peto himself. Furthermore, Peto is present by his work of the past, of the moment, and (by implication of the palette) of the future. In a variety of ways he is entertaining us, both lightheartedly and seriously, by showing us art as an extant fact and as a ready possibility, so to speak, once he returns from dinner and takes up palette or cornet again.

This notion of art's reflexivity is one we have cited earlier in discussing the work of the Peale family at the beginning of the nineteenth century. In particular, the patriarch of that family, Charles Willson Peale, was an especially creative and prolific painter of many subjects, the most important of which in one way or another focus our attention of the life and acts of the artist. Often his portraits and genre groups approach the formal artifice of still lifes, and frequently the subjects themselves are fellow artists in the family. Among the best known is *The Staircase Group*, 1795 (fig. 147), in which Peale's sons Titian and Raphaelle turn to face the viewer as they start to ascend some stairs. Importantly, Peale depicts them as painters; Raphaelle's palette is close to the center of the composition. It becomes the third

circular shape after the two heads above, completing a gentle arc which follows the axis of the staircase. Appropriately, the palette sits at the juncture between the painted figures and us, and thus it is the symbol and literal means of mediation between the created image and the viewer.

No wonder palettes fascinated Peto. Several working examples still remain in The Studio at Island Heights, and among his surviving glass plate photographs is one he took of a palette with a painted illusion of a small still life (fig. 148).[19] In a number of other instances he picked clean new palettes and on them painted familiar objects hanging from wall boards or nails (fig. 149). The handle of one mug circles around the thumb hole in a clever play on the way painted mug and real palette are held. In all of these the objects hang on a slight diagonal so that when the palette itself is placed on a peg, the trompe l'oeil image observes

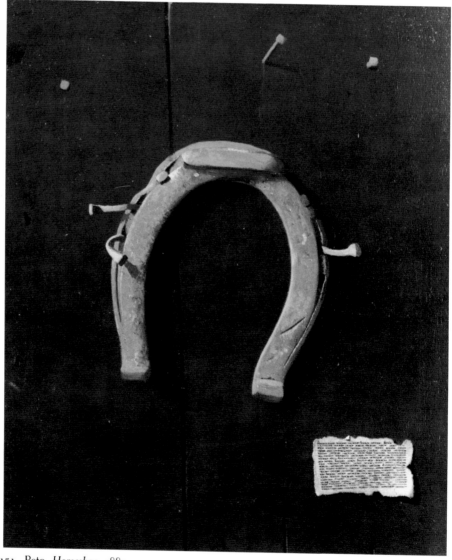

151. Peto. *Horseshoe*, 1889.

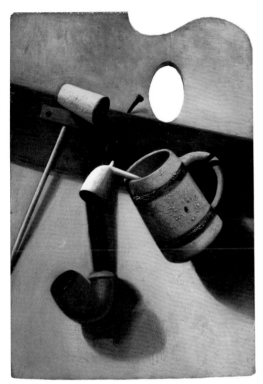

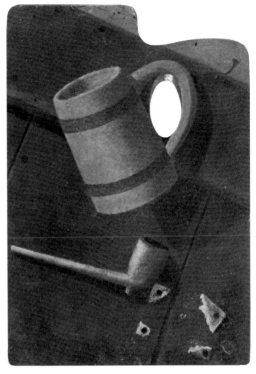

149. Peto. *Palette, Mug and Pipes*, c. 1890.

221. Peto. *Artist's Palette with Beer Mug and Pipe*, 1880s-1890s.

150. John Haberle. *The Palette*, 1889.

152. Peto. *Pipe and Church Sconce*, c. 1890.
153. Peto. *The Cup We All Race 4*, c. 1900 *(right)*.

gravity correctly. For Peto these were witty visual transformations in which the palette truly gave life to art. In a parallel way Peto's fellow illusionist John Haberle (1853-1933) painted an entire ensemble of his working tools, including a trompe l'oeil frame and nameplate (fig. 150). Such toying with the mundane materials of art would have recurring interest for modern realists, most notably pop artists like Jim Dine and Roy Lichtenstein, who also made images respectively of their palettes and brushes (see fig. 181).

Peto continued to make small oil studies of one or two objects alone at the same time he was assembling his full inventory together in the large door canvases. Increasingly he ex-

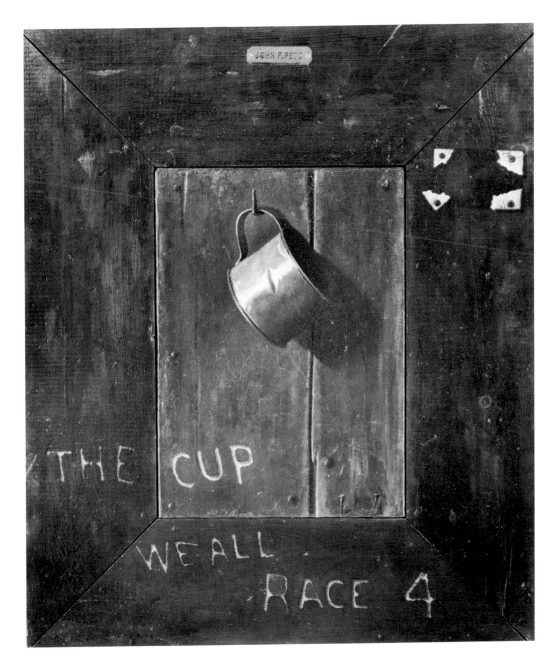

perimented with the challenge of placing solid volumes along with flat objects in the shallow space just out from the surface of his painted wall. He also attempted representing images in other than life size, most often in reduced, not quite miniature, versions. These tended to be less successful accomplishments for Peto, largely because his painting style of broad, rough textures was not always capable of a convincing definition of forms. When he stuck too close to Harnett's precedents, the results were mixed. Peto's *Horseshoe*, 1889 (fig. 151), follows almost exactly a work by his friend painted three years before.[20] Typically, Peto has bent his nails more and marred the horseshoe with gouges, but the shapes appear on the

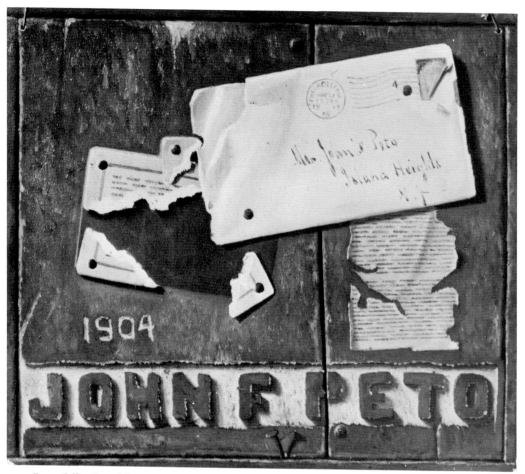

154. Peto. *Office Board for John F. Peto,* 1904.

edge of dissolving into powdery softness. Nonetheless, the shoe and newspaper fragment were forerunners of Peto's growing attention to planar objects tightly layered on their ground.

From this period date efforts to contrast a writing slate with the volumes of a mug and small pitcher, and a tin candle sconce with a pipe and hanging notebook (fig. 152). Here the single flattened form is the primary focus of Peto's exercise in low-relief composition. Elsewhere he would incorporate the candle holder into a large group of lanterns on a door or dispersed across a shelf (see fig. 126). When the object hung alone, it all the more emphasized the plane of the canvas ground behind, a situation masterfully resolved in *The Cup We All Race 4* (fig. 153). The cup in high relief contrasts with the cracks behind cut into the wood surface, just as the incised letters below differ from the nameplate above. Peto adds further visual ambiguity in his painted frame around the central panel and in the title's play on words. Together in the middle are the painted cup and the written noun, while the last symbol can be read as the numeral 4 or as a rebus suggesting the preposition *for.* We have further numerical echoes in the repeated quadrangles of the panel and frame and in the four points of the envelope corners at the upper right. Verbally, the phrase evokes nostalgia

227. Peto. *Sign Painting for Helen S. Peto*, 1903.

155. Frederic Edwin Church. *The Letter Revenge*, before 1892.

for a lost frontier past: in a sophisticated urban age the simple tin cup is a relic to dream on. It may also represent the drink Peto's neighbors sought despite local Methodist prohibitions. Whatever the overlay of meanings in this deceptively plain work, Peto is at his best here in delighting both the eye and the mind.

The next step conceptually for him was to limit the affixed objects to his backgrounds entirely to planar forms, and within this category he explored a rich variety of flat rectangles: envelopes, small notebooks, currency, business cards, photographs, newspaper fragments, and art reproductions. Some of these had of course made random appearances earlier in other contexts, but in the group of paintings dating mostly to the last years of Peto's life, we witness an advanced manipulation of essentially two-dimensional issues of design. Occasionally, these were studies in the arrangement or color of forms, as in the diagonal placement of a plain envelope against the larger horizontal rectangle of an academy board, or a green card contrasted with a blue notebook.

A few small paintings were highly personal signboards, in effect letters of affection to family or friends memorialized in pictorial form. In 1903 Peto painted an academy board on the occasion of his daughter's tenth birthday (fig. 227). An envelope addressed to Helen S. Peto and postmarked 29 December 1903 occupies the upper right center of the composition, while her name and year of birth are incised in block letters below. At the upper left Peto completed this surrogate family portrait by adding his own initials and those of his

156. Kurt Schwitters. *Merz 163, With Woman, Sweating*, 1920.

wife. At the same time he undertook a variant of this arrangement for his neighbor Miss Emily Perkins, whose name similarly appears in written and incised form.[21] The following year he executed a signboard for himself (fig. 154) as a sort of self-advertisement and verbal self-portrait. Though the rectangles remain few and simple here, the artist projects himself into his art in clever contrasts of shape and degrees of relief for the inscriptions of his name and the date.

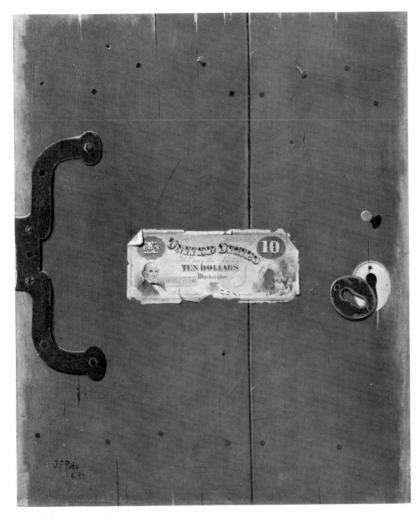

157. Peto.
Ten Dollar Bill,
February 1889.

158. Andy Warhol. *Printed Dollar Bill*, 1962.

Such motifs turn up periodically in American art. Raphaelle Peale was probably the earliest to try his hand at illusionist renderings of bunched letters and documents pinned to a wall (see fig. 197), while contemporaneous with Peto, still-life historians have cited *The Letter Revenge* (fig. 155) attributed to Frederic Edwin Church (1826-1900). Known foremost as the supreme American landscape painter of his generation, Church is believed to have undertaken this refined assemblage of three envelopes as a trick on a friend.[22] These intimate fragments of daily experience were to become a dominant preoccupation of modern art, especially in cubism and the movements deriving from its inventions. The many collages by the German dada artist Kurt Schwitters (1887-1948) naturally belong to that context of protest and disillusionment occasioned by World War I, but his work (fig. 156) makes a fitting comparison to Peto's in its concerns with abstract design, expressive textures and shapes, autobiographical content, and art made from the humblest scraps of the studio.[23] Although Peto's imagery remains fixed to his own personality, period, and place, it may also be understood as part of the larger ideas coming to the fore in early twentieth-century art.

Concurrent with his personal signboards Peto did a few related canvases of dollar bills pasted to sections of wooden doors. In most respects these involved one or two frayed rectangular sheets silhouetted against a dark background, except for the new element of the engraved portrait image. On the broadest level the attention to currency reflected the prevailing materialism of the later nineteenth century, the quick making and spending of money, the entrepreneurialism and financial empires, the allures of gold rush and gilded age. Some of Peto's colleagues indulged far more than he in extraordinary visual deceptions of painted

159. Peto. *Daniel Webster Patch Picture*, c. 1900.

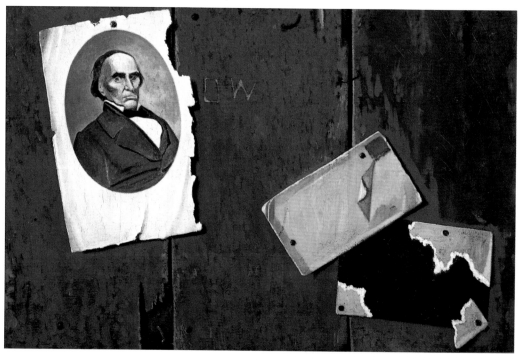

currency, most notably Victor Dubreuil, William Harnett, and John Haberle, to the extent that Harnett was actually arrested for forgery in 1886 and Haberle was ordered to stop painting such subjects by the Secret Service.[24] But Peto was never as concerned as they with rendering a perfect illusion, enjoying too much the nondescriptive presence of his paint textures and colors.

Although bills had only passing interest for Peto, he made an effort to try at least one rendering of each denomination. Pictures are known of *Shinplasters* (paper bills for ten and twenty-five cents) (private collection, New York), *Five Dollar Bill* (private collection, New York, and Brandywine Museum, Chadds Ford, Pennsylvania; fig. 225), and *Ten Dollar Bill* (fig. 157). These last two respectively bore the faces of Andrew Jackson and Daniel Webster, but Peto completed their features only enough to make them recognizable, in contrast to Haberle's meticulously finished detailing. Peto's incompleteness was intentional, comparable to the playful inaccuracy of Andy Warhol's pop treatment of the same subject in the 1960s (fig. 158). By calling attention to the fact that the work is a product of the artist's hand, he questions not only the fraudulence and inaccuracy of the image but also its technique of manufacture. For we realize it is a painting of an engraving made by silkscreening. More provocative than the dislocation in size are the transformations in identity which occur as one medium mimics another. It is just this investigation of the nature of even ordinary things which links Peto's art to such modern experiments in realism.

The images of famous faces from the past sufficiently appealed to Peto that he attempted another picture incorporating a Webster photograph (fig. 159). It is less inspired than his other series including photographs, especially those concentrating on friends and family or on Abraham Lincoln (see figs. 161 through 164, and 182 through 184). But these

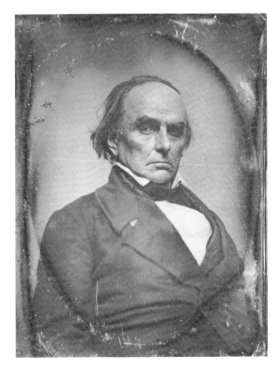

160. John A. Whipple studio, Boston. *Daniel Webster,* c. 1847-1848.

others had closer personal significance for him, whereas the Webster picture appears interesting mostly for its formal play of rectangular shapes: the three green panels bearing the three differently sized, placed, and colored sheets, even vertical planes contrasting with off-center diagonals. It is clear from surveying the details in Peto's later paintings that he had at hand various reproductions of other artists' work and printed illustrations. The Webster image he employed here was an oval engraving made by John Sartain after the well-known

161. Peto. *The Ocean County Democrat,* 1889 (?).

162. Peto. *Office Board for Eli Keen's Sons*, March 1888.

daguerreotype of about 1847-1848 by John A. Whipple of Boston (fig. 160). Sartain, art director for the Centennial Exposition in 1876, was the best known and most influential engraver of Peto's day in Philadelphia.

Whether or not Peto knew Sartain personally, he was certainly familiar with his work; the Webster engraving was frequently reproduced in books and other photographic or painted copies. Besides the accessibility of the image, Peto may well have had some per-

163. Albert Newsam. *Trade Card for P. S. Duval*, 1840.

sonal interest in the Webster legend. When Winfield Scott was nominated for president in 1852, Webster reacted by saying, "I still live," a slogan he is purported to have repeated in his dying hours. As this familiar view of his face and pose was repeated in successive photographic and printed copies, the phrase became attached to the durable presence of the Webster personality.[25] Although Peto's painting of this subject bears no specific date, stylistically it appears to belong with similar pictures from just around the turn of the century. We have already noted that Peto's father, to whom he was very close, died in 1895, and this loss seems to have triggered a number of paintings with details alluding to death. Recurring most often is the presence of the Civil War knife and pistol, but Peto also began in this period his series of rack paintings incorporating photographs of Lincoln. With his own father gone, Peto indulged in nostalgia for well-known statesmen who lived on powerfully after death in the collective imagination.

An especially productive extension of painting engraved faces emerged for Peto in compositions based on cartes-de-visite of friends and neighbors. One of the simplest and most effective was *The Ocean County Democrat* (fig. 161), which from its style and the blurred postmark on the envelope appears datable to 1889. A local newspaper account indicates that Peto worked on this canvas for some three months, from the time he came to the town newspaper offices to request a back issue and a photograph of the editor to a return visit later with the picture in hand. At the center of the canvas is a folded copy of the newspaper tacked to the painted wall boards, and tucked in just above it is an oval photograph of the gentle but serious-faced young editor, Charles S. Haskett. Once again playing on the verbal and visual identities of an image, Peto sets Haskett's carved initials off to the side and his full name on the envelope below.

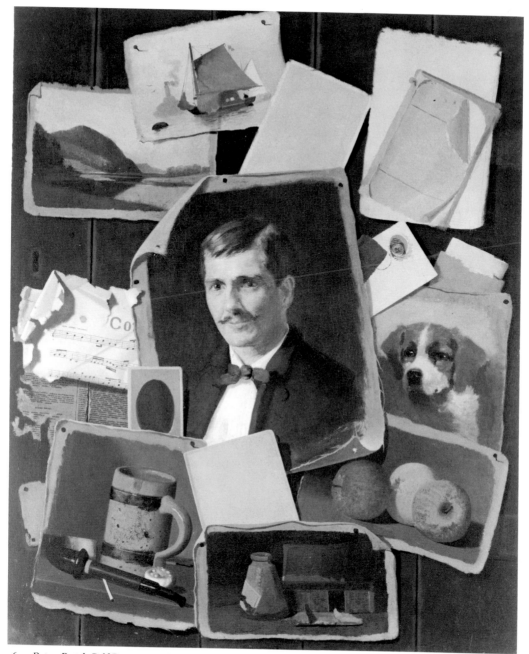

164. Peto. *Patch Self Portrait with Small Pictures*, c. 1900.

Peto's handling of paint here is relatively tight, the colors flat and unmodulated, and his detailing retains a certain crispness reminiscent of Harnett's work. As he continued this type of painting into his last years, Peto evolved an increasingly richer and more suggestive brushwork (compare fig. 211). But on its completion, *The Ocean County Democrat* was put on view in the Island Heights drug store of C. B. Mathis on Main Street, to be enthusiastically greeted as

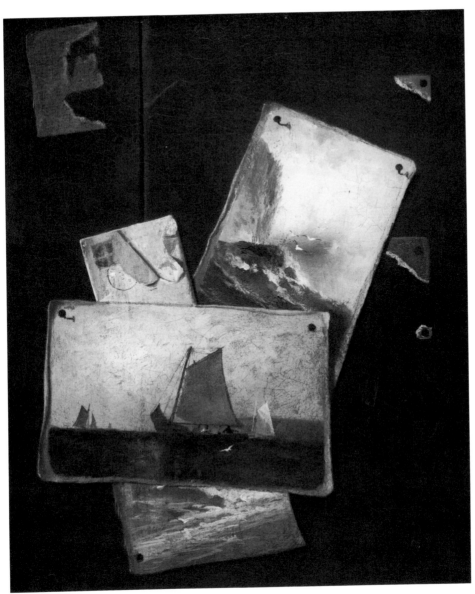

165. Peto. *Still Life (Patch Painting)*, c. 1890.

a piece of realistic painting of much interest as an achievement of skill in a special line of art. The work is done so deftly and with such regard for the truth of form and all the conditions of realistic art, that the most acute observer is deceived.[26]

In a similar vein the year previous Peto worked on a more complicated canvas, *Office Board for Eli Keen's Sons* (fig. 162). Centered around a calendar printed for the dry goods firm are photographs of the senior Keen and his three sons, along with business envelopes, an advertising card, and a separate newspaper clipping below. In a nice conceit the first two months on the calendar have been torn off to coincide with Peto's inscribed dating of March 1888 below. As elsewhere, he takes pleasure in contrasting various types of printed

167. Peto. *Study of a Dog's Head*, probably 1860s.

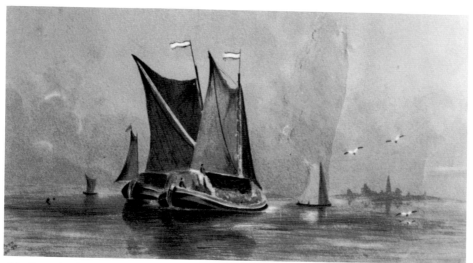

166. Peto. *Sailboats off the Coast*, November 1874.

and handwritten lettering, and graphic images of individuals, flowers, and architecture. Together, these fragments become a composite portrait of a family business, at once description and advertisement.

Although illusionary assemblages of letter racks were known in earlier German and English art, there existed in Philadelphia direct precedents which could have been readily familiar to Peto. One of the most obvious that comes to mind is Albert Newsam's *Trade Card for P. S. Duval*, c. 1840 (fig. 163). Newsam (1809-1864) was a deaf-mute from Ohio who had moved to Philadelphia as a young man, trained early as a draftsman and engraver. He became a popular and accomplished lithographer, working finally for Peter S. Duval, for whom he executed this finely wrought trade card. Such cards had been a commonplace

168. T. Brooks. *Picture of Sunday School Class & Teacher Center,* 1860s.

means of advertising since the eighteenth century and found wide use in America after the
introduction of the new techniques of lithography in the early nineteenth century.[27] Here
Newsam pays tribute to the inventor of the medium, the German Aloys Senefelder, seen at

169. Walker Evans. *Family Snapshots in Frank Tengle's Home, Hale County, Alabama,* Summer 1936.

the center, accompanied by appropriate details of local scenes, maps, and business correspondence. This too, then, is a carefully constructed image of accumulated visual fragments describing the aspects of an individual's profession. Both the balanced order of the overlapping sheets and the refined rendering of textures, including the turned corners and thin cast shadows, testify to the Duval firm's artistic abilities.

Peto obviously enjoyed doing such compositions because they combined artistic challenge with a personal involvement in the subject matter. *The Ocean County Democrat* was published in Toms River and Eli Keen was a neighborhood merchant. For an artist whose paintings so often carry autobiographic associations it was natural for the lives of family and friends to be woven into the fabric of Peto's art. Less an office board was a design Peto did entirely for himself, *Patch Self Portrait with Small Pictures* (fig. 164). His so-called patch paintings displayed primarily a group of small oil sketches on canvas or paper with occasional envelopes or news items, all tacked to a wall board. This one is related to his *Office Board* of 1904 (fig. 154), but instead of an envelope and carved sign Peto gathers around a self-portrait several other studies of one or two objects. The painted image of himself shows a younger man, about the age he was in the 1870s photographs taken in his Philadelphia studio (compare figs. 10 through 12), rather than one in middle age (see fig. 21) when he probably did this painting. Its style has lost the flat dryness of his first rack and patch paintings,

typified by the renderings of *The Democrat's* editor and the Keen brothers. In fact, all of the other surrounding sketches are also from the beginning of his career, as if this were a nostalgic review of his artistic past. In being a painting of paintings it contemplates art for itself. But beyond the images within the image there is a sense of the physical presence of paint itself, as we look closely, and of the abstract play of repeated geometric shapes.

Some of the seascape sketches included here appear in slightly varied form in *Still Life (Patch Painting)*, c. 1890 (fig. 165). The little coastal views and sailing scene belong, as do the dog's head, apples, pipe and mug, book and inkwell, to his first years as an artist (see figs. 37, 80, and 95). The coastal study is based on a painting by Franklin D. Briscoe that Peto had in his house, while the sketch of sailboats at sea derives from the rare early watercolors Peto essayed when just starting out; one dated November 1874 remains in the family house today (fig. 166). Likewise, the head of the dog goes back to a pencil drawing in an undated album of his youth (fig. 167). But the idea of photographs or pictures grouped on a page was one, like the trade card, that had familiar manifestations right at hand. Among the Peto papers is a mounted album photograph, marked by a family member "Picture of Sunday school class & teacher center" (fig. 168). To the left of the teacher's image the face of J. Peto as a boy is identified. Such composite gatherings, whether accomplished by lithograph or the camera, were favorite types of portraiture in the nineteenth century. One thinks, for example, of the youthful Winslow Homer's 1856 lithograph of the *Massachusetts Senate* or his 1859 wood engraving for *Ballou's Pictorial* of "Boston Street Characters," with faces and figures respectively circling the page.[28] In Peto's case both the subject and format were at his fingertips, and these small memories were a constant resource for his making of art.

Once more Peto invites a forward look to a similar work by Walker Evans contributed to *Let Us Now Praise Famous Men* in 1939. *Family Snapshots in Frank Tengle's Home, Hale County, Alabama* (fig. 169) is of course a photograph of photographs, a modern equivalent of Peto's meditation on his medium. Old and torn, these prints are reminders of the past, of age contrasted with youth, of all human mortality. James Agee's poetic language describing his mission with Evans to document the humble conditions of rural America during the Depression could apply as well to Peto's loving record of daily existence. On the one hand the directness of these subjects reveals "the effort to perceive simply the cruel radiance of what is"; on the other, the stark composition with its tension of forms just off-center reflects "a certain shuffling of erratism against pure symmetry."[29] Through just such economy of content and form Peto made his own eloquent observations.

Notes

1. Biographical details from the artist's granddaughter, Blossom S. Bejarano, Greenwich, Connecticut; correspondence with the author, 1 June 1981 and 10 August 1981.
2. This was a design Peto typically modified in other versions which introduced oil lamps, mugs, pipes, or inkwells, and which substituted green or blue tablecloths.
3. William H. Gerdts and Russell Burke, *American Still-Life Painting* (New York, 1971), 144-145.
4. See the perceptive discussion of this painting in Sylvan Schendler, *Eakins* (Boston, 1967), 216-218.
5. See Charles C. Eldredge, *American Imagination and Symbolist Painting* [exh. cat., Grey Art Gallery and Study Center] (New York, 1979), 71.
6. Eldredge, *American Imagination*, 57, 112. Eldredge argues the attraction of music in the larger context of a symbolist reaction against the materialist, naturalist, and determinist ethos of the period. "By focusing on the internal, symbolical world rather than the external, empirical one, by resorting to introspection rather than observation, they sought escapes from the tyranny of Fact and the denunciation of Soul which threatened the life of the imagination." Eldredge, *American Imagination*, 15.
7. Emmanuel Winternitz has thoroughly traced this iconography in his *Musical Instruments and Their Symbolism in Western Art*, 2d ed. (New Haven and London, 1979).
8. See Winternitz, *Musical Instruments*. He points out that even the number of strings on an instrument had specific associations—for example, seven with the number of known planets (in the late quattrocento) and nine with the number of Muses. Winternitz, *Musical Instruments*, 97.
9. Preceding this canvas Harnett painted *The Old Violin* (Collection William J. Williams, Cincinnati, Ohio) in 1886, showing the instrument hanging against a dark wood door. In 1889 he completed the much more complicated shelf and door combination, *Old Cupboard Door* (Graves Art Gallery, Sheffield, England). This was followed by a similar work in 1892, *Old Models* (Museum of Fine Arts, Boston), with the violin now resting upright on the shelf instead of hanging from one of the pegs above. See Alfred Frankenstein's discussion of these in his *After the Hunt: William Harnett and Other American Still Life Painters, 1870-1900*, rev. ed. (Berkeley and Los Angeles, 1969), 71-78.
10. Another hanging violin picture, also 1889, is in the Delaware Art Center, and a tabletop still life with violin, dated 1887, belongs to the Newark Museum. See the discussion of these in Gerdts and Burke, *American Still-Life Painting*, 145.
11. At least two other near-identical versions of this composition are known. One, *The Old Cremona*, interestingly bearing a Harnett signature, is in the Metropolitan Museum, New York, and has the same violin on a dark green door with hinges. A second (Kennedy Galleries, New York) shows the instrument against a rough gray-green wall, with a plain green notebook above. The idea of a neutral object seen in its place with other things is the basis of a poem by Louis Simpson, published in *The New Yorker*, 3 July 1978, which makes an apt footnote here:

The Pawnshop

The first time I saw a pawnshop
I thought, Sheer insanity.
A revolver lying next to a camera,
violins hanging in the air like hams . . .

But in fact there was a reason for everything.

So it is with all these lives:
one is stained from painting with oils;
another has a way of arguing
with a finger along his nose, the Misnagid tradition;
a third sits at a desk made of mahogany.

They are all cunningly displayed
to appeal to someone. Each has its place in the universe.

12. See the discussion of these in Edwin Mullins, *The Art of Georges Braque* (New York, 1968), 166-185.

13. See Celestine Dars, *Images of Deception, The Art of Trompe-L'Oeil* (New York, 1979), for a summary review of the subject. A more comprehensive treatment is M. L. d'Otrange Mastai, *Illusion in Art: Trompe l'Oeil, A History of Pictorial Illusionism* (New York, 1975). I am also grateful for information to Peter Sutton, Philadelphia Museum of Art.

14. Their work is extensively reproduced in Dars, *Images of Deception,* 36-41, and in Mastai, *Illusion in Art,* 161-163, 190-192.

15. See *American Paintings in the Museum of Fine Arts, Boston,* (Boston, 1969), 1:66.

16. See Frankenstein, *After the Hunt* (1969), figs. 67 through 74, between pp. 82-83. Besides the Peto versions of *The Fish House Door* discussed here, others are in the Dallas Museum of Fine Arts (fig. 245) and a private collection through Kennedy Galleries, New York.

17. A more heavily painted version of this subject is in the Memorial Art Gallery of the University of Rochester, New York (fig. 240).

18. Information from the artist's granddaughter, Blossom S. Bejarano, Greenwich, Connecticut; correspondence with the author, 11 August 1980. Besides these large canvases, Peto characteristically did some smaller studies of the knife alone with a lantern and of the pistol and powder horn together. Photographs in the Peto files, Kennedy Galleries, New York. Finally, there is the intriguing question of Peto's imagery here influencing the work of Richard LaBarre Goodwin (1840-1910), who painted his *Hunting Still Life* around 1890. While its general form owes a primary debt to Harnett's *After the Hunt,* a powder horn very close to Peto's examples hangs prominently down one side of the door. See E. A. Carmean, "Recent Acquisitions: An American Hunting Game Still Life," *The Museum of Fine Arts, Houston, Bulletin* (April 1972), 14-18.

19. On the reverse of the original photograph an inscription reads: "Belonging to Mrs. L. P. Potter/87 Franklin St./Greenfield, Mass."

20. *Golden Horseshoe,* 1886, by Harnett, collection of Mr. and Mrs. James W. Alsdorf, Chicago.

21. *Signboard for Miss Emily Perkins,* 1903, collection of Mrs. Bailey Aldridge, Cambridge, Massachusetts. Emily Perkins was the aunt of the current owner, who relates that "my father and his family, knew Peto in Island Heights—in fact, my grandfather frequently bought groceries for him." Correspondence with the author, 21 March 1980.

22. Alfred Frankenstein gives an account of the circumstances and background of Church's trompe l'oeil, a gift in 1904 from Charles F. Olney to Oberlin College. Olney had acquired the piece from Church and claimed the artist was stimulated to paint the deceit for "a friend who made the statement that a work of art is meretricious only as it may be mistaken for the original." See Frankenstein, *After the Hunt* (1969), 53. See also the reproduction of Raphaelle Peale's *Patch Picture for Dr. Physick,* 1808, formerly collection Cy Des Cartes, Brooklyn, N.Y.; Frankenstein, *After the Hunt* (1969), fig. 43.

23. For a discussion of Schwitters in relation to the dada movement see William S. Rubin, *Dada, Surrealism, and Their Heritage* [exh. cat., The Museum of Modern Art] (New York, 1968), 52-60.

24. See Frankenstein, *After the Hunt* (1969), 117. Examples worth noting here include Victor Dubreuil, *Is It Real?,* before 1890 (Allen Memorial Art Museum, Oberlin College, Oberlin, Ohio); and John Haberle, *U.S.A.,* 1889 (Collection Jo Ann and Julian Ganz, Jr., Los Angeles); *The Changes of Time,* 1888 (Collection Richard Manoogian, Detroit), and *A Bachelor's Drawer,* 1890-1894 (The Metropolitan Museum of Art, New York).

25. See Harold Francis Pfister, *Facing the Light: Historic American Portrait Daguerreotypes* [exh. cat., National Portrait Gallery] (Washington, D.C., 1978), 354. Thanks also for information to Katharine Martinez, Avery Library, Columbia University.

26. From an undated newspaper clipping in the family albums, The Studio, Island Heights, New Jersey. The full notice reads as follows:

 FINE PAINTING.

 About three months ago a gentleman walked into our office and asked for a copy of the DEMOCRAT and a photograph of its editor. As this isn't out of the usual line of requests made upon good-looking country editors we skirmished around and found a photo of ye editor, an old one—in fact, it was taken before the matrimonial bee entered our bonnet, and all must know that it is "just exquisite." This we gave the gentleman, who went away smiling and left the sanctum full of "thank yous." We thought about that picture more than a little—the paper we didn't care about—until we finally came to the conclusion that the poor fellow must have a domestic

quarrel on his hands and wanted the picture to show his wife just how he looked in younger days. Well that picture haunted us for two or three days until one fine morning Capt. John Grant called us up early and reported blue fish biting at the Inlet and away we went down the bay, the picture went out of our mind and everything was O.K.

Last Friday at noon there appeared at our sanctum door, a second time, the same gentleman who had made the odd request from us a few months previous. We naturally braced ourselves for something extraordinary, but before anything could be said the gentleman said, Mr. Editor, I have something which may disgust you or possibly please, look at it, and he sat a square frame on the floor and began taking off wrappers until he brought to light a large oil painting which represented ye editor and his paper, also an envelope, all painted on canvas made to represent a board on which the DEMOCRAT is tacked and the picture is stuck back of it, the whole making a piece of realistic painting of much interest as an achievement of skill in a special line of art. The work is done so deftly and with such regard for the truth of form and all the conditions of realistic art, that the most acute observer is deceived. The artist was Mr. John F. Peto of Island Heights, formerly of Philadelphia. The picture is on exhibition at the drug store of C. B. Mathis, Main street.

27. For information on Newsam and Duval see *Philadelphia: Three Centuries of American Art, Bicentennial Exhibition* [exh. cat., Philadelphia Museum of Art] (Philadelphia, 1976), 310-311. I am also indebted for help on this material to Katharine Martinez, Avery Library, Columbia University.

28. For the former image see Lloyd Goodrich, *The Graphic Art of Winslow Homer* [exh. cat., The Museum of Graphic Art] (New York, 1968), cat. no. 4, plate 3; and for the latter see Philip C. Beam, *Winslow Homer's Magazine Engravings* (New York, 1979), 78.

29. James Agee and Walker Evans, *Let Us Now Praise Famous Men* (Boston, 1969), 141, 11.

173. Peto. *Toms River*, 1905.

6

TOMS RIVER

Office Boards and Rack Pictures

THREE TYPES OF PAINTING IN PETO'S late career deserve special focus, for they represent the culminating originality and complexity of his art. The first type involves just a small number, which depict papers or photographs against a wooden wall surrounded by an illusionistically painted frame. The second group explores various manifestations of the Lincoln imagery affixed in different ways to plain walls. The final series comprises Peto's some dozen rack pictures dating from 1879 to 1904. Together these recapitulate the evolution of his aesthetic ideas and rekindle our fascination with the always protected details of his personal and professional existence.

The pictures with painted frames are of special interest for the extreme to which Peto pushes his playfulness with both the shape and content of his art. His 1901 *Portrait of the Artist's Daughter* (fig. 170) is first of all a touching memento of Helen, seen in the small photograph at the center. In addition, the imaginary frame makes our reading of the shallow depth more provocative, questioning our notion of just what is the work of art itself. Peto had included an illusionistic frame in *The Cup We All Race 4* (fig. 153) from about the same time, but here (save the small corncob pipe above) almost all the elements are lines and rectangles pressed to the painting's flat surface. Instead of the three-dimensional tin cup presented as object and word, we now have a personal portrait as the focal subject. It is an image within an image, and both the photograph and the total canvas are unmistakably *painted*. Typically Peto brings us to the verge of illusionism, only to assert ultimately the primacy of paint, color, design, perception—in other words, the reality of artifice itself.

Undertaken when his daughter was eight years old and a constant object of his affection, the painting bears a poignant combination of love and pain. Photographs of Helen from these years (figs. 171 and 172) give us a child of beguiling charm. Peto obviously photographed her often as she was growing up, here with a favorite Japanese doll, also the subject of a small oil sketch, and seated in a chair with the familiar props of books and inkwell nearby. There is something ethereal and haunting in the blurred passages of these photographs, and the face staring at us has a fixed, thoughtful air which Peto makes even more stark and pensive in his painting. The positioning of the little photograph on his canvas makes clear that Helen was literally at the center of his life and brought him pleasure especially in the midst of the painful kidney disease plaguing his last years. That suffering is evident in the scarred boards and bent nails which surround the saddened face.

Peto made a lasting impact on his family as a devoted father, a modest and serious individual, who pursued his art with a sense of commitment approaching perfectionism. He doted on his daughter, hanging a swing from the beams in his studio so he might have her

171. Peto. *Helen Peto, Aged 2*, 27 June 1895.

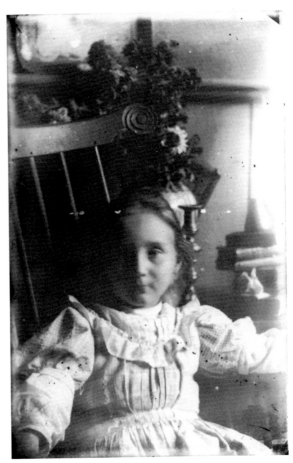

172. Peto. *Helen Peto as a Child*, 1890s (*right*).

nearby as he painted. When she was about six, he made her a sled, and a couple of years later he built her a large playhouse next to his grape arbor behind the house. Closer to his own heart, he introduced her at an early age to the pursuits of sailing, drawing, cello playing, and singing. On winter evenings he cracked hickory nuts for her in front of the fire, and, returning from his infrequent trips to Philadelphia to see his art supplier, occasionally he would bring back a piece of jewelry, sometimes of his own design.[1]

One feels the force of this intimate devotion in the glance which here holds the artist and his daughter directly facing one another. What makes the image so moving is the linking of childhood and mortality, of bright open innocence and dark enclosing world-weariness. This is a mood one encounters often in American art at the century's turn and perhaps no more powerfully than in the work of Thomas Eakins and Augustus Saint-Gaudens (see figs. 218 and 187). First exposed to Eakins' presence in his student academy days, Peto would have continued to encounter the influence of his art and personality during periodic visits to Philadelphia in later years. In the face of Eakins' wife is to be found a burdened spirit Peto would have sympathetically recognized. For Eakins, too, conveys the close bonds between artist and sitter, in a portrait carrying the weight of human frailty and endurance.

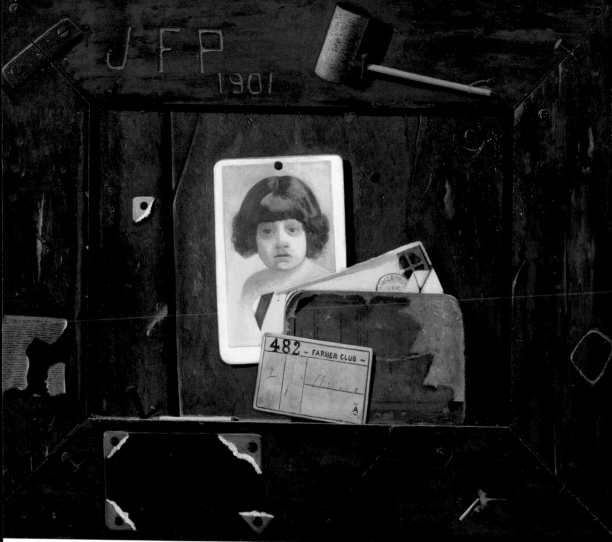

170. Peto. *Portrait of the Artist's Daughter,* 1901.

Peto painted another framed portrait in 1905, two years before his death, called *Toms River* (fig. 173). Here the photograph is more crudely rendered, possibly due as much to Peto's ultimate disinterest in perfect illusionism as to the inroads personal problems may have made in his ability to work in his last years. The frame is both more cleverly and extensively worn, badly bleached on one side and recently patched on the other. The picture takes its title of course from the town name incised in the central panel, the place where Peto passed his mature life as a happy family man. Still to be concretely explained are the initials *H H*, which presumably belong to the man pictured above. Most likely this is Hoffman Ham, Peto's maternal grandfather, whose wife had helped to raise Peto as a child. The Ham family was very much in the artist's mind from 1900 on, for in these years he had to give much of his time and passion to fighting the lawsuit in upstate New York over the disposition of Ham family lands along the middle reaches of the Hudson River.[2] Exhaustion from constant travel and the battle itself contributed to Peto's failing energies. The final enigmatic detail in *Toms River* of the incised Star of David, generally understood as an emblem of martyrdom, may thus be a private reference to suffering. If so, it is the clarifying link to his

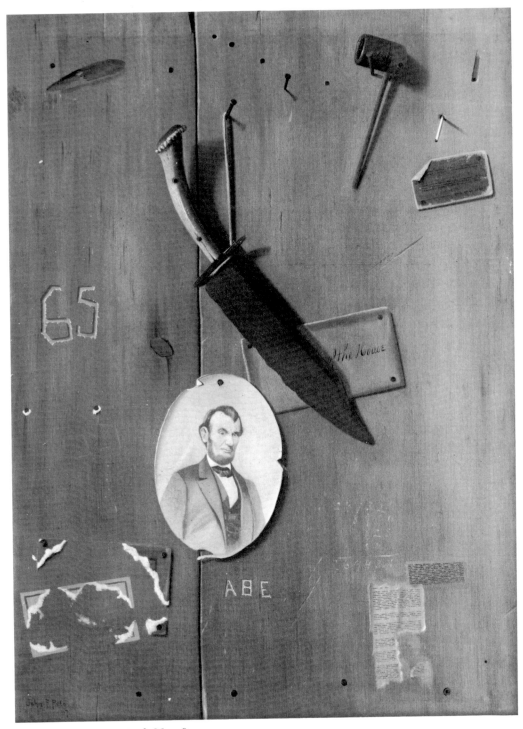

174. Peto. *Reminiscences of 1865*, 1897.

175. Artist unknown. *Abraham Lincoln*, n.d.

series of Lincoln pictures, which also deal with the shadows of disorder and death.

Peto's obsession with Lincoln imagery found expression in some dozen canvases painted regularly through the 1890s and early 1900s. We have already taken note of his apparent psychological association of the fallen president with his own late father. Frankenstein first commented on the connection, citing family stories about Thomas Hope Peto picking up a blood-stained bowie knife on the Gettysburg battlefield.[3] In several of the pictures an oval engraving of the familiar Lincoln face is juxtaposed with the knife, sometimes hanging threateningly nearby. About half of the group which have come to light are varying arrangements of these and other flat objects nailed to sections of old wooden doors, with the balance employing the crossed tapes in a letter rack motif. Incised in most of these are such details as Lincoln's nickname "Abe" or his birth and death dates of 1809 and 1865. Occupying the center of the 1897 version called *Reminiscences of 1865* (fig. 174), the knife hangs like a large and heavy guillotine over a representation of Lincoln's bust and literally cuts across the first words on an envelope marked "Head of the House."

The source of this likeness, an engraving, was a commonly reproduced and available print, and Peto owned a copy (fig. 175) which he made use of for almost all of these paintings. It shows the tears and abrasions of much handling, but Peto also strengthened certain details with pencil, such as Lincoln's hair and beard, and he repeatedly pressed into the outlines of the president's face, presumably as a means of transferring it exactly, like a cartoon,

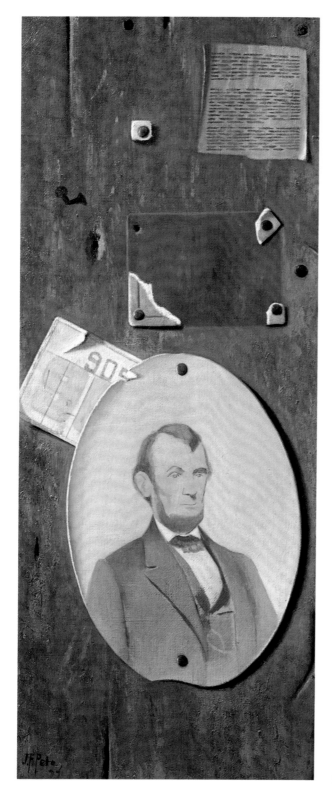

176. Peto. *Portrait of Lincoln*, 1899 (?).

to his canvas surface. In a number of cases the measurements of the oval and its interior details coincide directly with his print, though Peto concerned himself mainly with the planes of light and dark and a few essential linear features.

Peto experimented with different formats, and some works in the series are less than successful because the details have a generalized and simplified air bordering on the perfunctory. One of these (fig. 176) is interesting chiefly for its attempt to exploit the expressive effects of an unusually narrow vertical canvas and a subtle range of subdued colors—here, tan, ochre, and the palest of blue and lavender. In another singular case *Lincoln and the Phleger Stretcher* (fig. 177), he set his painted oval engraving on the back of a canvas, a perceptual conceit which has occasionally appealed to other painters both in the nineteenth century and our own time. Disturbing to certain viewers has been the patently unfinished likeness of Lincoln, though this is a familiar Peto procedure to remind his audience that the image is the result of an act of painting. It complements the trick of delineating the canvas back on its front. Given Peto's sensibility, it treats Lincoln as a private and discarded memento.

The unfinished canvas was a phenomenon which Peto shared with Eakins. Peto's image is little more than a broad blocking in of forms, a method he first learned at the Pennsyl-

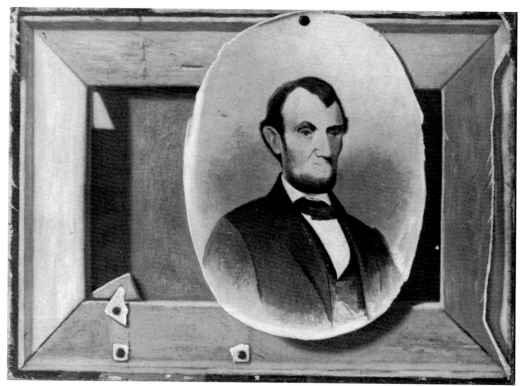

177. Peto. *Lincoln and the Phleger Stretcher*, c. 1900.

vania Academy. Both artists toward the ends of their careers increasingly left parts of pictures incomplete, though reasons for this varied. Eakins' *Unfinished Portrait of Mrs. Joseph W. Drexel*, c. 1900 (fig. 178) makes an apt comparison with Peto. The sitter in this instance,

178. Thomas Eakins. *Unfinished Portrait of Mrs. Joseph W. Drexel*, c. 1900.

as frequently happened because of Eakins' intensely truthful and often unflattering records, lost interest in having the work completed or in accepting it. Yet Eakins still achieves an image of self-contained thought, in which the contemplative demeanor of the figure is forcefully embodied in the sufficiently sketched-in form. Elsewhere, Eakins might only give ambiguous texture to a background or block out in almost crude simplicity an individual's torso, while completing the details of the face and head enough to give concrete life to the corporeal and psychological presence of his subject. On one level, then, unfinished works for both painters represented incidences of failure or lack of acceptance by others,

179. William M. Davis. A *Canvas Back*, c. 1870.

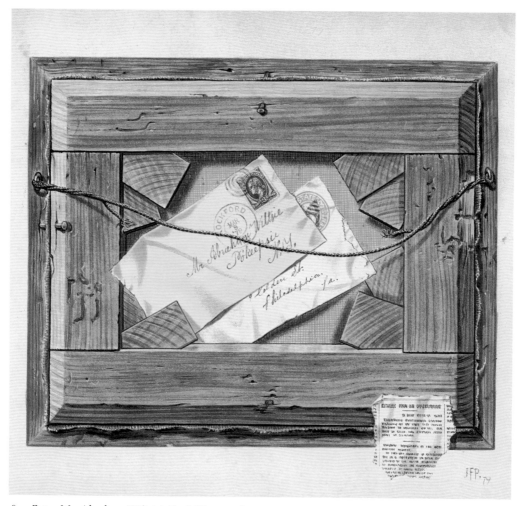

180. Peto. *Mr. Abraham Wiltsie's Rack Picture*, 1879.

moments of halting resolve, recognitions of their own mortality. On another, these works may often be read as complete to the degree the artist intended, and they may in fact convey an emotional power through raw color, brushstroke, or abstracted form. This is certainly the case with some of Peto's late bookshelf and letter rack paintings (see figs. 122 and 215).

The idea of making a picture of the reverse side of a canvas and its stretcher was one with precedents in earlier European art, most notably in the work of Cornelis Gysbrechts from the second half of the seventeenth century.[4] Like other forms of deception painting, it found its way into the American tradition, and not long before Peto tried his example, the Long Island painter William M. Davis produced A *Canvas Back* (fig. 179). Little is known about Davis (1829-1920) save that he was an acquaintance of the well-known genre painter William Sidney Mount and did at least one other complicated trompe l'oeil painting.[5] Aside from its similarity of conception to Peto's *Lincoln and the Phleger Stretcher*, the inscription at the top of the Davis canvas is startlingly close to the writing in a number of other Peto compositions (see figs. 117, 119, and 122). At present no solid connections can be

181. Roy Lichtenstein.
Things on the Wall,
1973.

drawn between the Long Island and Philadelphia painters, but obviously illusionistically painted frames held an interest for other artists of this period.

Peto himself painted one other image of a canvas stretcher, unusual because it is an early dated work and one of his few known watercolors. *Mr. Abraham Wiltsie's Card Rack* (fig. 180) shows two envelopes tucked into the stretcher frame; the top one is addressed to a merchant in Poughkeepsie, New York, who presumably had business with the artist's family in that area. Peto had visited his aunt Caroline Ham and other relatives often at their Hudson River farm lands in Madalin. This small town was near Tivoli, Rhinebeck, and Poughkeepsie. Peto recorded his childhood affection for the local countryside in his early farm landscapes (figs. 7 and 19). This watercolor bears the tight handling and concentration of his recent academic training at the Pennsylvania Academy. Its bright clear colors— yellow, green, red, and tan—are similar to those in other early paintings in oil (for example, figs. 19, 46, and 202). Besides its special interest as a singular watercolor following Davis' *Canvas Back* by not many years, it embodies Peto's instincts from the start for a strong design and for incorporating autobiographical associations. Here the different handwriting of the Poughkeepsie and Philadelphia addresses on the two letters hints at some personal exchange of correspondence. More interesting, given its date of 1879, the watercolor coincides with Peto's commencement of his larger, more ambitious letter rack pictures in oil (compare fig. 194). In those he was to pursue with ever greater emotional force the implications of abstraction and illusionism so charmingly initiated here.

This imagery continues to thrive in contemporary art, especially in the witty and provocative canvases of such pop painters as Jim Dine, Jasper Johns, and Roy Lichtenstein. Not surprisingly, their methods and themes share much with Peto and his generation. Dine has collected works by John Haberle, and both Johns and Lichtenstein have freely drawn on

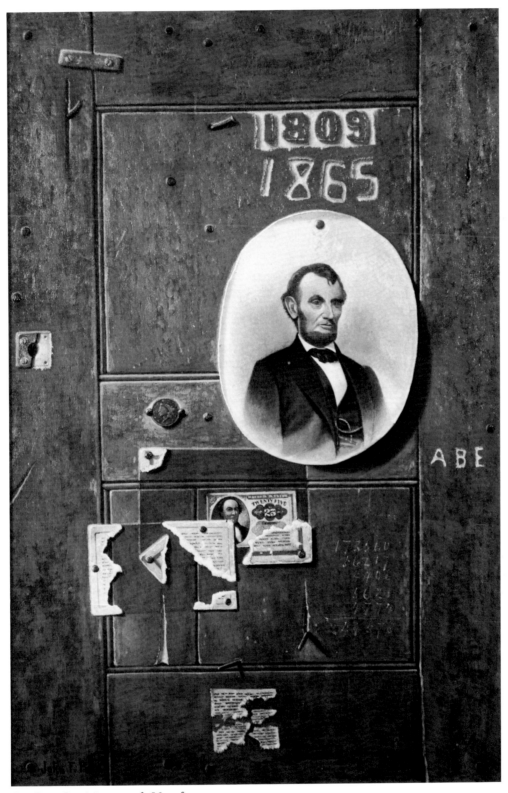

182. Peto. *Reminiscences of 1865,* after 1900.

the trompe l'oeil examples of Peto and Harnett. In particular, Lichtenstein (born 1923) undertook in the 1970s a series of canvases depicting stretchers with attached studio items, which consciously recall details from Haberle, Harnett, and Peto. Lichtenstein's style of large-scale, glossy, comic book painting is but a modern form of deceptive realism, addressing both what we see and how we see.

In *Things on the Wall*, 1973 (fig. 181), the imitation photo-mechanical technique of execution and the reliance on the three primary colors call attention to the basics of art and its relationship to the processes of representation. Likewise, his subject makes multiple references to other artists, their works, and their materials. Beyond the more modern fragments drawn from Fernand Léger, we recognize Haberle's paintbrushes and Peto's horseshoe (see figs. 150 and 151), the envelopes of Peto and Harnett (see figs. 200 and 201), and playing cards from Peto to Picasso (see figs. 190 through 193). Lichtenstein has said he takes pleasure in Peto's art for the play he makes himself in transforming ordinary things and the way we ordinarily see them.[6] Again we are in the presence of an artist who makes the contents of his studio into an interior landscape and large-scale still life combined.

Although Peto did few paintings of illusionary frames and canvas backs, they were indicative of his imaginative experimentation with imagery in his late career. The one recurring subject which serves as a transition from these formal inventions to his last important series of rack paintings is the Lincoln theme. The oval engraving of the president's figure dominated several later canvases by Peto which displayed relatively plain wood surfaces. In their austere flatness and their visual provocations Peto continued to invest his paintings with touches of wit and mystery. He amplified the Lincoln presence with a variety of associative details. In some, like *Reminiscences of 1865*, a second work with this title (fig. 182), he included other official images—contrasting pieces of currency, for example, such as the twenty-five cent shinplaster and tarnished coin fixed to the door. Here Peto imposes a more severe linear order than usual on his whole design by the generally balanced and repeated rectangles throughout.

More chaotic is the randomly cracked panel and dispersed arrangement of *Lincoln and the Star of David* (fig. 183), dated 1904, which manifests the advancing decay often found in Peto's late works. Lincoln was the first American president to be assassinated, and the legacy of hatred and distrust left by his death stirred powerful emotions to the end of the nineteenth century. With the panic of 1893 and the collapse of the banks, Americans faced new challenges of despair and survival. On the one hand there had been the triumphs of American industry, the railroads, and corporate development. Howard Mumford Jones writes of the parallel visions of John D. Rockefeller, Sr., and Walt Whitman of America as "a happy, wasteless, and plentiful society."[7] On the other hand the disorder apparent in various spheres at the turn of the century gave rise to bitterness, sectional strife, and turbulence. As ineffectual presidencies and further assassinations followed Lincoln's, a fin de siècle sense of being adrift overtook much of American culture. Peto's ragged conjunction of the martyred president and the associations with suffering in the sign of the Star of David appear to draw no less from the tribulations of the period than of self.

183. Peto. *Lincoln and the Star of David*, 1904.

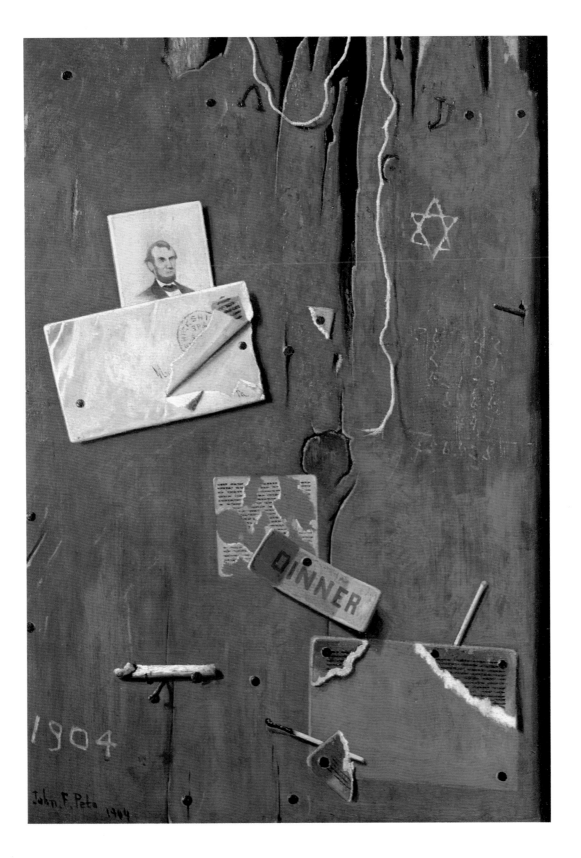

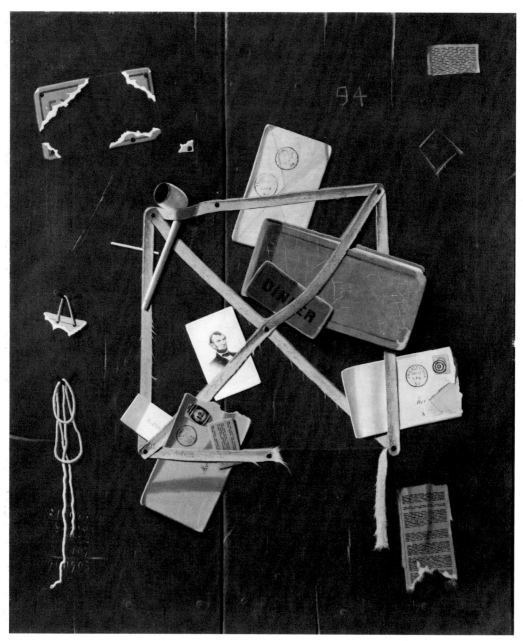

184. Peto. *Old Time Letter Rack*, 1894.

A more provocative psychological connection is to be raised between Peto's use of the incised star and his larger designs of the letter racks themselves. Aside from their general similarities of linear form on different scales, we have to wonder if there is not some shared emotional content here as well. It is true that Peto's first rack pictures of 1879 and the early eighties (figs. 194, 201, and 202) begin as mostly literal and whimsical transcriptions of office boards with the practical possibility of serving as business advertisements. However, in the later rack paintings, beginning in 1894, not only do we see the Lincoln imagery making

185. George Cope. *Union Mementoes on a Door*, 1889 *(left)*.
186. Alexander Pope. *Emblems of the Civil War*, 1888 *(right)*.

its reappearance (concurrent with Peto's mourning over his father's death), but we also face a new mood of strain and assault in the form of the rack's tapes. At least in the Lincoln series these crisscrossed lines now bear the full physical and spiritual burdens initially hinted at in the earlier small signs.

Coloristically, the letter rack paintings are very beautiful canvases, with their rich impenetrable grounds of black or dark green and intense patches of isolated pinks, yellows, oranges, and blues (fig. 184). They were much admired in their day, as contemporary newspaper commentaries affirm. One of the Lincoln series elicited the following description on the occasion of a visit Peto and his wife made to his in-laws in Lerado, Ohio:

A piece of realistic painting which shows great achievement of skill in this special line of art in which Mr. Peto stands almost alone, is a canvass [sic] two and a half by two feet, a card rack, under the crossed red tapes of which are stuck a number of letters and papers, prominent is a copy of the Commercial Gazette. There are also letters, a postal card and an engraving of Abraham Lincoln in the lower left corner, and other such articles as belong to the office of a newspaper. The work is done so deftly and with such regard for the truth of form, perspective, light and shadow, and the conditions of realistic art, that the most acute observer is deceived. He does not think he is inspecting a painting, but believes he sees before him a genuine card rack with the actual article inserted.[8]

Peto, and for that matter Harnett too, did not always receive such favorable criticism of his illusions, and other rack paintings were to be damned for being so visually deceitful as to border on the immoral. At the same time the admiration for technical dexterity and straightforward literalness is a longstanding American trait. In fact, Peto almost never attained the completely deceptive effects his viewers believed or wished they saw. Reality in the service of art, rather than vice versa, instead led him generally to ends more disturbing, unpredictable, and thought-provoking.

Although the personality of Lincoln seems to have had focal meaning for Peto personally, reminiscence of the Civil War was more broadly shared with many of his generation. Termed the first great modern war,[9] in terms of mass brutality and slaughter and the use of steam technology and advanced firearms, the conflict shattered the fabric and self-confidence of the nation. By century's end the natural deaths of its veterans heightened the poignance of memory, and numerous artists turned to subjects much like Peto's. Typical cases in point are *Union Mementoes on a Door*, 1889 (fig. 185) by George Cope (1855-1929), and *Emblems of the Civil War*, 1888 (fig. 186) by Alexander Pope (1829-1924). The former painter worked mostly around his native West Chester, Pennsylvania, while the latter grew up and trained in Boston; both turned to large door still lifes during the later 1880s in response to the influential example of Harnett, especially his popular *After the Hunt* (fig. 24). For his part, Cope preferred to render with extreme naturalism the often blond wood graining of his background, compactly massing his hanging objects at the center. With Pope the elements are more ambitiously dispersed, though he relies on some of Harnett's circular and diagonal motifs for his design. Like the antler horns, these are the trophies of manly

187. Augustus Saint-Gaudens. *Adams Memorial*, 1891, Rock Creek Cemetery, Washington, D.C.

conflict, reminders (in uniforms, bugles, pistols, dress swords, and battle flags) of past glories. Although their basic compositions and subject matter relate to Peto's series, he alone personalizes the significance of Lincoln and the family bowie knife as almost enigmatic presences.

This intimate, mysterious sense of death found haunting expression in one of the great sculptures of the period, Augustus Saint-Gaudens' *Adams Memorial* of 1891 (fig. 187) in Rock Creek Cemetery, Washington, D.C. The international training and travel, the genteel patronage and popularity of Saint-Gaudens (1848-1907) set him well apart from Peto, his near exact contemporary. Yet in this generalized, slightly larger than life-sized bronze figure the sculptor created a brooding image about the inexplicability of death. The specific circumstances of the commission are well known: following the shock of his wife's unexpected suicide in 1885, Henry Adams asked his friend to undertake an appropriate memorial. The result is one of the most abstracted of all Saint-Gaudens' public pieces, suggesting a genderless figure in repose, neither asleep nor dead. By its simplified forms and its engagement of the viewer in contemplation, this work brings us back to the tragic spirit of Peto's last great still lifes.

For many at the close of the nineteenth century there was a vogue in despondency and a certain romance in senseless death. We have seen how Peto probably tied his father's death to Civil War motifs, through most notably the Lincoln portrait, the pistol, and the bowie knife. The theme of the gun is one pervasively embedded in the traditions of nineteenth-century America, from the hunting of animals on the western plains and self-defense in settling the frontier to the romance of militarism fueled by the several wars during those decades. As life grew more difficult and complex, the gun became a reminder of clear, aggressive solutions and of militaristic pride. The chivalric ideals and actions of an earlier generation of warriors stood in contrast to the sense around 1900 of impending uncertainty, impotence, and upheaval. Following the Civil War waves of violence arose with the force of a cult. As the demand for arms escalated, Samuel Colt for one doubled production at his factory in Hartford.[10] No wonder weapons held evocative associations for Peto and his colleagues.

The passions of the Civil War and the romance of youth cut down surfaced as well in literature of the period, most familiarly in the writings of Stephen Crane and Walt Whitman. On the basis of his readings of the war's history and visits to some of the battlefields, Crane constructed his popular novel *The Red Badge of Courage.* From the point of view of a common private he gives the terrible conflict a poignant immediacy. Although vivid details and a sense of ordinariness are intended to convey a documentary flavor of reality, Crane invests his story, written in 1895, with values belonging more to the end of the century than to the early 1860s—concerns with the unknown, boredom, self-doubt, panic, and confusion. The youthful narrator remarks that

The battle was like the grinding of an immense and terrible machine to him. Its complexities and powers, its grim processes, fascinated him. He must go close and see it produce corpses.[11]

Crane was writing in a generation anxious about abstract forces larger than individuals and out of their control. Caused first by the Civil War, this anxiety intensified with the further

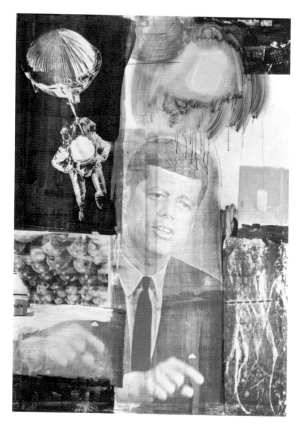

188. Robert Rauschenberg. *Retroactive,* 1964.

upheavals in national life during subsequent decades. On the minds of the novelist, painter, and their contemporaries were questions regarding the nature of both personal and national mortality. Thus did the exploits and personalities of an earlier period of crisis come to have significant emotional appeal for turn-of-the-century America.

Likewise, Whitman's poetry was engaged in a mixture of itemized facts and imaginative reminiscence. Time's veil affected him as much as it did Crane or Peto:

Dusk becomes the poet's atmosphere, I too have sought, and ever seek, the brilliant sun, and make my songs according. But as I grow old, the half-lights of evening are far more to me.[12]

In his recollections of the Civil War, the sacrifice of Lincoln's death held heroic meaning for Whitman. Written in the aftermath of the assassination, the memorable "When Lilacs Last in the Dooryard Bloom'd" came to occupy a central position in the later editions of *Leaves of Grass.* In the light of Peto's fascination with the imagery of Lincoln and the Star of David, it is worth noting here that Whitman in his first lines describes the slain president as a "powerful western fallen star," a metaphor repeated throughout his poem. Well known in Philadelphia and America by his last years, Whitman himself died in 1892. It may not be too much to speculate that the great poet's passing, like that of Peto's father three years later, could have been a factor in the artist's turn to more somber rack pictures during the mid-nineties.

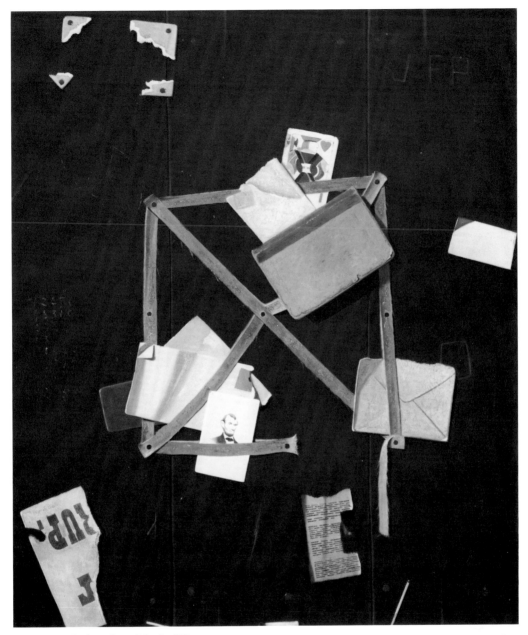

189. Peto. *Card Rack with Jack of Hearts*, c. 1900.

Whitman's direct experiences of the war years as an army nurse in Washington occasioned an accumulation of journalistic notes and observations which he finally published as *Specimen Days* in 1882. These record the commonplace details of death's horror and, as time passed, the romantic overlay of majesty seen in great causes. The loss of a beloved father figure like Lincoln was a parallel obsession for Peto and Whitman. To both, the past event and present recollection fused. In 1882 the poet looked back to 1865 (as the painter was to do in the 1890s):

190. Peto. *Hanging Knife with Jack of Hearts*, 1903.

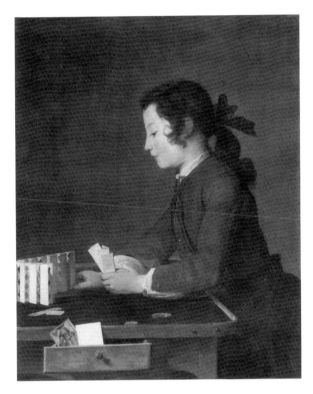

191. Jean-Baptiste-Siméon Chardin. *The House of Cards*, c. 1737.

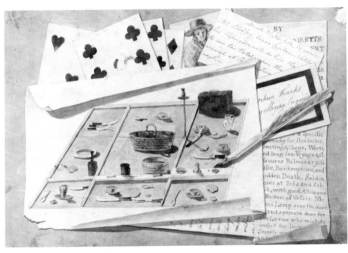

192. Benjamin Latrobe. *Breakfast Equipage of the "Eliza,"* 1795.

I find in my notes of the time, this passage on the death of Abraham Lincoln: He leaves for America's history and biography, so far, not only its most dramatic reminiscence—he leaves, in my opinion, the greatest, best, most characteristic, artistic, moral personality. . . . The tragic splendor of his death, purging, illuminating all, throws round his form, his head, an aureole that will remain and will grow brighter through time, while history lives, and love of country lasts.[13]

In introducing a modern edition of *Specimen Days*, the critic Alfred Kazin reminds us that Whitman identified the cause of the nation, and its embodiment in the slain president, with no less than the sacred theme of Christ's Passion.[14] Indeed Lincoln was killed on Good

Friday, 1865, and such an association only enhances Peto's visual alignment of his Lincoln engraving with a Star of David.

This particular subject of Peto's allows us another projection forward to a corollary image of our own time. Close to a century after Lincoln's death America witnessed the assassination of President John F. Kennedy. Amateur historians have since indulged in the many coincidences of circumstance and individuals involved in each event, but the important comparison to be drawn here is that with Kennedy's death another bubble of national optimism burst and the country plummeted into despair, self-doubt, and contention. Many Americans were nostalgically preoccupied with lost leadership and promise in the years following. Not surprisingly, the image of his grieving widow pervaded the national consciousness, perhaps exemplified in the multiple silkscreen canvases produced at the time by pop artist Andy Warhol. Kennedy's own presence was the subject for Robert Rauschenberg's *Retroactive*, 1964 (fig. 188), what might be described as a collage landscape created by a mixed technique of oil painting and silkscreening on the canvas. He employed or suggested different modes of production at once (photography, printmaking, and conventional painting), and equally he assembled various disparate images of the Kennedy years. In so doing, Rauschenberg joined form and content to describe the complex, often inconsistent and incoherent character of modern America, as Peto had given visual expression to the national temper in his day.

One further variant in Peto's Lincoln series remains. In at least two of the later rack paintings the detail recurs with enough prominence to warrant consideration. *Card Rack with Jack of Hearts* (fig. 189) calls attention to the new element of the playing card jammed behind the strip of tape opposite a picture of Lincoln. So far as is known, Peto introduced and repeated just this face card in his compositions, and again, so far as is known, just in the Lincoln subjects. We can only guess Peto's motivations here, but given the patterns of themes described so far, he obviously wished to juxtapose the two similarly sized images of the president and the knave.

We may think of the jack variously as prince, knave, or even joker. In some games he serves as an esteemed and useful wild card. Somehow Peto saw a correlation to Lincoln in the game of chance with both its calculated and unexpected discards. That correlation took on a more ominous cast in a smaller canvas of 1903, *Hanging Knife with Jack of Hearts* (fig. 190). Here the Lincoln face is not present at all; instead the Civil War bowie knife looms over the jack below. We can only ask whether that figure stands as an ironic emblem for the beleaguered Lincoln or for the knavish assassin John Wilkes Booth.

The playing card may have been related to an aspect of Peto's life in Island Heights, one seen as well in his repeated images of beer mugs, wine bottles, and pipes. In his day the Methodists ran the town, and wrote into its bylaws a prohibition on the sale of liquor (still in effect today). A religious man himself, Peto would have been well familiar with the adamant Methodist views on the evils of drinking, smoking, and cardplaying, and although he did not indulge in their temptations, they were frequently present in his paintings in surrogate visual form. Games of cards and dice, along with goblets, pipes, and musical instruments, have long appeared in art as objects of taste and pleasure. To the seventeenth-century Dutch painter, for example, they constituted standard symbols for the *vanitas* still

193. Pablo Picasso. *Card Player*, Winter 1913-1914.

life, warning against prodigality and self-indulgence.

Bringing us back to a reference made previously, the example of Chardin provides an especially appropriate precedent from the eighteenth century. Among the most touching of that master's vignettes of humble pleasures and daily pursuits are his paintings of youths absorbed in leisurely pastimes—blowing soap bubbles, playing knucklebones or shuttlecock, making drawings, and essaying the house of cards. This last is the title of several versions on this subject, a couple of which interestingly depict a jack of hearts sticking up from a drawer in the foreground (fig. 191). As with his paintings of pure still lifes (see figs. 69 and 70), Chardin treats this genre subject with the same stillness of mood and clarity of construction. The house of cards itself is a fitting metaphor for the playfulness, fragility, and dreaminess of the eighteenth century. At the same time, the dreamy intensity, the purity of form and color, and the precariousness of the game perfectly convey the essential idea of youth. The knave on the one identifiable playing card is a final touch in keeping with the gaming instincts of a young man.[16] Whatever the degree of Peto's consciousness of this tradition, he certainly followed in its spirit.

Playing cards, like prints, letters, and business cards, appeared periodically in nineteenth-century American art, as has been seen in examples by Frederic Church, Albert Newsam, and William Davis (figs. 155, 163, and 180). Even earlier, artists and draftsmen in the Federal period tried deception pieces incorporating fragments of letters, notable examples being Raphaelle Peale (fig. 197) and Benjamin Latrobe (fig. 192). Latrobe (1764-1820) is best known as one of America's first professionally trained architects, responsible for helping to introduce the new, severe Greek-revival style with such buildings as the Bank of Pennsylvania in Philadelphia and the Baltimore Cathedral. An accomplished engi-

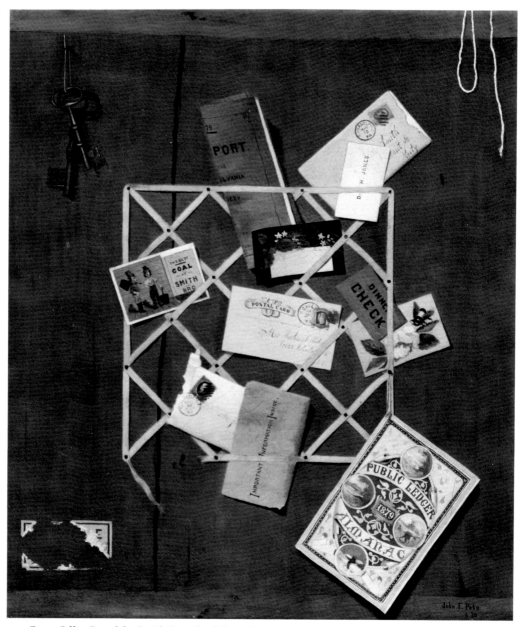

194. Peto. *Office Board for Smith Bros. Coal Co.*, 1879.

neer and designer, he produced meticulous architectural drawings, often with shaded mod-
eling and touches of color. Thus, his attempt at a letter rack arrangement (titled from details
within it) is a witty, visually convincing diversion. The four playing cards he introduces at
the top join the other references to pastimes of pleasure, while also serving to reinforce the
flatness of the composition. Similarly, with Peto, it is always well to keep in mind the paint-
er's equal attention to the content and placement of such details.

The dual concern for the emotional associations and the formal character of things re-
turns us to the zenith of cubism. Picasso's *Card Player* of 1913-1914 (fig. 193) carries this

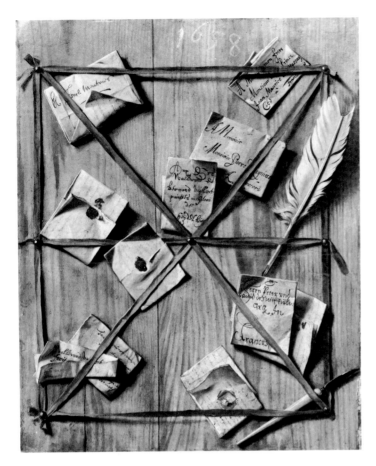

195. Wallerant Vaillant. *Letter Rack*, 1658.

theme into modern abstraction, but his introduction of newsprint and playing cards at the center is an intellectual gesture we have already seen made, more traditionally, by Peto. In Picasso's overlapping forms and repeated silhouettes radiating out from the middle, one discerns the sense of table, cards, and finally the figure of the player and walls of the room behind. Thus does the still life take on the richness and fullness of its environment, at the same time that its basic components assert and manipulate the language of art. In this sense, for Picasso as for Peto, the cardplayer is an extension in turn of the joker, the harlequin, the performer, the magician, the artist himself. With cubism the textures, colors, and patterns of items like cards or letters are central to organizing pictorial design. As metaphors and as literal things, such details are instruments of art's playful transformation. The cubist still life ultimately makes a significant comparison with Peto's work in the way both can be seen to join the ordinary world at everyone's hand to the interior realm of the artist's ruminations.[17]

With this examination of Peto's Lincoln imagery and its introduction into some of his later rack pictures, it is now possible to summarize the developments of his later career by looking at the rack series as a whole. Unlike Harnett or any of his other colleagues, Peto completed more than a dozen rack compositions with crisscrossed tapes. These evolved in almost a yearly sequence in two distinct periods, the first running from 1879 to 1885 and the

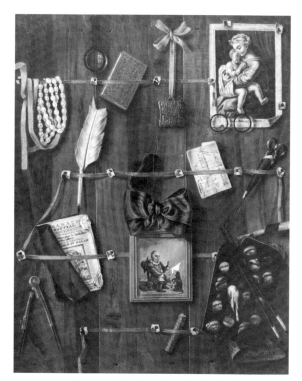

197. Raphaelle Peale. A *Deception*, 1802.

196. Jean Valette-Penot. *Trompe l'Oeil with an Engraving of Sarrabat*, 2nd half 18th century.

198. American unknown. *The All-Seeing Eye*, 1827.

second from 1894 to 1904. The earlier of these works were clearly executed as more literal office boards or trade advertisements, often with engaging touches of humor, and generally came about as commissions from neighboring businessmen or friends. Among them were several Philadelphians: Christian Faser, a framemaker; William Malcolm Bunn, editor of the *Sunday Transcript*; William Miskey Singerly, owner of the *Record*; and Dr. B. M. Goldberg, a chiropodist on Chestnut Street.[18] The names of dry goods dealer Eli Keen and

199. John Haberle. *Torn in Transit*, 1880s or 1890s.

Ocean County Democrat editor Charles S. Haskett have already come up in relation to their similar patch paintings (figs. 161 and 162).

Although in many cases he took up and elaborated subjects initially painted by Harnett, the letter rack image was apparently one Peto completed first. Both men began work on rack paintings in 1879, with Peto dating his in June (fig. 194) and Harnett finishing in August. [19] This hardly makes a definitive case for one originating the idea before the other, though Peto made emphatic his dating by clearly painting "'79" in three places on his canvas: on the folded Report at the top, the Public Leader Almanac below, and with his signature at the bottom right. The painting is known as *Office Board for Smith Bros. Coal Co.* from one of the addressed letters and illustrated advertising cards held in the crossed tapes. It is a lively and rather busy work due to the extensive tape patterns, number of cards included, contrasting rectangles of bright color, and reproductions of floral and figural illustrations. These elements, along with the envelope enigmatically titled "Important Information Inside," would find their way into subsequent rack arrangements (compare figs. 201 and 202).

As has been noted in conjunction with still-life motifs inherited by American artists from a long tradition in Europe, the flat letter or card rack display also has a series of European precedents, especially from the seventeenth century. Of course the fascination with manipulating spatial recession existed in ancient Greece and had later manifestations in the illusionistic wall frescoes first painted by the Romans and then revived by the Italian masters of the Renaissance. But trompe l'oeil generally, and letter rack subjects particularly, had special appeal for the Dutch school in the seventeenth century. This Protestant merchant

200. William M. Harnett. *Mr. Huling's Rack Picture*, 1888.

society, like that subsequently in nineteenth-century America, valued the practical, the orderly, and the immediate. It follows that its art would include images of currency and familiar objects from the domestic environment. Both content and execution were admired for their focus on craftsmanship and enterprise. [20] These ideas, bringing together the scientific and intellectual background of the Greco-Roman world reborn in the Renaissance with the sensible, matter-of-fact values of mercantile Holland, descended directly into American culture.

Most descriptions of trompe l'oeil stress foremost the element of deception. The following definition is serviceable enough, although as it applies to Peto, we can see in fact his distance and distinctiveness from classic illusionism.

201. Peto. *Rack Picture with Telegraph, Letter and Postcards*, November 1880.

Trompe-l'oeil does not tell a story. It is as unemotional as it is clever. The trompe-l'oeil artist aims to create an illusion convincing enough to deceive the eye of the beholder by making a flat surface appear three-dimensional when the painting is finished. Thus, in a sense, his technical skill is meant to go undetected. . . . The genre is essentially decorative and ambiguous.[21]

The examples that proliferated in Europe and served as prototypes for American adaptations include the rack pictures, often cited in the literature, of Wallerant Vaillant in the

202. Peto. *Office Board for Christian Faser*, 1881.

seventeenth century and Jean Valette-Penot in the eighteenth (figs. 195 and 196). In form, content, and technical execution, they fulfill the essential expectations for trompe l'oeil painting. This tradition is taken up early by American artists, and though the rack subject was not a frequent one, it provided the basis for some fine examples. Raphaelle Peale's *A Deception* of 1802 (fig. 197) grounds the imagery firmly in the Philadelphia still-life school centered around the Peale family. The idea clearly had a wider appeal, evident in the more enigmatic work called *The All Seeing Eye* (fig. 198) by an unknown artist, though once at-

203. Detail of figure 202.

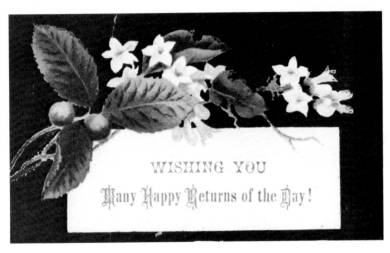

WISHING YOU
Many Happy Returns of the Day!

204. Anonymous American. Greeting card, late 19th century.

205. Peto. Business card, 1890s.

tributed to Nathaniel Peck on the basis of his name appearing on a letter at the upper right.

Thus this type of still-life picture joined others in entering America's evolving artistic vocabulary. But it was not until Peto's generation in the last quarter of the nineteenth century that artists broadly and repeatedly took up such illusions with a passion. John Haberle

was typical in his delight with the pictorial deceptions he carried out in his canvases of partly unwrapped pictures. He did not essay the classic letter rack format, but came close in *Torn in Transit* (fig. 199) with its play of layered pictures in a teasingly shallow plane. Both its puns on art about art and its sense of two-dimensional abstraction bring it close in spirit to Peto's work.

206. Detail of figure 202.

Harnett undertook only two rack paintings, and both are very fine. His first, mentioned above (Metropolitan Museum of Art), coincides with Peto's earliest effort, and his second, *Mr. Huling's Rack Picture* (fig. 200), is dated 1888. As is typical of Harnett, the technical level of execution is consistently high, showing little of the struggle and step-by-step progress evident in Peto's series. Harnett's painting reconfirms the command of orderly clarity we expect to find in his work: his tapes are clean and taut; his tears in envelopes seem almost crisp and fresh; even his torn-away newspaper fragment at the top left suggests a deliberate abstract pattern more than the accidents of wear. Above all, Harnett's smooth finish and meticulous detailing perfectly embody the visual strategies to deceive in the trompe l'oeil mode. His imagery also takes pleasure in ordinary domestic things, just as his execution calls attention to superlative craftsmanship.

Leaving aside for the moment the stylistic differences between Harnett and Peto, we ought to remember that these depictions of printed materials and disposable cards belonged to a flourishing production of what are now called the popular mass media. Existing concurrently with the elevated international tastes of genteel society, bourgeois Victorian America more broadly enjoyed the new availability of serialized stories, magazines and pa-

207. Peto. *Rack Picture for William Malcolm Bunn*, 1882.

perback journals, comic strips, chromolithographs, and sheet music.[22] Reading newspapers, writing letters, exchanging calling cards, and indulging in popular novels became widely shared, pervasive activities in nineteenth-century culture.

While Harnett's response to this aspect of contemporary life resulted in one of his most finely polished compositions, he appears to have had little interest in the letter rack arrangement beyond mastering its illusionism. Having done it twice, he returned to his other still-life subjects. There is no question that *Mr. Huling's Rack Picture* is of a quality surpassing

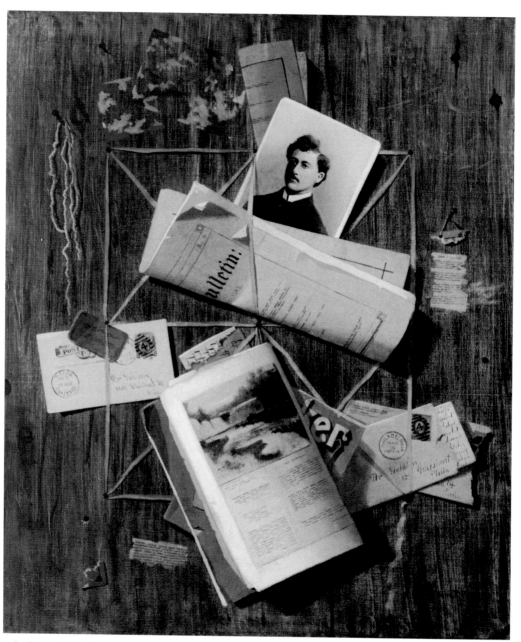

208. Peto. *Office Board*, April 1885.

many of Peto's attempts, especially his earlier ones; equally, Harnett's singular efforts had some influence on Peto's later examples. Frankenstein has pointed out that Peto kept in his studio a photograph of his friend's 1879 version and freely adapted certain motifs years later.[23] But as was characteristic in this artistic relationship, Peto seized certain of Harnett's themes when they offered special personal significance, repeating them in variants until he made them his own.

In contrast to Harnett's objectivity, Peto became increasingly subjective, if not autobi-

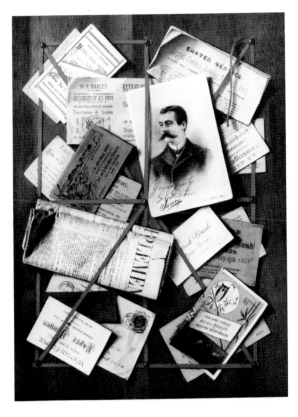

209. Thomas H. Hope. *The Artist's Letter Rack*, 1886.

ographical. As he did, his paintings gained in confidence and expressiveness; at their best they possess qualities altogether different from those of Harnett but nonetheless comparable in their beauty. What is important to recognize are the ways in which Peto modifies the traditional trompe l'oeil mode. While his paintings do not spell out a literal story, their elements often evoke narrative or anecdotal associations. While he works with effects of illusionistic rendering of forms in space, visual trickery is seldom an aim in itself. Most of all, while he is capable of totally convincing effects of deception, Peto prefers to exploit, rather than suppress, the mark of his brushwork. Finally, his vision of the genre is more than decorative; instead of a neutral and self-effacing stance, he makes his forms express deeply felt emotion.

Almost immediately following his 1879 rack painting (fig. 194) Peto began to simplify his design and eliminate the fussy accumulation of forms. At least two pictures in this series date from 1880, *The Rack* (Arizona State University, Tempe; fig. 228) and *Rack Picture with Telegraph, Letter and Postcards* (fig. 201). In both, the tapes now fill more of the canvas, and the tight multiple crossings of his first work give way to a much reduced number of squares. Peto must have been at work more or less concurrently on these examples, for he completed and dated both in November 1880. Various floral cards and a folded paper ambiguously headlined "Legal Intel [ligence]" fill *The Rack*, while a folded copy of the *Telegraph*, dated 27 October 1880, dominates the center of the second canvas, set off by a pair of printed cards and two pieces of mail. Typical of these earlier works in the series are the pink tapes and the relatively light-grained wood background.

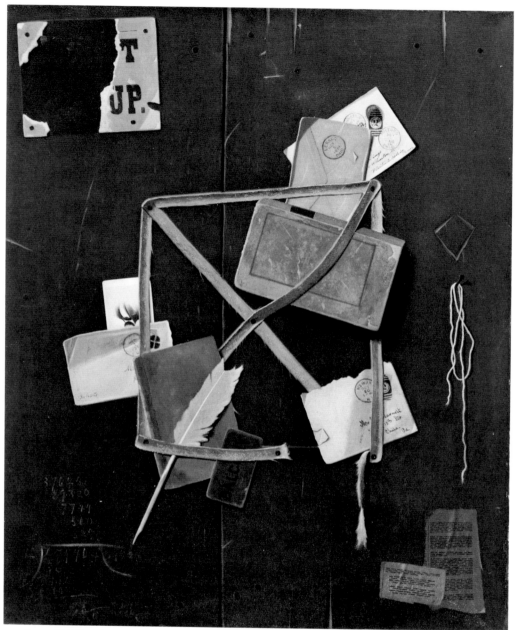

210. Peto. *Old Time Letter Rack*, 1894.

Obviously caught up in the challenge of abstraction, especially in the contrast of lines, rectangles, and colors with each other, Peto started right in on two new rack paintings the next year. One, known as *Old Souvenirs* (Metropolitan Museum of Art; fig. 226), must have engaged his attention on and off for several years. Originally dated 1881 (with an added false Harnett signature), it bears a postcard datable to 1887, and x-rays have shown that the photograph of the artist's daughter in the upper left was painted over an earlier image, probably around 1900.[24] It is the same photograph which appears in his dated still life

of the next year (fig. 170) showing Helen at about the age of seven. Very similar in organization and in better condition is *Office Board for Christian Faser* (fig. 202). Repeated from its predecessors are such elements as the floral decorated card, the coal company advertisement now bearing the name of Benson, the *Public Ledger Almanac* now dated 1881, and the provocative orange envelope labeled "Important Information Inside."

The painting takes its title and origin from Christian Faser, the dealer in frames and mirrors on Arch Street in Philadelphia who commissioned it. An envelope with his firm's label sits at the center of the design; above it is placed a mounted oval photograph probably of Faser, his face partly obscured. The card with the floral border, an ordinary greeting card, is one that Peto kept at hand and that still exists today (figs. 203 and 204). Interestingly, Peto did not care to paint the printed message, delighting most in the colorful pattern of the background. He also had an assortment of business and advertising cards, each with its distinctive typography and layout. His own calling card (fig. 205) is a reminder of how such fragments were both literally informative and visually arresting. Like the half-visible photograph and the incomplete greeting card in *Office Board* the legend on the torn envelope holds out information for us but does not yield it fully. The name and signs and dates in Peto are usually enough to fix a work in time and place, yet they invite the viewer to contemplate secrets within. The fact is that Peto does not reveal the "Important Information Inside" (fig. 206) but forces us to see words, shapes, and colors for their non-verbal, aesthetic qualities. This concern with forms would explain two arresting aspects here: the attenuated capital I's, which can also read as the *eyes* by which we see and understand, and the arresting play of colors set up by the bright pink tape crossing the equally intense orange envelope.

The wit on several levels implied in this painting led Peto to more ribald humor in his next undertaking, the *Rack Picture for William Malcolm Bunn* (fig. 207). Begun in 1881 according to the folded *Report* visible in the picture and dated on its completion in 1882, this canvas has undergone a bit of cracking in the paint surface. Its lively details again provide tantalizing references to its principal subject. Bunn was the editor of the Philadelphia *Sunday Transcript*, and below his dashing photograph sit a copy of his paper and letters to the editor. The other caricatures at the left may possibly allude to his career as a humorist, political aspirant, and *bon vivant*, though we are left to wonder if Garibaldi McFod is real or fictional and just what the connection might be between the three profile faces aligned here.[25]

Turning his attention to other subjects, some with related pictorial issues like the patch paintings and door panel compositions, Peto briefly slacked his production of rack pictures in the mid-eighties. The concluding canvas of this series in its first run is dated 1885 (fig. 208). Most likely it was a commission from Dr. Bernard Goldberg, to whom the letters shown here are addressed. A chiropodist and Philadelphia neighbor of Peto at this time, he is probably the subject of the photograph in the composition, one typical of the portrait photographs Peto himself was then taking. The open magazine hanging below displays an illustration of Trenton High Falls. This was a view that had been often engraved in books on the American landscape, such as N. P. Willis' *American Scenery*, 1840, and William Cullen Bryant's *Picturesque America*, 1872-1874, but it was a nearby site Peto could well have seen first hand with his family.[26] The painting generally is a more serious work than those pre-

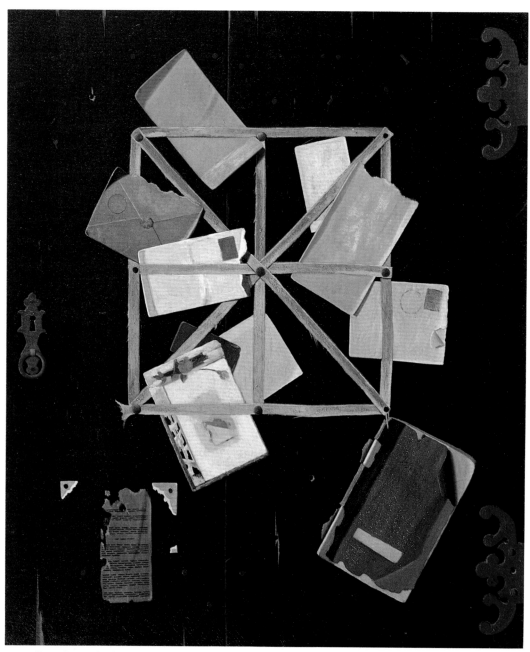

211. Peto. *Letter Rack on Black Door*, 1895.

ceding it: its tones are more muted, replacing the lighthearted accents seen earlier, and there is now greater evidence of varied brushwork, hinting at the expressive textures and increasingly tattered fragments to come. Significantly, more torn shreds of paper are visible around the edges. When Peto resumed this series in the next decade, these physical records of deterioration would carry new symbolic power.

In any case, he had reached an assured level of competence with the form, to the degree that his style now had a direct influence on his relative Thomas Hope's work. Hope's

213. Winslow Homer. *Right and Left*, 1909.

212. Albert P. Ryder. *Marine*, 1890s.

most ambitious letter rack painting (fig. 209) followed Peto's canvas for Dr. Goldberg by a year, incorporating with few changes the same elements and approach. More colorful and cluttered than any of Peto's versions, it correspondingly lacks somewhat in economy of design and suggestive feeling, though for Hope it stands as a remarkable achievement.[27] Critics took strong stands on such paintings, some praising and others condemning their realistic effects. From the outset Peto's were favorably noticed when exhibited. He contributed an early example to the exhibition of the Philadelphia Society of Artists at the Pennsylvania Academy, one the newspapers in early December 1880 termed "an unprecedented success both in attendance and sales."[28] On another occasion, date unknown but most likely in the later eighties, Peto showed several paintings at the Boston Fair, including a rack picture "which attracted great admiration and favorable comment . . . so cunningly conceived and executed as to give the impression of a bona fide rack."[29]

On other occasions, however, both Harnett and Peto were subjected to ringing critical attacks for this same verisimilitude. For instance, Harnett's *Old Violin* of 1887 was virtually deemed immoral in one description delivered as part of a sermon:

The delineation is perfect, the deception complete. And yet that picture is a specimen of the humblest function of the art of painting. It is simply a trick. . . . There is nothing whatever in the picture to please or instruct or elevate you. . . . The picture is unworthy, because its purpose is low and selfish.[30]

A critic writing in a New Orleans newspaper in 1886 took the same approach in appraising a Peto rack painting:

We do not recommend this work for its subject matter, but for its execution.
The imagination plays no part here. . . .
The artist, Mr. Peto of Philadelphia, intended this original freak of the brush for our Exposition. Unfortunately it arrived too late to take its place there, but the painter is nevertheless having his inning by exhibiting his work at Uter's. See it; it is quite curious and extremely striking in its realism.[31]

These phrases are noteworthy reminders of the American admiration for practicality, craftsmanship, and directness. With Harnett's work it is in fact possible to be convinced of

visual deception, but this is almost never really the issue with Peto. Nonetheless, viewers want to see execution as an index of success. Peto's imagination was indeed at work, but it was also elusive, secretive, and haunting. This deeper resonance of feeling has made his art seem less accessible or understandable than that of Harnett, contributing to a reputation of uncertain significance.

Whether Peto was familiar with or bothered by criticism of his rack paintings is unknown, but almost a decade passed before he took up the motif again. In this second group of about another half dozen, his style has evolved markedly. *Old Time Letter Rack*, 1894 (fig. 210) is typical of the later series as well as interesting for its history. Replacing the blond panels of works in the earlier group, the background in the later rack pictures is usually a very dark green or brown approaching impenetrable black. Now only one square with crossed tapes occupies the center, with evidence of fraying and tearing much more common. Fewer explicit references to specific individuals are present, suggesting Peto cared less about commissions for personalized office boards and more about abstract questions of design and expressive force. Despite the Lerado, Ohio, postmark on the upper envelope tying this picture to the home of Peto's in-laws, the address on the envelope below was later partly forged to include Harnett's name. An additional false Harnett signature at the bottom clinched the painting's temporary reattribution, which it retained when it came as a gift to the Museum of Modern Art. [32] In 1947 the museum's conservation staff confirmed these alterations, now seen to be inconsistent with internal details of fact and style. Especially intriguing is the upended photograph at the left, the face of its sitter cropped in the familiar Peto manner. But the visible beard and turn of the torso also unmistakably suggest the Lincoln image, here victimized again by an accident of design.

The following year, 1895, Peto completed a related composition, *Letter Rack on Black Door* (fig. 211), which appears at once finished and unfinished. On the one hand the total design seems compact and balanced. Most of the letter fragments cohere in a pinwheel pattern around the center, and the pale lavender tapes, though frayed, make a full square, now crossed diagonally and vertically. On the other hand, with the exception of one decorative floral edge, all these envelopes, cards, and pages have almost no interior detailing. Peto only blocks in the small panels where a legend or stamp would appear, otherwise leaving the larger rectangles without addresses or writing. What is left is sufficient: a wonderfully subtle harmony of pure color blocks, made up of three patches of green, trilogies of blues and of whites, and a remaining trio of pink, yellow, and orange. The blue pamphlet hanging at the lower right is a veteran from other arrangements, while the orange envelope previously proclaimed "Important Information Inside" (see figs. 122 and 202). Yet the painting is complete in the sense of being fully resolved, hence signed and dated at the bottom. It marks how far Peto had moved from his more literary and anecdotal beginnings and his earlier more descriptive approach to subject matter. While this image remains recognizably a letter rack, its effectiveness is unrelated to accuracy of record. Its beauty in fact forces us to enjoy color and form and texture in ways that were quite unusual and modern for their time.

There are useful parallels to be drawn with some of Peto's contemporaries, among them Albert P. Ryder (1847-1914), whose intimate moonlight marines (fig. 212) also evoke a private contemplative world. Like Peto's paintings, they derive their power from the im-

214. Piet Mondrian. *Diamond Painting in Red, Yellow, and Blue*, c. 1925.

215. Betty Hahn. *Chicago Family: Grandmother*, 1979.

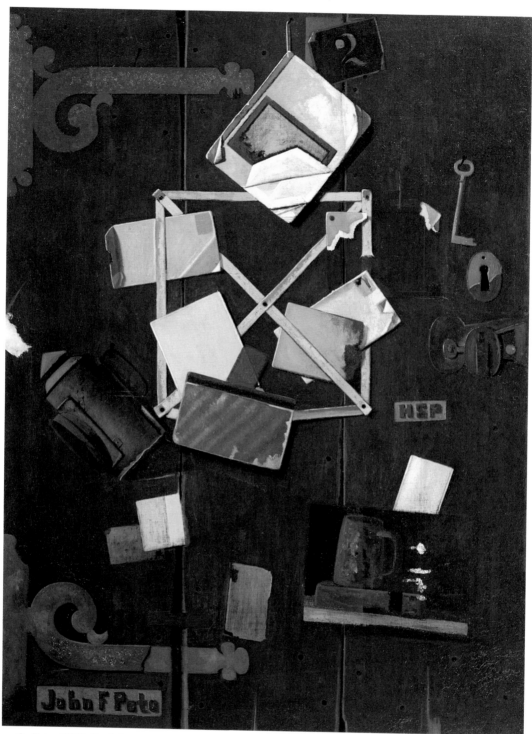

216. Peto. *HSP's Rack Picture*, c. 1900.

pulses toward abstraction and generalization of form, color exploited for nondescriptive functions, and patterns based on the seen things of this world but transformed into independent musical rhythms. More of a visionary than Peto, Ryder pursued a similarly reclusive course, and his generally small canvases, often repainted over the years, present an intimate, hermetic world. Like Peto, Ryder moved beyond observation of the immediate with a poet's sense for the symbolic and subjective. Whether landscape or still life, these works represent distillations of thought and ultimately elevate their subjects beyond the moment.

Comparison with the supreme American realist, Winslow Homer (1836-1910), may initially seem tenuous, yet in some of his last canvases we can find issues of form and content not very distant from Peto's art at the turn of the century. Also drawing a mantle of seclusion about himself on the coast of Maine, Homer painted the forces of nature as he daily saw them before him. But in his later works his vision gained in symbolic power. *Right and Left*, 1909 (fig. 213), is nominally a landscape subject with elements of genre in the men distantly seen shooting at the birds before us. But because of the obscuring of the horizon and consequent flattening of the space, the silhouetted figures of the two ducks seem fixed against the planes of color behind. These animated yet simplified shapes and the broad anonymous expanse of sea create an effect of turning the landscape into a large-scale still life. Although drawn from the observed natural world, Homer's theme takes on a transcendent grandeur as we realize we are witness to a moment of mortality in balance. Supposedly each shot from the gun will take the pair sequentially, though as one bird rises while the other plunges, we in fact cannot tell which has been hit. We are present at that sublime moment between life and death, when they face each other, an instant of tension and equilibrium at the same time. Thus the great disturbing power of this image is its ability to transcend ordinary experience to yield profound human meaning. What merits drawing links to Peto are its concerns with expressive design and the gravity of our mortal passage.

Peto's most thoughtful art of this period has analogies as well with some of the major currents in American literature. Henry James in his short biography of Nathaniel Hawthorne touched on the changes in mood and outlook which he felt marked American life after the Civil War.[33] In 1904 James returned from an expatriate period abroad to record his impressions of the country. Over several months he toured the places of his past, often disturbed by the evidence of decay he noticed, especially in the cities. Having written his observations in the same years as Peto's last somber still lifes, James published *The American Scene* in 1907. Though treating a different subject, his description of the streets in lower Manhattan uses phrases we would find applicable to Peto's disheveled racks:

confusion carried to chaos . . . a welter of objects and sounds . . . the interesting, appealing, touching vision of waste.[34]

Visiting Richmond, Virginia, James saw the legacy of the Civil War, "the collapse of the old order,"

only echoes—daubs of portraiture, scrawls of memoranda, old vulgar newspapers, old rude uniforms, old unutterable "mid-Victorian" odds and ends of furniture, all ghosts as of things noted at a country fair.[35]

Just a year or two before in 1905, another figure central to this age was summarizing his

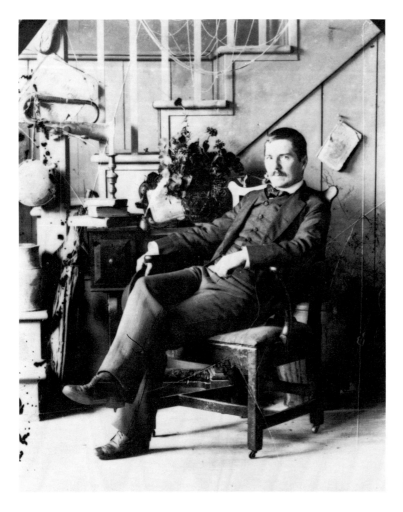

217. Peto in his studio at
Island Heights, 1890s.

awareness of modern complexity and disequilibrium. Henry Adams was a historian conscious of his family's shift of power from politics to art. In *The Education of Henry Adams*
he treated the self as an object and so equated autobiography with art, just as Peto made his
still lifes a projection of himself. Contemplating the past, sometimes nostalgically, brooding
on loss, worrying about mortality, seeing art as holding a clue to harmony and order, giving
factuality poetic form—Adams shared these acts with Peto. And with both men the preoccupation with disorder and death increased toward the end of life.[36]

Like Peto, Adams drew a line from Lincoln's assassination to the unraveling of affairs
in his own time: "he saw before him a world so changed as to be beyond connection with the
past . . . his life was once more broken into separate pieces."[37] Adams also had on his mind
the imminence of a new energy and of chaos. What unsettled him and his generation in
1900 was the sense of an age beginning defined only by mystery, chance, and tension.

Man had translated himself into a new universe which had no scale of measurement with the old. . . . Satisfied
that the sequence of men led to nothing and that the sequence of their society could lead no further, while the
mere sequence of time was artificial, and the sequence of thought was chaos, he turned at last to the sequence of
force.[38]

218. Thomas Eakins. *Portrait of a Lady with a Setter Dog (Mrs. Eakins)*, 1885.
219. William Merritt Chase. *A Friendly Call*, 1895 *(below)*.

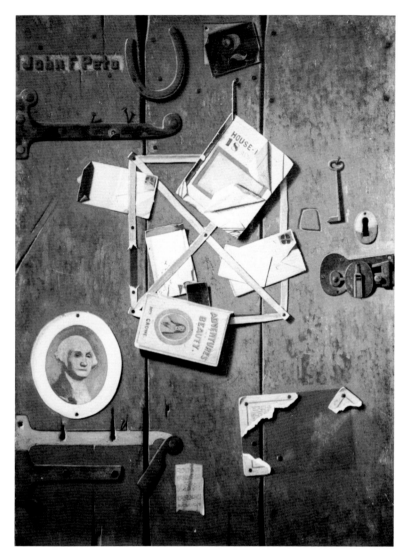

223. Peto. A *Closet Door*, 1904/1906.

These intimations of collapsing order are the modern marks as well in Peto's culminating years. His concern with the assaults on basic colors and geometries makes the squares and rectangles of his office boards a map of his cultural terrain. More than one critic has drawn a comparison between Peto's designs and the abstractions of Piet Mondrian (1872-1944) later in the twentieth century (fig. 214). The analogy is one of both form and meaning. We know how Mondrian's early views of the Dutch countryside and seashore systematically evolved through a cubist-influenced period to his mathematical and philosophical compositions of the 1930s onward. In purely formal terms these works are examinations, like Peto's, of balanced designs on flat planes. But we ought not detach them entirely from Mondrian's native landscape and period of work. Even though he relentlessly pursued the resolution of fundamental relationships—horizontal and vertical, line and plane, the three primary colors and neutral black and white—as a purely aesthetic problem, his painted planes remain distillations of nature. After all, a Dutch artist would retain a deep

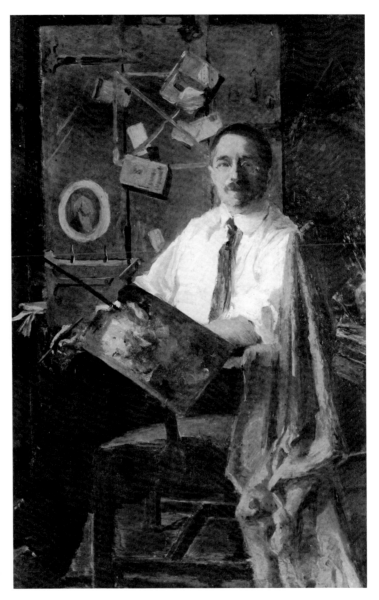

220. Peto. *Self Portrait with Rack Picture*, 1904.

consciousness of his flat Lowlands, punctuated by spires and trees, an orderly countryside subdivided by crossing canals, a compact geography making maximum use of its available surface. For an artist, too, whose nation was being overrun by a foreign army, and whose life outwardly was being disrupted by crisis, it would be natural to find harmony and clarity within the realm of art. When Henry Adams asserted that "Chaos was the law of nature; Order was the dream of man,"[39] he was speaking of a modern world as unsettling for Peto's generation as for Mondrian's.

If the abstract compositions of Mondrian represent one line of descent from Peto's vision, another is suggested by the overt subject matter of Betty Hahn (born 1940). A photographer now teaching at the University of New Mexico, she has pursued experimentation

with a mixture of contemporary and turn-of-the century techniques, using Polaroid and revived gum bichromate processes. *Chicago Family: Grandmother* (fig. 215) pays admitted homage to Peto's rack series, though it is more self-conscious in its nostalgia.[40] Within the familiar format are contained old album photographs, three-cent letters postmarked 1956, a copy of the old New York *Daily Tribune* from 1911, and gathered memorabilia dating from well before the work's execution in 1979. Not least, this assemblage stands as interesting testimony to the renewed appeal Peto has for modern eyes.

Peto continued to paint rack pictures into his final years. The last ones hint of both tragic grandeur and of dissolution. The kidney stones which gave him constant pain were presumed in his day to be fatal, and he lived with forebodings of premature death. At the same time the family lawsuit in New York dragged on and on, distracting him in a different way. Though undated, *HSP's Rack Picture* (fig. 216) bears a large block-letter signature typical of works from around 1900 and after.[41] It is one of Peto's larger paintings, and the biggest in the rack series, though there is a sense of ambition outstripped by exhaustion here. The initials *HSP* refer to his daughter, Helen Serrill Peto, whose middle name came from an Island Heights neighbor and protégée. Included are other familiar elements from the past: a hanging lantern, keylatch, and small oil sketch of a book and mug (see figs. 142 through 144). Given new prominence now are the large wrought iron hinges at the left corners, details introduced unobtrusively in *Letter Rack on Black Door* (fig. 211). Their rough texture and curving silhouettes lend an animating contrast to the multiple paper rectangles elsewhere. But despite its impressive scale and the attractiveness of certain details, the canvas has a somewhat drained quality, perhaps exemplified in the pale, flat colors. Peto seems to have relied more on repetition than invention, to have created a work more from unreplenished than fresh reserves.

Nonetheless, even in this late piece Peto has kept us resolutely centered in the stimulating environment of his studio, where his walls and tables had repeatedly become separate panels of art. It is altogether fitting that among his last dated works should be a rare painted self-portrait, which brings us to some concluding thoughts about the artist in his studio (figs. 217 through 220). Peto was obviously comfortable in his house with its living and working quarters inseparable. Seated at the bottom of the stairs in the living room of the Island Heights house (fig. 217), he is truly at home with the items about that he at once took for granted and made into art. He posed often for photographs like this, records of his domestic landscape and ultimately sources for details in his paintings (fig. 220).

Such a pose and view were fairly common subjects for later nineteenth-century painting, and American artists of diverse styles took up variations. Thomas Eakins comes first to mind in his many depictions of family members, most particularly his touching *Portrait of a Lady with a Setter Dog (Mrs. Eakins)*, 1885 (fig. 218). This picture gives a saddened but self-accepting image of the artist's wife, surrounded by the family dog at her feet and studies for other works on the walls nearby. The oblique angle of the rug, open glances of the two faces, and casual balancing of details suggest an intimacy, directness, and grace appropriate for a canvas in and of the artist's studio. Quite different from the psychological presence and objective realism of Eakins' manner is the impressionist touch of William Merritt Chase's *A Friendly Call* (fig. 219). More at home in international circles and fluent in the plein-air

modes of French painting, Chase (1849-1916) was equally attracted to the imagery of quiet contemplation in the studio. Here he shows his wife, fashionably attired, in genial conversation with a caller in his sunny Shinnecock, New York, quarters. His light colors, luminous brushwork, and touches of *japonisme* recall the world of Whistler or the other American impressionists. And the genteel flavor of this anecdotal conversation piece is far removed from Peto's silent, shadowy companions of the shelf. Yet Chase's intricate concern with the play of planar versus spatial elements, his musical rhythms of rectangles throughout, his use of the mirror to fuse ambiguously inside and out, all contrive to return our attention to the sheer joys of artifice. In describing the studio interior, Chase in his way celebrates its physical as well as spiritual contents.

These contemporaneous examples set a context for Peto's last self-image (fig. 220), delineating for a final time his place within and apart from his period. Looser in handling than most of his previous works, the self-portrait in fact has a quasi-impressionist touch. This quality may be due as much to diminished artistic strength during his last years as to a fresh, improvisatory sense of setting his own person onto canvas. Much as Henry Adams had put himself into the third person in his *Education*, so Peto transcribes his figure into a still-life object. Behind him is visible a letter rack painting known as A *Closet Door* (fig. 223), dated by Frankenstein to 1906, but obviously near completion at the time of this canvas in 1904. For the first time in a rack arrangement Peto incorporated an oval portrait of George Washington, another famous father figure in American life. Instead of the usual *Public Ledger Almanac* previously used, at the center is a pamphlet which is titled in the actual rack painting, "Adventures in Beauty." Without knowing exactly Peto's intentions, one can still appreciate how such references to an enduring reputation and the pleasures of art would have been relevant for him.

In terms of design it is worth observing that Peto has deftly balanced the size of his face with that of the oval image of Washington, and the shape of his palette with that of square tapes in the painting behind. As always, he and his work are one. Facing us with self-assurance and poise, the artist holds his palette close to the center of this composition. To his side a vivid red cloth descends from the chair back to the floor, as if an assertion of pure color and bravura of paint texture alone. Not a large canvas in actuality, it is more than a miniature obviously, but its measurements of some twenty by twelve inches are those consistent with his most common still lifes. A painting of himself, it situates the artist at the juncture between his raw palette and his created canvas. Also a painting about art, it incorporates three levels of imagery—the canvas itself, and within it the rack picture, and within that the Washington oval—all joined by Peto's head and hands, poised to act in their adventure together.

Notes

1. I am much indebted for personal family information to the artist's granddaughter, Blossom S. Bejarano, Greenwich, Connecticut; correspondence with the author, 1 June 1981 and 10 August 1981. Evidently Peto started his daughter drawing by letting her use some of his own sketchbooks, two of which still remain in the family's possession. Although Helen had a natural lyric voice, she concentrated her study at the Philadelphia Conservatory on the cello. The family recalls that she "was often late and would almost miss her train for Philadelphia, and being petite at only five, she was barely as big as her cello, and made quite a sight running down the hill. It amused the engineer so much, he held the train for her before backing it across the river on the spur onto the main line of the old Jersey Central."

Mrs. Bejarano adds that "living near the water, Helen became a good sailor, something she never forgot, so that at seventy-six she grabbed the helm, and took the younger members of the family sailing." Letter to the author, 10 August 1981.

2. Details from Peto's granddaughter, Blossom S. Bejarano, in correspondence with the author, 1 June 1981. See also Chapter 1, especially footnote 5. The phrase "legal intel[ligence]," which appears on at least one occasion in Peto's work (see fig. 238), could well refer to the family lawsuit.

3. Alfred Frankenstein, *After the Hunt: William Harnett and Other American Still Life Painters*, 1870-1900, rev. ed. (Berkeley and Los Angeles, 1969), 107.

4. For example, see Gysbrechts' *Vanitas* (Ferens Art Gallery, Kingston upon Hull, England), and *Painter's Easel* (National Museum of Art, Copenhagen), reproduced in Celestine Dars, *Images of Deception* (New York, 1979), 33, 37; and *Turned-Over Canvas* (National Museum of Art, Copenhagen), reproduced in M. L. d'Otrange Mastai, *Illusion in Art* (New York, 1975), 163.

5. See Frankenstein, *After the Hunt* (1969), xiii.

6. Roy Lichtenstein, in conversation with the author, 31 July 1981. See also Jack Cowart, *Roy Lichtenstein*, 1970-1980 (New York, 1981), 58-61.

7. Howard Mumford Jones, *The Age of Energy: Varieties of American Experience*, 1865-1915 (New York, 1971), 105; see also 358-388.

8. From an undated newspaper clipping in the Peto family albums, The Studio, Island Heights, New Jersey. The article goes on to take note of Peto's painting of a plucked chicken (fig. 82) and some of his other subjects:

> Another handsome oil painting represents a rooster hanging on an old door, the chicken has
> been picked and presents a very natural appearance. He has many other beautiful paintings in
> realistic art representing book, fruit and hunters, studies which we have no room to describe.

It should also be recorded here that one of Peto's rack pictures with a Lincoln engraving, *Old Reminiscences*, 1900 (Phillips Collection, Washington, D.C.; fig. 230), was at one point repainted so that an address on a letter would read "Mr. W. Harnett," and thus be attributed to him. In keeping with Peto's interpretation of the Lincoln mythology, another envelope nearby bears only the word "Proprietor." Yet another Lincoln rack painting, *Jack of Hearts*, 1902 (Des Moines Art Center; fig. 232), displays a hanging booklet with a partly obscured title of "HOUSE KEEP[ER]."

9. See Jones, *Age of Energy*, 100.

10. For a discussion of the different images of guns, in relationship to masculinity, animal hunting, fighting the Indians, opening the frontier, and the romantic militarism after the Civil War, see Roxanna Barry, *Plane Truths: American Trompe l'Oeil Painting* [exh. cat., The Katonah Gallery] (Katonah, New York, 1980), unpaginated. On the chivalric and martial cults ascendant in the later nineteenth century, see T. J. Jackson Lears, *No Place of Grace: Antimodernism and the Transformation of American Culture*, 1880-1920 (New York, 1981), esp. 98-102. See also Jones, *Age of Energy*, 102.

11. Stephen Crane, *The Red Badge of Courage*, in *The Portable Stephen Crane*, ed. Joseph Katz (New York, 1969), 238; see also Katz, introduction, xiv-xv.

12. Walt Whitman, *Specimen Days* (Boston, 1971), 120.

13. Whitman, *Specimen Days*, 41.

14. Alfred Kazin, introduction to Whitman, *Specimen Days*, xx.

15. See Ingvar Bergstrom, *Dutch Still-Life Painting in the Seventeenth Century* (London, 1956), 154. For related information thanks also to Blossom S. Bejarano.

16. For documentation on the several treatments of the house of cards see Pierre Rosenberg, *Chardin*, 1699-1779 [exh. cat., The Cleveland Museum of Art] (Cleveland, Ohio, 1979), 218-221, 231-233, 236-237. For

illustrations of eighteenth-century playing cards, especially of jacks and knaves, in France and central Europe, see Detlef Hoffman, et al., *Spielkarten: ihre Kunst und Geschichte in Mitteleuropa* [exh. cat., Graphische Sammlung Albertina] (Vienna, 1974), 72. In addition, I am grateful to Jo Ann Ganz for discussion of the Lincoln rack pictures.

17. On this aspect of cubism especially see Robert Rosenblum, "Picasso and the Typography of Cubism," in *Picasso in Retrospect*, eds. Sir Roland Penrose and John Golding (New York, 1973), 75.

18. See Frankenstein's summary of the characteristics and patrons of Peto's rack paintings in *After the Hunt* (1969), 103-104, and 107-109.

19. Harnett's painting *The Artist's Letter Rack* is now in the Metropolitan Museum of Art. For discussion of its contents and chronology, see Frankenstein, *After the Hunt* (1969), 51-53; and Doreen Bolger Burke, *American Paintings in the Metropolitan Museum of Art*, vol. 3: *A Catalogue of Works by Artists Born between 1846 and 1864* (New York, 1980), 50-53.

20. See Dars, *Images of Deception*, 9-10, 33-38.

21. Dars, *Images of Deception*, 7.

22. See Jones, *Age of Energy*, 181.

23. Frankenstein, *After the Hunt* (1969), 52.

24. See Burke, *American Paintings in the Metropolitan Museum*, 170-171.

25. For details on W. M. Bunn see Frankenstein, *After the Hunt* (1969), 103-104.

26. For details on this canvas see Burke, *American Paintings in the Metropolitan Museum*, 172. My thanks to Jeremy Adamson for assistance in identifying the illustrated view. See especially the engraving *Trenton High Falls* by William Bartlett in N. P. Willis, *American Scenery* (London, 1840), 156.

27. A smaller, more modest rack picture with photograph, letters, and decorated cards is in the collection of the Shelburne Museum, Shelburne, Vermont. Though unsigned, it bears all the hallmarks of Hope working after Peto's example. It even includes the characteristic verbal pun: the envelopes are addressed to Miss Imogene See, which, when abbreviated to I. See, recalls Peto's references to perception.

28. "Upward of eighty works have been disposed of [including] Office Rack, by John F. Peto." Newspaper clippings, one marked *Record*, 3 December 1880, and the other just dated 1 December 1880, in the Peto family albums, The Studio, Island Heights, New Jersey.

29. From an unidentified and undated clipping in the family albums, The Studio, Island Heights, New Jersey; it reads in full:

PREMIUM PICTURE

Among the many very handsome and attractive paintings at the Boston Fair last week was the collection of John F. Peto, a skilled artist, whose home is in Lerado. The particular picture in this collection which attracted great admiration and favorable comment, was that of an antique card rack, containing a copy of the Clermont Courier, a clay pipe and a letter or two, superscribed in clear business chirography and embellished with post mark, stamp and cancelling mark—complete and perfect as if they had just been handed through the post-office delivery. All of these articles were so cunningly conceived and executed as to give the impression of a bona fide rack containing the things mentioned in the original form. The copy of the Courier, which was the most conspicuous object in the display, was a perfect photograph of the paper, and was complete in every detail. The entire collection was greatly admired and the card rack picture was given first premium.

30. Quoted in Frankenstein, *After the Hunt* (1969), ix.

31. L. Placide Canonge in *L'Abeille de la Nouvelle-Orleans*, 30 May 1886, quoted in Frankenstein, *After the Hunt* (1969), 102-103.

32. Frankenstein details his uncovering of real and falsified Harnetts in his opening chapter, "The Problem and Its Solution," in *After the Hunt* (1969), 3-24. Another undated rack picture definitely from this period, *Letter Rack on Panel of Boards* (Kennedy Galleries, New York), has virtually no signage or outside references in it at all. Each of its letters is torn, the tape is ripped and sagging, and an unfinished oval sits to the right, probably awaiting the filling in of the Lincoln torso.

33. See the discussion of this in Chapter 2 above.

34. Henry James, *The American Scene* (Bloomington, Indiana, and London, 1968), 83, 158.

35. James, *The American Scene*, 386.

36. A useful study of Adams' intellect and ideas is J. C. Levenson, *The Mind and Art of Henry Adams* (Stanford, California, 1957).

37. Henry Adams, *The Education of Henry Adams* (Boston, 1961), 209.

38. Adams, *Education*, 381-382.

39. Adams, *Education*, 451.

40. "What I find particularly attractive about Peto is his use of paper and printed material in his racks. I know there were other Americans and some Flemish painters who included graphic arts but Peto's always struck me as being more mysterious and provocative." Letter from Betty Hahn to the author, 19 June 1981.

41. Most especially this compares with *A Closet Door*, 1904-1906 (fig. 223), which is also visible in the background of Peto's *Self Portrait with Rack Picture*, 1904 (fig. 220). In *A Closet Door* the same block-letter signature appears in the upper left.

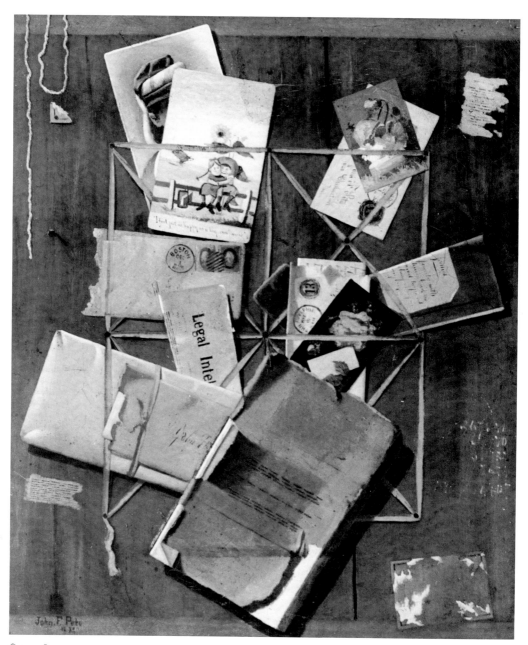

fig. 228

Works by Peto in Public Collections

ARIZONA

Arizona State University, Tempe
The Rack, 1880
Oil on canvas
24 x 20 in. (61 x 50.8 cm.)
Gift of Oliver B. James
(fig. 228)

CALIFORNIA

The Fine Arts Museums of San Francisco
Candle and Books, c. 1900
Oil on canvas
22¼ x 29¼ in. (56.5 x 74.3 cm.)
(fig. 104)

The Cup We All Race 4, c. 1900
Oil on canvas and wood
25½ x 21½ in. (64.8 x 54.6 cm.) .
Gift of Mr. and Mrs. John D. Rockefeller 3rd
(fig. 153)

Job Lot Cheap, after 1900
Oil on canvas
38¼ x 29¾ in. (97.2 x 75.6 cm.)
Gift of Mr. and Mrs. John D. Rockefeller 3rd
(fig. 119)

Virginia Steele Scott Foundation, Pasadena
A *Full Shelf*, May 1891
Oil on canvas
20 x 24 in. (50.8 x 61 cm.)
(fig. 105)

The Santa Barbara Museum of Art, Santa Barbara
Things to Adore: My Studio Door, 1890s
Oil on canvas
49½ x 29⅜ in. (125.7 x 74.6 cm.)
Preston Morton Collection
(fig. 143)

CONNECTICUT

The New Britain Museum of American Art, New Britain
Lincoln and the Phleger Stretcher, c. 1900
Oil on canvas
10 x 14 in. (25.4 x 35.6 cm.)
(fig. 177)

Wadsworth Atheneum, Hartford
Reminiscences of 1865, 1897
Oil on canvas
30 x 22 in. (76.2 x 55.9 cm.)
Ella Gallup Sumner and Mary Catlin Sumner Collection
(fig. 174)

Yale University Art Gallery, New Haven
Nine Books, c. 1900
Oil on academy board
6⅛ x 9³⁄₁₆ in. (15.6 x 23.3 cm.)
Gift of Mr. and Mrs. Charles F. Montgomery
(fig. 109)

DISTRICT OF COLUMBIA

Hirshhorn Museum and Sculpture Garden, Smithsonian Institution, Washington

Mug, Book, Pipe, Matchstick and Biscuit on a Brown Ledge, c. 1887
Oil on academy board
5¾ x 8¾ in. (14.6 x 22.2 cm.)
(fig. 229)

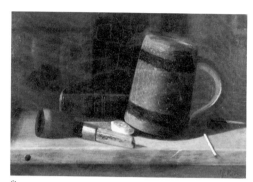

fig. 229

Mug, Pipe and Match, c. 1887
Oil on academy board
6 x 9 in. (15.2 x 22.9 cm.)
(fig. 44)

National Gallery of Art, Washington

The Old Violin, c. 1890
Oil on canvas
30⅜ x 22⅞ in. (77.2 x 58.1 cm.)
Gift of the Avalon Foundation 1974
(fig. 132)

National Museum of American Art (formerly National Collection of Fine Arts), **Smithsonian Institution, Washington**

Rack Picture for William Malcolm Bunn, 1882
Oil on canvas
24 x 20 in. (61 x 50.8 cm.)
Gift of Nathaly Baum in Memory of Harry Baum
(fig. 207)

The Phillips Collection, Washington

Old Reminiscences, 1900
Oil on canvas
30 x 25 in. (76.2 x 63.5 cm.)
(fig. 230)

fig. 230

FLORIDA

Museum of Fine Arts, St. Petersburg

Evening at Home, 1882 (?)
Oil on academy board
6 x 9 in. (15.2 x 22.9 cm.)
(fig. 231)

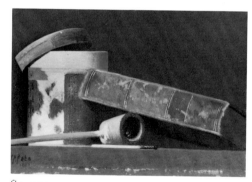

fig. 231

GEORGIA

High Museum of Art, Atlanta

Jug, Books and Candle on a Cupboard Shelf, probably 1890s
Oil on canvas
30 x 22 in. (76.2 x 55.9 cm.)
Gift of Julie and Arthur Montgomery 1980
(fig. 103)

ILLINOIS
The Art Institute of Chicago
Lights of Other Days, 1906
Oil on canvas
30½ x 45¼ in. (77.5 x 114.9 cm.)
Goodman Fund
(fig. 126)

IOWA
Des Moines Art Center, Des Moines
Rack Painting with Jack of Hearts, 1902
Oil on canvas
40 x 30½ in. (101.6 x 77.5 cm.)
(fig. 232)

fig. 232

MARYLAND
**Washington County Museum of Fine Arts,
Hagerstown**
Brass Kettle and Candlestick, probably
1890s
Oil on canvas
16 x 10 in. (40.6 x 25.4 cm.)
(fig. 64)

MASSACHUSETTS
**The Addison Gallery of American Art,
Phillips Academy, Andover**
Office Board for Smith Bros. Coal Co., 1879
Oil on canvas
24 x 28¼ in. (61 x 71.8 cm.)
(fig. 194)

Deerfield Academy, Deerfield
Still Life on a Palette, c. 1890
Oil on palette
13¼ x 9⅛ in. (33.7 x 23.2 cm.)
Charles P. Russell Collection
(fig. 148)

Museum of Fine Arts, Boston
Old Time Letter Rack, 1894
Oil on canvas
30 x 25 in. (76.2 x 63.5 cm.)
Bequest of Maxim Karolik
(fig. 184)

The Poor Man's Store, 1885
Oil on canvas and wood
36 x 25½ in. (91.4 x 64.8 cm.)
M. and M. Karolik Collection
(fig. 86)

Pots and Pans, c. 1880
Oil on canvas
22 x 16 in. (55.9 x 40.6 cm.)
Bequest of Maxim Karolik
(fig. 62)

Student's Materials, c. 1890-1900
Oil on canvas
20¼ x 16¼ in. (51.4 x 41.2 cm.)
Bequest of Maxim Karolik
(fig. 233)

fig. 233

Smith College Museum of Art, North-ampton
Discarded Treasures, c. 1904
Oil on canvas
22 x 40 in. (55.9 x 101.6 cm.)
(fig. 117)

Williams College Museum of Art, Wil-liamstown
Pipe and Church Sconce, c. 1890
Oil on canvas
20 x 12 in. (50.8 x 30.5 cm.)
(fig. 152)

MICHIGAN

The Detroit Institute of Arts, Detroit
After Night's Study, 1880s
Oil on canvas
14½ x 20 in. (36.8 x 50.8 cm.)
Gift of Robert H. Tannahill
(fig. 234)

fig. 234

MINNESOTA

The Minneapolis Institute of Arts, Min-neapolis
Reminiscences of 1865, after 1900
Oil on canvas
30 x 20 in. (76.2 x 50.8 cm.)
The Julia B. Bigelow Fund
(fig. 182)

NEW JERSEY

Montclair Art Museum, Montclair
Pipe, Mug, Book and Candlestick, probably
1880s
Oil on canvas
12 x 10 in. (30.5 x 25.4 cm.)
(fig. 235)

fig. 235

Newark Museum, Newark
Books and Ink Bottle, probably 1880s
Oil on academy board
6 x 9 in. (15.2 x 22.9 cm.)
Dr. Donald M. Dougall Bequest 1954
(fig. 236)

fig. 236

Inkwell and Bills, probably 1890s
Oil on academy board
4¼ x 6½ in. (10.8 x 16.5 cm.)
Dr. Donald M. Dougall Bequest 1954
(fig. 237)

fig. 237

Wine Bottle, Raisins and Box, 1894
Oil on academy board
6 x 9 in. (15.2 x 22.9 cm.)
Dr. Donald M. Dougall Bequest 1954
(fig. 67)

Hanging Grapes, 1902
Oil on academy board
8¾ x 5¾ in. (22.2 x 14.6 cm.)
Dr. Donald M. Dougall Bequest 1954
(fig. 81)

Still Life with Lard Oil Lamp, 1900s
Oil on canvas
14⅛ x 24⅛ in. (35.9 x 61.3 cm.)
Dr. Donald M. Dougall Bequest 1954
(fig. 124)

**New Jersey State Museum Collection,
 Trenton**
Miniature Still Life, possible 1890s
Oil on academy board
3⅛ x 5¼ in. (7.9 x 13.3 cm.)
Gift of Mr. and Mrs. Robert F. Stein 1963
(fig. 58)

Battered Pot, probably 1890s
Oil on academy board
6 x 9⅛ in. (15.2 x 23.2 cm.)
Museum Purchase 1963
(fig. 65)

Joseph Westray, probably 1890s
Oil on canvas
20 x 14⅛ in. (50.8 x 35.9 cm.)
Gift of Julius Garfield
(fig. 113)

The Ocean County Democrat, 1889 (?)
Oil on canvas
24 x 20 in. (61 x 50.8 cm.)
Gift of Mrs. Mary G. Roebling
(fig. 161)

NEW YORK
 The Brooklyn Museum, Brooklyn
Door with Lanterns, late 1880s
Oil on canvas
50 x 30 in. (127 x 76.2 cm.)
Dick S. Ramsay Fund
(fig. 238)

fig. 238

The Hyde Collection, Glens Falls
Mug, Pipe, and Book, 1880
Oil on academy board
8 x 10 in. (20.3 x 25.4 cm.)
(fig. 239)

fig. 239

Memorial Art Gallery of the University of Rochester, Rochester
Articles Hung on a Door, late 1880s
Oil on canvas
30 x 21¾ in. (76.2 x 55.3 cm.)
Marion Stratton Gould Fund
(fig. 240)

fig. 240

The Metropolitan Museum of Art, New York
Old Souvenirs, 1881/1900
Oil on canvas
26¾ x 22 in. (67.9 x 55.9 cm.)
Bequest of Oliver Burr Jennings 1968
(fig. 226)

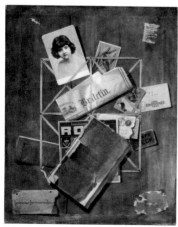

fig. 226

Office Board, April 1885
Oil on canvas
24⅜ x 19⅞ in. (61.9 x 50.5 cm.)
George A. Hearn Fund 1955
(fig. 208)

The Old Cremona, probably 1893
Oil on canvas
16 x 12 in. (40.6 x 30.5 cm.)
Harris Brisbane Dick Fund 1939
(fig. 241)

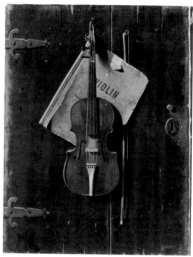

fig. 241

Munson-Williams-Proctor Institute, Utica
Fish House Door with Eel Basket, 1890s
Oil on canvas
60 x 43 in. (152.4 x 109.2 cm.)
(fig. 141)

The Museum of Modern Art, New York
Old Time Letter Rack, 1894
Oil on canvas
30 x 25⅛ in. (76.2 x 63.8 cm.)
Gift of Nelson A. Rockefeller 1940
(fig. 210)

OHIO
The Butler Institute of American Art, Youngstown
Books, Mug, Candlesticks and Pipe, probably 1880s
Oil on canvas
12 x 16 in. (30.5 x 40.6 cm.)
(fig. 242)

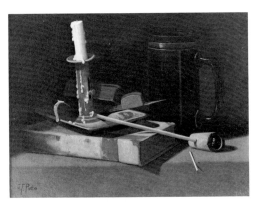

fig. 242

The Cleveland Museum of Art, Cleveland
Card Rack with Jack of Hearts, c. 1900
Oil on canvas
30 x 25 in. (76.2 x 63.5 cm.)
Purchase from the J. H. Wade Fund
(fig. 189)

PENNSYLVANIA
Brandywine River Museum, Chadds Ford
Five Dollar Bill, c. 1885
Oil on canvas
10¼ x 14 in. (26 x 35.5 cm.)
Partial gift private collection
(fig. 225)

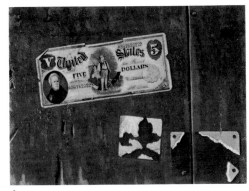

fig. 225

The Pennsylvania Academy of the Fine Arts, Philadelphia
The Fish House Door, 1890s
Oil on canvas
60 x 30 in. (152.4 x 76.2 cm.)
Collections Fund Purchase
(fig. 140)

Philadelphia Museum of Art
Umbrella, Bag and Hat, 1903
Oil on canvas
20 x 12 in. (50.8 x 30.5 cm.)
The Albert M. Greenfield and Elizabeth M. Greenfield Collection
(fig. 243)

fig. 243

Museum of Art, Carnegie Institute, Pittsburgh
Candlestick, Pipe and Tobacco Box, probably 1890s
Oil on academy board
9½ x 6½ in. (24.1 x 16.5 cm.)
The Edith H. Fisher Fund
(fig. 244)

fig. 244

RHODE ISLAND
Rhode Island School of Design, Museum of Art, Providence
Pipe and Mug, probably 1880s
Oil on academy board
7 x 9¼ in. (17.8 x 23.5 cm.)
Gift of the Museum Associates
(fig. 39)

TEXAS
Amon Carter Museum, Fort Worth
Lamps of Other Days, c. 1900
Oil on canvas
27⅛ x 36⅛ in. (68.9 x 91.8 cm.)
(fig. 32)

Dallas Museum of Fine Arts, Dallas
Fish House Door, late 1880s
Oil on canvas
30 x 22 in. (76.2 x 55.9 cm.)
Dallas Art Association Purchase
(fig. 245)

fig. 245

VERMONT
Shelburne Museum, Shelburne
Ordinary Objects in the Artist's Creative Mind, 1887
Oil on canvas
56 x 33 in. (142.2 x 83.8 cm.)
(fig. 144)

VIRGINIA
The Chrysler Museum, Norfolk
Candle, Books and Jug, probably 1890s
Oil on canvas
22¼ x 27 in. (56.5 x 68.6 cm.)
Gift of Walter P. Chrysler, Jr.
(fig. 246)

fig. 246

WISCONSIN
Milwaukee Art Center
Market Basket, Hat and Umbrella, after 1890
Oil on canvas
12 x 18 in. (30.5 x 45.7 cm.)
Layton Art Collection
(fig. 47)

PUERTO RICO
Museo de Arte de Ponce
Books on a Shelf, probably 1890s
Oil on academy board
16¾ x 24⅝ in. (42.5 x 62.5 cm.)
Gift of Union Carbide Corporation
(fig. 247)

fig. 247

Lenders to the Exhibition

Addison Gallery of American Art, Phillips Academy, Andover, Massachusetts
Mr. and Mrs. James W. Alsdorf
Blossom Smiley Bejarano
Brandywine River Museum, Chadds Ford, Pennsylvania
Mr. and Mrs. Vincent Carrozza
Amon Carter Museum, Fort Worth
Cleveland Museum of Art
David David, Inc., Philadelphia
Mr. and Mrs. R. Philip Hanes, Jr.
High Museum of Art, Atlanta
Hirschl & Adler Galleries, New York
Kennedy Galleries, Inc., New York
Mr. and Mrs. Cheston M. B. Keyser
Bernard & S. Dean Levy, Inc., New York
Cornelia and Meredith Long
James A. Maroney, New York
Mr. and Mrs. Paul Mellon, Upperville, Virginia
The Metropolitan Museum of Art, New York
Milwaukee Art Center
Minneapolis Institute of Arts
Dr. Leopold S. Moreno
Mr. and Mrs. Don Mullins
Munson-Williams-Proctor Institute, Utica, New York
Museum of Fine Arts, Boston
The Museum of Modern Art, New York
National Gallery of Art, Washington, D.C.
New Jersey State Museum Collection, Trenton
Newark Museum Association
Newhouse Galleries, New York

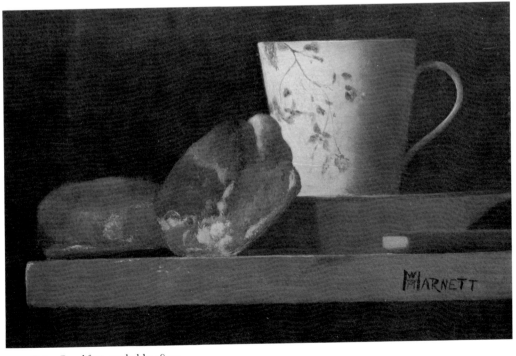

222. Peto. *Breakfast*, probably 1890s.

List of Illustrations

A note on titles: Many owners of Peto works have understandably used the words "still life" in titling their pictures. This redundancy has, except in rare instances, been eliminated in the following list. Only a handful of Peto's original titles are known. Those given here straightforwardly reflect the primary contents or subject of the works in question. This symbol indicates the work listed was shown in the Peto exhibition at the National Gallery of Art and the Amon Carter Museum: ⬛

1. Peto in his studio, mid-1880s. Glass plate photograph. 8 x 10 in. (20.3 x 25.4 cm.). Shelburne Museum, Shelburne, Vermont.

2. Peto. *The First Fire Chief of Philadelphia: Portrait of the Artist's Father*, 1878. Oil on canvas. 31 x 25 in. (78.7 x 63.5 cm.). The Barra Foundation, Philadelphia.

3. Peto. Thomas Hope and Catherine Ham Peto in the Island Heights studio, early 1890s. Photograph. 4 x 5 in. (10.2 x 12.7 cm.). Peto family albums, The Studio, Island Heights, New Jersey.

4. Business invoice of Thomas H. Peto, 1890s. Engraved. 7 x 8½ in. (17.8 x 21.6 cm.). Peto family albums, The Studio, Island Heights, New Jersey.

5. Business card of Thomas H. Peto, 1890s. Engraved. 2¾ x 4¼ in. (7 x 10.8 cm.). Peto family albums, The Studio, Island Heights, New Jersey.

6. Peto. *Memento Mori for Thomas Peto*, 1904. Oil on canvas. 10 x 14 in. (25.4 x 35.5 cm.). Private collection.

7. Peto. Childhood sketches of boat and buildings. Pencil on paper. 8 x 10 in. (20.3 x 25.4 cm.). Peto family albums, The Studio, Island Heights, New Jersey.

8. Peto. *Apple Blossoms*, probably 1860s. Pencil and watercolor on paper. 8 x 10 in. (20.3 x 25.4 cm.). Peto family albums, The Studio, Island Heights, New Jersey.

9. Unknown photographer, Lynn, Massachusetts. Peto in the Third Regiment Band of Philadelphia, 29 June 1877. Tintype. 3½ x 2½ in. (8.9 x 6.4 cm.). Peto family albums, The Studio, Island Heights, New Jersey.

10. Peto in a Philadelphia studio, 1870s. Photograph. 7 x 5⅛ in. (17.8 x 13 cm.). Peto family albums, The Studio, Island Heights, New Jersey.

11. Peto with models, Philadelphia, 1870s. Photograph. 8 x 10 in. (20.3 x 25.4 cm.). Peto family albums, The Studio, Island Heights, New Jersey.

12. Peto and William M. Harnett in Peto's Philadelphia studio, 1870s. Glass plate photograph. 7⅛ x 8⅜ in. (18.1 x 21.3 cm.). Peto family albums, The Studio, Island Heights, New Jersey.

13. Peto. Christine Smith Peto in the studio at Island Heights, 1890s. Photograph. 5 x 7 in. (12.7 x 17.8 cm.). Peto family albums, The Studio, Island Heights, New Jersey.

14. Peto on Holly Avenue, 1893. Photograph. 4⅜ x 3½ in. (11.1 x 8.9 cm.). Peto family albums, The Studio, Island Heights, New Jersey.

15. ⬛ Peto. *Afternoon Sailing*, 1890s. Oil on canvas. 12 x 20 in. (30.5 x 50.8 cm.). Thyssen-Bornemisza Collection, Lugano, Switzerland.

16. Peto. The artist's daughter Helen with his parents at Toms River, early 1890s. Glass plate photograph. 5 x 8 in. (12.7 x 20.3 cm.). Peto family albums, The Studio, Island Heights, New Jersey.

17. Peto. The Studio, front view, 1890s. Glass plate photograph. 8 x 10 in. (20.3 x 25.4 cm.). Peto family albums, The Studio, Island Heights, New Jersey.

18. Peto. The Studio, side view, 1890s. Photograph. 3¼ x 3¼ in. (8.3 x 8.3 cm.). Peto family albums, The Studio, Island Heights, New Jersey.

19. Peto. *Landscape with Duck Pond*, probably 1880s. Oil on canvas. 20 x 24 in. (50.8 x 61 cm.). Collection Blossom Smiley Bejarano and Joy M. Smiley, Island Heights, New Jersey.

20. Peto. *Harper's Ferry*, 1907. Oil on canvas. 10⅛ x 14¼ in. (25.7 x 36.2 cm.). Collection Dr. Leopold S. Moreno, Norfolk, Virginia.

21. Peto and his daughter Helen, c. 1900. Glass plate photograph. 8 x 5 in. (20.3 x 12.7 cm.). Peto family albums, The Studio, Island Heights, New Jersey.

22. Peto. The artist's maternal aunts: Margaret, Maria, and Louisa Ham, 1890s. Glass plate photograph. 5 x 8 in. (12.7 x 20.3 cm.). Peto family albums, The Studio, Island Heights, New Jersey.

23. Cover of Alfred Frankenstein's *After the Hunt: William Harnett and Other American Still Life Painters, 1870-1900* (Berkeley and Los Angeles, 1969).

24. William M. Harnett. *After the Hunt* (fourth version), 1885. Oil on canvas. 71 x 48 in. (180.3 x 121.9 cm.). The Fine Arts Museums of San Francisco, Gift of H.K.S. Williams to the Mildred Anna Williams Collection.

25. Adolphe Braun. *Hare and Ducks*, c. 1860. Carbon photograph. 30½ x 21½ in. (77.5 x 54.6 cm.). The Metropolitan Museum of Art, New York.

26. Raphaelle Peale. *Lemons and Sugar*, c. 1822. Oil on panel. 12 x 15½ in. (30.5 x 39.4 cm.). The Reading Public Museum and Art Gallery, Reading, Pennsylvania.

27. Charles Bulfinch. Massachusetts State House, Boston, 1797.

28. John F. Francis. *Still Life with Apples and Chestnuts*, 1859. Oil on canvas. 25 x 30 in. (63.5 x 76.2 cm.). Museum of Fine Arts, Boston, M. and M. Karolik Collection.

29. Alexander Parris. Quincy Market, Boston, 1825.

30. Severin Roesen. *Still Life: Flowers*, 1860s. Oil on canvas. 40 x 50⅜ in. (101.6 x 128 cm.). The Metropolitan Museum of Art, New York, Gift of Various Donors, 1967.

31. Alexander Jackson Davis. Residence of Henry Delamater, Rhinebeck, New York, 1844.

32. Peto. *Lamps of Other Days*, c. 1900. Oil on canvas. 27⅛ x 36⅛ in. (68.9 x 91.8 cm.). Amon Carter Museum, Fort Worth.

33. Henry Hobson Richardson. Crane Memorial Library, Quincy, Massachusetts, 1880-1883.

34. Peto. *Pipe, Mug and Newspaper*, 1887. Oil on academy board. 6 x 8 in. (15.2 x 20.3 cm.). Private collection.

35. William M. Harnett. *His Pipe and His Mug*, 1880. Oil on canvas. 10 x 14 in. (25.4 x 35.6 cm.). Private collection.

36. Peto. *Mugs, Pipe and Matches*, probably 1880s. Oil on academy board. 6⅛ x 9¼ in. (15.6 x 23.5 cm.). Meredith Long & Company, Houston.

37. Peto. *Book, Pipe and Mug*, probably 1880s. Oil on academy board. 7⅞ x 12 in. (20 x 30.5 cm.). Private collection.

38. Attributed to Adolphe Ancker. *Still Life with Cigarettes, Matches, Book and Mug*, 1880s or 1890s. Oil on cigar box panel. 6 x 9 in. (15.2 x 22.9 cm.). Private collection.

39. Peto. *Pipe and Mug*, probably 1880s. Oil on academy board. 7 x 9¼ in. (17.8 x 23.5 cm.). Rhode Island School of Design Museum, Providence, Gift of the Museum Associates.

40. Peto. *Salt Glazed Mug, Book, Pipe and Match*, probably 1880s. Oil on academy board. 5⅝ x 8⅝ in. (14.3 x 22 cm.). Meredith Long & Company, Houston.

41. Peto. *Book, Mug, Pipe and Match*, probably 1880s. Oil on academy board. 9⅛ x 6 in. (23.2 x 15.2 cm.). Private collection.

42. Peto. *Book Leaning against Mug with Pipe Used as Book Mark*, 1889. Oil on academy board. 6 x 9 in. (15.2 x 22.9 cm.). Private collection.

43. Peto. *Pipe, Mug and Match*, 1899. Oil on canvas. 9½ x 6½ in. (24.1 x 16.5 cm.). Meredith Long & Company, Houston.

44. Peto. *Mug, Pipe and Match*, c. 1887. Oil on academy board. 6 x 9 in. (15.2 x 22.9 cm.). Hirshhorn Museum and Sculpture Garden, Smithsonian Institution, Washington, D.C.

45. Thomas Eakins. *Three Wooden Forms, Painted Red, White, and Black*, probably 1879-1886. Painted wood. Height 2½ in., diameter 1⅝ in. (6.4 x 4.1 cm.). Hirshhorn Museum and Sculpture Garden, Smithsonian Institution, Washington, D.C.

46. Peto. *Fruit, Vase and Statuette*, February 1875. Oil on canvas. 28¼ x 24¼ in. (71.6 x 61.4 cm.). Ira Spanierman, Inc., New York.

47. Peto. *Market Basket, Hat and Umbrella*, after 1890. Oil on canvas. 12 x 18 in. (30.5 x 45.7 cm.). Layton Art Collection of the Milwaukee Art Center.

48. Attributed to Claude Raguet Hirst. *Hat, Gloves, Shoe and Umbrella*, possibly 1904. Charcoal on paper. 16¾ x 22¼ in. (42.5 x 56.5 cm.). David David, Inc., Philadelphia.

49. Peto. *Straw Hat, Bag and Umbrella*, 1890s/early 1900s. Oil on academy board. 16 x 10 in. (40.6 x 25.4 cm.). Private collection.

50. Peto. *Crumbs of Comfort*, November 1881. Oil on canvas. 12 x 15 in. (30.5 x 38.1 cm.). Collection Mr. and Mrs. William J. Poplack, Birmingham, Michigan.

51. Peto. *Mugs, Bottle and Pipe*, 1890. Oil on canvas. 12¼ x 16¼ in. (31.1 x 41.3 cm.). Collection Mr. and Mrs. Vincent A. Carrozza.

52. Claude Raguet Hirst. *Pipe and Tobacco*, late 1880s/early 1890s. Watercolor on paper. 7½ x 10½ in. (19.1 x 26.7 cm.). Kennedy Galleries, Inc., New York.

53. Attributed to Claude Raguet Hirst. *Library Table*, late 1880s/early 1890s. Pencil on paper. 13 x 17¼ in. (33 x 43.8 cm.). Collection Dr. and Mrs. Irving F. Burton.

54. Thomas H. Hope. *Still Life on Newspaper*, probably 1880s. Oil on canvas. 18 x 24 in. (45.7 x 61 cm.). Barridoff Galleries, Portland, Maine.

55. William M. Harnett. *Just Dessert*, 1891. Oil on canvas. 22¼ x 26¾ in. (56.5 x 68 cm.). The Art Institute of Chicago, Friends of American Art Collection.

56. Peto. *Bottle, Candlestick and Oranges*, probably 1890s. Oil on canvas. 21¾ x 27 in. (55.3 x 68.6 cm.). Meredith Long & Company, Houston.

57. Peto. *Still Life with Box*, probably 1890s. Oil on academy board. 5½ x 5½ in. (14 x 14 cm.). Collection Mr. and Mrs. Philip H. Sieg.

58. Peto. *Miniature Still Life*, possibly 1890s. Oil on academy board. 3⅛ x 5¼ in. (7.9 x 13.3 cm.). New Jersey State Museum Collection, Trenton, Gift of Mr. and Mrs. Robert F. Stein 1963.

59. Peto. *Wine and Brass Stewing Kettle (Preparation of French Potage)*, probably 1890s. Oil on canvas. 22 x 29¾ in. (55.8 x 75.5 cm.). Private collection.

60. Elihu Vedder. *Old Pail and Tree Trunk*, 1865. Oil on canvas. 8½ x 14 in. (21.6 x 35.6 cm.). The Newark Museum, Newark, New Jersey, Gift of the American Academy of Arts and Letters, 1955.

61. Emil Carlsen. *Still Life with Fish*, 1882. Oil on canvas. 29⅝ x 39¾ in. (75.2 x 101 cm.). National Gallery of Art, Washington, D.C., Gift of Chester Dale 1962.

62. Peto. *Pots and Pans*, c. 1880. Oil on canvas. 22 x 16 in. (55.9 x 40.6 cm.). Museum of Fine Arts, Boston, Bequest of Maxim Karolik.

63. Stuart Davis. *Egg Beater No. 1*, 1927. Oil on canvas. 27 x 38¼ in. (68.6 x 97.2 cm.). The Phillips Collection, Washington, D.C.

64. Peto. *Brass Kettle and Candlestick*, probably 1890s. Oil on canvas. 16 x 10 in. (40.6 x 25.4 cm.). Washington County Museum of Fine Arts, Hagerstown, Maryland.

65. Peto. *Battered Pot*, probably 1890s. Oil on academy board. 6 x 9⅛ in. (15.2 x 23.2 cm.). New Jersey State Museum Collection, Trenton, Museum Purchase 1963.

66. Peto. *Brass Kettle*, probably 1890s. Oil on academy board. 6 1/16 x 9 in. (15.4 x 22.9 cm.). Private collection.

67. Peto. *Wine Bottle, Raisins and Box*, 1894. Oil on academy board. 6 x 9 in. (15.2 x 22.9 cm.). The Newark Museum, Newark, New Jersey, Dr. Donald M. Dougall Bequest 1954.

68. Peto. *Oranges, Lemons, Nuts, Pitcher and Honey Pot on Box*, probably 1890s. Oil on academy board. 9 x 12 in. (22.9 x 30.5 cm.). Private collection.

69. Jean-Baptiste-Siméon Chardin. *Still Life*, c. 1755. Oil on canvas. 13 1/4 x 17 in. (33.5 x 43 cm.). National Gallery of Art, Washington, D.C., Gift of Chester Dale 1943.

70. Jean-Baptiste-Siméon Chardin. *Still Life with a White Mug*, c. 1756. Oil on canvas. 13 x 16 1/4 in. (33.1 x 41.2 cm.). National Gallery of Art, Washington, D.C., Gift of the W. Averell Harriman Foundation in memory of Marie N. Harriman 1972.

71. Peto. *Cucumber*, probably 1890s. Oil on academy board. 6 1/4 x 9 1/4 in. (15.9 x 23.5 cm.). Collection Mr. and Mrs. R. Philip Hanes, Jr.

72. Peto. *Banana and Orange*, probably 1890s. Oil on academy board. 6 x 9 in. (15.2 x 22.9 cm.). Private collection.

73. Peto. *Ginger Jar and Orange*, probably 1890s. Oil on academy board. 6 x 9 in. (15.2 x 22.9 cm.). Private collection.

74. Peto. *Ginger Jar and Oranges*, probably 1890s. Oil on canvas. 10 x 14 1/4 in. (25.4 x 36.2 cm.). Collection Mr. and Mrs. Cheston M. B. Keyser.

75. Peto. *Cup, Biscuit and Fruit*, probably 1890s. Oil on canvas. 5 7/8 x 9 1/4 in. (14.9 x 23.5 cm.). Meredith Long & Company, Houston.

76. Peto. *Teacup and Slice of Cake*, probably 1890s. Oil on academy board. 6 x 9 in. (15.2 x 22.9 cm.). Collection Mr. and Mrs. Carroll M. Williamson, Jr.

77. Peto. *Oranges and Goblet of Wine*, 1880-1890s. Oil on academy board. 6 1/8 x 9 1/8 in. (15.6 x 23.2 cm.). Collection Mr. and Mrs. Paul Mellon, Upperville, Virginia.

78. Peto. *Cake, Lemon, Strawberries and Glass*, 1890. Oil on canvas. 10 1/8 x 14 in. (25.7 x 35.6 cm.). Collection Mr. and Mrs. Paul Mellon, Upperville, Virginia.

79. Peto. *Basket of Strawberries*, 1887. Oil on academy board. 7 x 10 in. (17.8 x 25.4 cm.). Collection Mr. and Mrs. Don Mullins.

80. Peto. *Peanuts—Fresh Roasted, Well Toasted*, probably 1900s. Oil on panel. 10 3/4 x 16 in. (27.3 x 40.7 cm.). Private collection.

81. Peto. *Hanging Grapes*, 1902. Oil on academy board. 8 3/4 x 5 3/4 in. (22.2 x 14.6 cm.). The Newark Museum, Newark, New Jersey, Dr. Donald M. Dougall Bequest 1954.

82. Peto. *For a Sunday Dinner*, 1893. Oil on canvas. 30 3/16 x 22 in. (76.7 x 55.9 cm.). Private collection.

83. William M. Harnett. *Plucked Clean*, 1882. Oil on canvas. 34 1/8 x 20 1/4 in. (87.3 x 51.4 cm.). The Corcoran Gallery of Art, Washington, D.C., William A. Clark Fund.

84. Peto. *Peppermint Candy*, 1878. Oil on canvas. 9 7/8 x 13 in. (25.1 x 33 cm.). Private collection.

85. Peto. *Help Yourself*, 1881. Oil on canvas. 8 1/16 x 10 1/16 in. (20.5 x 25.6 cm.). Private collection.

86. Peto. *The Poor Man's Store*, 1885. Oil on canvas and wood. 36 x 25 1/2 in. (91.4 x 64.8 cm.). Museum of Fine Arts, Boston, M. and M. Karolik Collection.

87. Walker Evans. *Bedroom Fireplace, Tenant Farmhouse, Hale County, Alabama*, 1936. Photograph. 7 1/2 x 9 1/2 in. (19.1 x 24.1 cm.). The Library of Congress, Washington, D.C.

88. Peto. *Still Life with a Pipe*, 1880s-1890s. Oil on academy board. 6 x 8 7/8 in. (15.2 x 22.5 cm.). Knoedler-Modarco S.A., New York.

89. Peto. *Tobacco Canister, Book and Pipe*, 1888. Oil on academy board. 6 3/4 x 9 in. (17.2 x 22.9 cm.). Meredith Long & Company, Houston.

90. Peto. *Candlestick, Pipe and Mug*, 1880s-1890s. Oil on panel. 9 x 6 in. (22.9 x 15.2 cm.). Collection Erving and Joyce Wolf, New York.

91. Peto. *The Green Envelope*, probably 1890s. Oil on panel. 4½ x 6½ in. (11.4 x 16.5 cm.). Meredith Long & Company, Houston.

92. William M. Harnett. *The Writing Table*, 1877. Oil on canvas. 8 x 12 in. (20.3 x 30.5 cm.). Philadelphia Museum of Art, The Alex Simpson, Jr., Collection.

93. Peto. *Inkwell and Plume on Old Book*, probably 1880s. Oil on academy board. 6 x 8 in. (15.2 x 20.3 cm.). Kennedy Galleries, Inc., New York.

94. Attributed to Adolphe Ancker. *Ink Pot, Book and Copper Ewer*, probably 1890s. Oil on panel. 6 x 9 in. (15.2 x 22.9 cm.). Estate of Dr. Adolphe Ancker, Island Heights, New Jersey.

95. Peto. *Old Books*, 1890. Oil on academy board. 6 x 9 in. (15.2 x 22.9 cm.). Collection Alice M. Kaplan.

96. Peto. *Quill in Inkwell, Book and Candle*, 1894. Oil on academy board. 9 x 6 in. (22.9 x 15.2 cm.). Private collection.

97. Peto. *Books*, probably 1890s. Oil on panel. 7 x 9¾ in. (17.8 x 24.8 cm.). Hirschl & Adler Galleries, New York.

98. Peto. *Candle, Book, Jug and Pipe*, probably 1890s. Oil on academy board. 8 x 10 in. (20.3 x 25.4 cm.). Private collection.

99. Peto. *The Writer's Table: A Precarious Moment*, probably 1890s. Oil on canvas. 27 x 22¼ in. (68.6 x 56.5 cm.). Private collection.

100. Peto. *Forgotten Friends*, probably 1890s. Oil on canvas. 15⅞ x 10⅛ in. (40.3 x 25.7 cm.). Private collection.

101. Peto. *Salt Glazed Beaker, Books, Pipe, Matches, Tobacco Box and Newspaper*, 1899. Oil on canvas. 14⅛ x 10¹/₁₆ in. (35.9 x 25.6 cm.). Collection C. Thomas May, Jr., Dallas.

102. William M. Harnett. *My Gems*, 1888. Oil on panel. 18 x 14 in. (45.7 x 35.5 cm.). National Gallery of Art, Washington, D.C., Gift of the Avalon Foundation 1957.

103. Peto. *Jug, Books and Candle on a Cupboard Shelf*, probably 1890s. Oil on canvas. 30 x 22 in. (76.2 x 55.9 cm.). High Museum of Art, Atlanta, Gift of Julie and Arthur Montgomery 1980.

104. Peto. *Candle and Books*, c. 1900. Oil on canvas. 22¼ x 29¼ in. (56.5 x 74.3 cm.). The Fine Arts Museums of San Francisco.

105. Peto. *A Full Shelf*, May 1891. Oil on canvas. 20 x 24 in. (50.8 x 61 cm.). Virginia Steele Scott Foundation, Pasadena, California.

106. Peto. *Books on a Table*, c. 1900. Oil on canvas. 24½ x 43 in. (62.2 x 109.2 cm.). James Maroney, New York.

107. Peto. *Pipe and Candle*, c. 1900. Oil on academy board. 6 x 8 in. (15.2 x 20.3 cm.). Private collection.

108. Peto. *Pipe and Book*, c. 1900. Oil on academy board. 4½ x 9 in. (11.4 x 22.9 cm.). Davis & Langdale Company, New York.

109. Peto. *Nine Books*, c. 1900. Oil on academy board. 6⅛ x 9³/₁₆ in. (15.6 x 23.3 cm.). Yale University Art Gallery, New Haven, Connecticut, Gift of Mr. and Mrs. Charles F. Montgomery.

110. Winthrop Chandler. *Shelf of Books*, c. 1769. Oil on panel. 27 x 58 in. (68.6 x 147.3 cm.). Shelburne Museum, Shelburne, Vermont.

111. Sol LeWitt. *Autobiography* (detail), 1979. Black and white photographs mounted on boards, 62 sheets, each 12 x 24 in. (30.5 x 61 cm.). John Weber Gallery, New York.

112. A. & B. Peto. *Shelf of Books* (two details), probably 1890s. Oil on plaster mural. Two of eleven fragments.
A. 14 x 18¾ in. (35.6 x 47.6 cm.). Collection Mr. and Mrs. Herbert Glanz, Brooklyn, New York.
B. 15 x 18 in. (38.1 x 45.7 cm.). Bernard & S. Dean Levy, Inc., New York.

113. Peto. *Joseph Westray*, probably 1890s. Oil on canvas. 20 x 14⅛ in. (50.8 x 35.9 cm.). New Jersey State Museum Collection, Trenton, Gift of Julius Garfield.

114. Winthrop Chandler. *Mrs. Samuel Chandler*, c. 1780. Oil on canvas. 54¾ x 47⅞ in. (139.1 x 121.7 cm.). National Gallery of Art, Washington, D.C., Gift of Edgar William and Bernice Chrysler Garbisch 1964.

115. Eastman Johnson. *Boy Reading*, 1876. Oil on panel. 7¾ x 10 in. (19.7 x 25.4 cm.). Private collection.

116. Thomas Eakins. *Professor William D. Marks*, 1886. Oil on canvas. 76 x 53½ in. (193.1 x 134.9 cm.). Washington University Gallery of Art, St. Louis.

117. Peto. *Discarded Treasures*, c. 1904. Oil on canvas. 22 x 40 in. (55.9 x 101.6 cm.). Smith College Museum of Art, Northampton, Massachusetts.

118. William M. Harnett. *Job Lot Cheap*, 1878. Oil on canvas. 18 x 36 in. (45.7 x 91.4 cm.). Reynolda House, Winston-Salem, North Carolina.

119. Peto. *Job Lot Cheap*, after 1900. Oil on canvas. 38¼ x 29¾ in. (97.2 x 75.6 cm.). The Fine Arts Museums of San Francisco, Gift of Mr. and Mrs. John D. Rockefeller 3rd.

120. William M. Harnett. *Memento Mori*, 1880s. Oil on canvas. 24 x 32 in. (61 x 81.3 cm.). The Cleveland Museum of Art, Mr. and Mrs. William H. Marlatt Fund.

121. Charles Bird King. *Poor Artist's Cupboard*, c. 1815. Oil on panel. 29¾ x 27¾ in. (75.6 x 70.5 cm.). The Corcoran Gallery of Art, Washington, D.C.

122. Peto. *Take Your Choice*, 1885. Oil on canvas. 20½ x 30¼ in. (52.1 x 76.8 cm.). Private collection.

123. Henry Hobson Richardson. Interior, Winn Memorial Library, Woburn, Massachusetts, 1887-1888.

124. Peto. *Still Life with Lard Oil Lamp*, 1900s. Oil on canvas. 14⅛ x 24⅛ in. (35.9 x 61.3 cm.). The Newark Museum, Newark, New Jersey, Dr. Donald M. Dougall Bequest 1954.

125. Peto. *Old Companions*, 1904. Oil on canvas. 22 x 30 in. (55.9 x 76.2 cm.). Collection Jo Ann and Julian Ganz, Jr., Los Angeles.

126. Peto. *Lights of Other Days*, 1906. Oil on canvas. 30½ x 45¼ in. (77.5 x 114.9 cm.). The Art Institute of Chicago, Goodman Fund.

127. Joseph Cornell. *The Hotel Eden*, 1945. Assemblage with music box. 15⅛ x 15⅝ x 4¾ in. (38.3 x 39.7 x 12.1 cm.). The National Gallery of Canada, Ottawa.

128. Peto. *Violin, Fan and Books*, 1880. Oil on canvas mounted on board. 9⅛ x 13 in. (23.2 x 33 cm.). David David, Inc., Philadelphia.

129. Jefferson David Chalfant. *Interrupted Musicale*, 1880s-1890s. Pencil on paper. 5½ x 4 in. (14 x 10.2 cm.). Private collection.

130. Thomas Eakins. *Mrs. William D. Frishmuth*, 1900. Oil on canvas. 96 x 72 in. (243.8 x 182.9 cm.). Philadelphia Museum of Art, Given by Mrs. Thomas Eakins and Miss Mary A. Williams.

131. Thomas Wilmer Dewing. *Lady with a Lute*, 1886. Oil on panel. 20 x 15 in. (50.8 x 38.1 cm.). National Gallery of Art, Washington, D.C., Gift of Dr. and Mrs. Walter Timme 1978.

132. Peto. *The Old Violin*, c. 1890. Oil on canvas. 30⅜ x 22⅞ in. (77.2 x 58.1 cm.). National Gallery of Art, Washington, D.C., Gift of the Avalon Foundation 1974.

133. William M. Harnett. *Music and Good Luck*, 1888. Oil on canvas. 40 x 30 in. (101.6 x 76.2 cm.). The Metropolitan Museum of Art, New York, Catherine Lorillard Wolfe Fund.

134. Jefferson David Chalfant. *Still Life*, 1889. Oil on canvas. 36 x 25⅝ in. (91.4 x 65.1 cm.). The Metropolitan Museum of Art, New York, George A. Hearn Fund.

135. Peto. *Violin*, early 1890s. Oil on canvas. 16 x 12 in. (40.6 x 30.5 cm.). Collection Mr. and Mrs. James W. Alsdorf, Chicago.

136. Georges Braque. *The Blue Mandolin*, 1930. Oil on canvas. 45⅝ x 34⅝ in. (115.9 x 87.9 cm.). The St. Louis Art Museum.

137. Samuel van Hoogstraten. *Still Life*, 1655. Oil on canvas. 36⅜ x 28⅜ in. (92.5 x 72 cm.). Gemaldegalerie der Akademie de bildenden Kunste, Vienna.

138. John Singleton Copley. *Corkscrew Hanging on a Nail*, c. 1766-1774. Oil on panel. 3½ x 3¾ in. (8.9 x 9.5 cm.), painted area only. Museum of Fine Arts, Boston.

139. Peto. *Lock and Key*, 1890s. Oil on academy board. 8 x 6 in. (20.3 x 15.2 cm.). Private collection.

140. Peto. *The Fish House Door*, 1890s. Oil on canvas. 60 x 30 in. (152.4 x 76.2 cm.). The Pennsylvania Academy of the Fine Arts, Philadelphia, Collections Fund Purchase.

141. Peto. *Fish House Door with Eel Basket*, 1890s. Oil on canvas. 60 x 43 in. (152.4 x 109.2 cm.). Munson-Williams-Proctor Institute, Utica, New York.

142. Peto. *Stag Saloon Commission, Lerado, Ohio*, 1885. (Size of painting, c. 60 x 40 in.) Glass plate photograph, 8¾ x 6 in. (22.2 x 15.2 cm.). Peto family albums, The Studio, Island Heights, New Jersey.

143. Peto. *Things to Adore: My Studio Door*, 1890s. Oil on canvas. 49½ x 29⅜ in. (125.7 x 74.6 cm.). The Santa Barbara Museum of Art, Preston Morton Collection.

144. Peto. *Ordinary Objects in the Artist's Creative Mind*, 1887. Oil on canvas. 56 x 33 in. (142.2 x 83.8 cm.). Shelburne Museum, Shelburne, Vermont.

145. Winslow Homer. *The Bathers*, 1873. Wood engraving (*Harper's Weekly*, 2 August 1873). 13¾ x 9⅛ in. (34.9 x 23.2 cm.). Bowdoin College Museum of Art, Brunswick, Maine.

146. Peto. *Mug, Pipe and Book*, 1880s. Oil on academy board. 8 x 10 in. (20.3 x 25.4 cm.). Private collection.

147. Charles Willson Peale. *The Staircase Group*, 1795. Oil on canvas. 89 x 39½ in. (226.2 x 100.3 cm.). The Philadelphia Museum of Art, George W. Elkins Collection.

148. Peto. *Still Life on a Palette*, c. 1890. Oil on palette. 13¼ x 9⅛ in. (33.7 x 23.2 cm.). Charles P. Russell Collection, Deerfield Academy, Deerfield, Massachusetts.

149. Peto. *Palette, Mug and Pipes*, c. 1890. Oil on palette. 13½ x 9½ in. (34.3 x 24.1 cm.). Private collection.

150. John Haberle. *The Palette*, 1889. Oil on canvas. 17¾ x 24 in. (45.1 x 61 cm.). Private collection.

151. Peto. *Horseshoe*, 1889. Oil on canvas. 14½ x 12½ in. (36.8 x 31.8 cm.). Private collection.

152. Peto. *Pipe and Church Sconce*, c. 1890. Oil on canvas. 20 x 12 in. (50.8 x 30.5 cm.). Williams College Museum of Art, Williamstown, Massachusetts.

153. Peto. *The Cup We All Race 4*, c. 1900. Oil on canvas and wood. 25½ x 21½ in. (64.8 x 54.6 cm.). The Fine Arts Museums of San Francisco, Gift of Mr. and Mrs. John D. Rockefeller 3rd.

154. Peto. *Office Board for John F. Peto*, 1904. Oil on academy board. 10½ x 12¼ in. (26.7 x 31.1 cm.). Collection Oscar Selzer, Los Angeles.

155. Frederic Edwin Church. *The Letter Revenge*, before 1892. Oil on canvas. 8¼ x 10¼ in. (21 x 26 cm.). Allen Memorial Art Museum, Oberlin College, Oberlin, Ohio, Gift of Charles F. Olney.

156. Kurt Schwitters. *Merz 163, With Woman, Sweating*, 1920. Paper and cloth collage mounted on paper mat. 11⅞ x 8¾ in. (30.2 x 22.2 cm.). The Solomon R. Guggenheim Museum, New York, Gift Katherine S. Dreier Estate.

157. Peto. *Ten Dollar Bill*, February 1889. Oil on canvas. 21 x 17 in. (53.3 x 43.2 cm.). Location unknown.

158. Andy Warhol. *Printed Dollar Bill*, 1962. Synthetic polymer paint silkscreened on canvas. 6 x 10 in. (15.2 x 25.4 cm.). Collection Mr. and Mrs. Burton Tremaine, Meriden, Connecticut.

159. Peto. *Daniel Webster Patch Picture*, c. 1900. Oil on canvas. 14 x 22 in. (35.6 x 55.9 cm.). Hirschl & Adler Galleries, New York.

160. John A. Whipple studio, Boston. *Daniel Webster*, c. 1847-1848. Daguerreotype. 4¼ x 3⅛ in. (10.8 x 7.9 cm.). Dartmouth College Library, Hanover, New Hampshire.

161. Peto. *The Ocean County Democrat*, 1889 (?). Oil on canvas. 24 x 20 in. (61 x 50.8 cm.). New Jersey State Museum Collection, Trenton, Gift of Mrs. Mary G. Roebling.

162. Peto. *Office Board for Eli Keen's Sons*, March 1888. Oil on canvas. 20 x 16 in. (50.8 x 40.6 cm.). Private collection.

163. Albert Newsam. *Trade Card for P. S. Duval*, 1840. Lithograph with watercolor. 15⅝ x 14¾ in. (39.6 x 37.3 cm.). Historical Society of Pennsylvania, Philadelphia.

164. Peto. *Patch Self Portrait with Small Pictures*, c. 1900. Oil on canvas. 26¾ x 24¾ in. (68 x 62.9 cm.). Private collection.

165. Peto. *Still Life (Patch Painting)*, c. 1890. Oil on canvas. 17⅛ x 14⅛ in. (43.5 x 35.9 cm.). Collection Edward Wilson, Houston.

166. Peto. *Sailboats off the Coast*, November 1874. Watercolor. 12 x 17 in. (30.5 x 43.2 cm.). Collection Blossom Smiley Bejarano and Joy M. Smiley, Island Heights, New Jersey.

167. Peto. *Study of a Dog's Head*, probably 1860s. Pencil on paper. 8 x 10 in. (20.3 x 25.4 cm.). Peto family albums, The Studio, Island Heights, New Jersey.

168. T. Brooks. *Picture of Sunday School Class & Teacher Center*, 1860s. Photograph. 7¾ x 5¾ in. (19.7 x 14.6 cm.), oval. Stamped lower center: "T. Brooks, Photographer, 630 Arch St., Philada." Peto family albums, The Studio, Island Heights, New Jersey.

169. Walker Evans. *Family Snapshots in Frank Tengle's Home, Hale County, Alabama*, Summer 1936. Photograph. 8 x 10 in. (20.3 x 25.4 cm.). The Library of Congress, Washington, D.C.

170. Peto. *Portrait of the Artist's Daughter*, 1901. Oil on academy board. 17⅝ x 21⁷⁄₁₆ in. (44.8 x 54.4 cm.). Collection of Cornelia and Meredith Long, Houston.

171. Peto. *Helen Peto, Aged 2*, 27 June 1895. Photograph. 5½ x 3⅞ in. (14 x 9.8 cm.). Peto family albums, The Studio, Island Heights, New Jersey.

172. Peto. *Helen Peto as a Child*, 1890s. Glass plate photograph. 7¾ x 5⅛ in. (19.7 x 13 cm.). Peto family albums, The Studio, Island Heights, New Jersey.

173. Peto. *Toms River*, 1905. Oil on canvas. 20 x 16 in. (50.8 x 40.6 cm.). Thyssen-Bornemisza Collection, Lugano, Switzerland.

174. Peto. *Reminiscences of 1865*, 1897. Oil on canvas. 30 x 22 in. (76.2 x 55.9 cm.). Wadsworth Atheneum, Hartford, Ella Gallup Sumner and Mary Catlin Sumner Collection.

175. Artist unknown. *Abraham Lincoln*, n.d. Wood engraving. 9¾ x 7¾ in. (24.8 x 19.7 cm.). Peto family albums, The Studio, Island Heights, New Jersey.

176. Peto. *Portrait of Lincoln*, 1899 (?). Oil on canvas. 17½ x 7½ in. (44.5 x 19.1 cm.). Hirschl & Adler Galleries, New York.

177. Peto. *Lincoln and the Phleger Stretcher*, c. 1900. Oil on canvas. 10 x 14 in. (25.4 x 35.6 cm.). The New Britain Museum of American Art, New Britain, Connecticut.

178. Thomas Eakins. *Unfinished Portrait of Mrs. Joseph W. Drexel*, c. 1900. Oil on canvas. 47¼ x 37¼ in. (119.8 x 94.4 cm.). Hirshhorn Museum and Sculpture Garden, Smithsonian Institution, Washington, D.C.

179. William M. Davis. *A Canvas Back*, c. 1870. Oil on canvas. 8¼ x 10¼ in. (21 x 26 cm.). The Museums at Stony Brook, New York, Gift of Mrs. Beverly Davis.

180. Peto. *Mr. Abraham Wiltsie's Rack Picture*, 1879. Watercolor. 8 x 10 in. (20.3 x 25.4 cm.). Private collection.

181. Roy Lichtenstein. *Things on the Wall*, 1973. Oil and magna on canvas. 60 x 74 in. (152.4 x 188 cm.). Collection David Whitney.

182. Peto. *Reminiscences of 1865*, after 1900. Oil on canvas. 30 x 20 in. (76.2 x 50.8 cm.). The Minneapolis Institute of Arts, The Julia B. Bigelow Fund.

183. Peto. *Lincoln and the Star of David*, 1904. Oil on canvas. 20 x 14 in. (50.8 x 35.6 cm.). Private collection.

184. Peto. *Old Time Letter Rack*, 1894. Oil on canvas. 30 x 25 in. (76.2 x 63.5 cm.). Museum of Fine Arts, Boston, Bequest of Maxim Karolik.

185. George Cope. *Union Mementoes on a Door*, 1889. Oil on canvas. 52 x 32 in. (132.1 x 81.3 cm.). Private collection.

186. Alexander Pope. *Emblems of the Civil War*, 1888. Oil on canvas. 51⅛ x 54³⁄₁₆ in. (129.8 x 137.6 cm.). The Brooklyn Museum, Dick S. Ramsay Fund, Governing Committee of The Brooklyn Museum, and Anonymous Donors.

187. Augustus Saint-Gaudens. *Adams Memorial*, 1891. Bronze. Height, 70 in. (177.8 cm.). Rock Creek Cemetery, Washington, D.C.

188. Robert Rauschenberg. *Retroactive*, 1964. Oil and silkscreen ink on canvas. 84 x 60 in. (213.4 x 152.4 cm.). Wadsworth Atheneum, Hartford, Gift of Susan Morse Hilles.

189. Peto. *Card Rack with Jack of Hearts*, c. 1900. Oil on canvas. 30 x 25 in. (76.2 x 63.5 cm.). The Cleveland Museum of Art, Purchase from the J. H. Wade Fund.

190. Peto. *Hanging Knife with Jack of Hearts*, 1903. Oil on canvas. 20 x 14 in. (50.8 x 35.6 cm.). Private collection.

191. Jean-Baptiste-Siméon Chardin. *The House of Cards*, c. 1737. Oil on canvas. 32⅜ x 26 in. (82.2 x 66 cm.). National Gallery of Art, Washington, D.C., Andrew W. Mellon Collection 1937.

192. Benjamin Latrobe. *Breakfast Equipage of the "Eliza,"* 1795. 6¹⁵⁄₁₆ x 10⁵⁄₁₆ in. (17.6 x 27.8 cm.). Maryland Historical Society, Baltimore.

193. Pablo Picasso. *Card Player*, Winter 1913-1914. Oil on canvas. 42½ x 35¼ in. (108 x 89.5 cm.). The Museum of Modern Art, New York, Lillie P. Bliss Bequest.

194. Peto. *Office Board for Smith Bros. Coal Co.*, 1879. Oil on canvas. 24 x 28¼ in. (61 x 71.8 cm.). The Addison Gallery of American Art, Phillips Academy, Andover, Massachusetts.

195. Wallerant Vaillant. *Letter Rack*, 1658. Oil on canvas. 20¼ x 16 in. (51.5 x 40.5 cm.). Staatliche Kunstsammlungen, Dresden.

196. Jean Valette-Penot. *Trompe l'Oeil with an Engraving of Sarrabat*, 2nd half 18th century. Oil on canvas. 31½ x 24¾ in. (80 x 63 cm.). Musée des Beaux-Arts, Rennes, France.

197. Raphaelle Peale. *A Deception*, 1802. Ink and pencil on paper. 16 x 10¾ in. (40.6 x 27.3 cm.). Private collection.

198. American unknown. *The All-Seeing Eye*, 1827. Oil on canvas. 16¼ x 28½ in. (41.3 x 72.4 cm.). Wadsworth Atheneum, Hartford, Ella Gallup Sumner and Mary Catlin Sumner Collection.

199. John Haberle. *Torn in Transit*, 1880s or 1890s. Oil on canvas. 14 x 12 in. (35.6 x 30.5 cm.). Memorial Art Gallery, University of Rochester, Marion Stratton Gould Fund.

200. William M. Harnett. *Mr. Huling's Rack Picture*, 1888. Oil on canvas. 30 x 25 in. (76.2 x 63.5 cm.). Collection Alice M. Kaplan.

201. Peto. *Rack Picture with Telegraph, Letter and Postcards*, November 1880. Oil on canvas. 24 x 20 in. (61 x 50.8 cm.). Hirschl & Adler Galleries, James Maroney, and Newhouse Galleries, New York.

202. Peto. *Office Board for Christian Faser*, 1881. Oil on canvas. 24 x 20 in. (61 x 50.8 cm.). Collection Jo Ann and Julian Ganz, Jr., Los Angeles.

203. Detail of figure 202.

204. Anonymous American. Greeting card, late 19th century. Colored engraving. 2¾ x 4 in. (7 x 10.2 cm.). Collection Jo Ann and Julian Ganz, Jr., Los Angeles.

205. Peto. Business card, 1890s. Engraving. 2½ x 4⅛ in. (6.4 x 10.5 cm.). Peto family albums, The Studio, Island Heights, New Jersey.

206. Detail of figure 202.

207. Peto. *Rack Picture for William Malcolm Bunn*, 1882. Oil on canvas. 24 x 20 in. (61 x 50.8 cm.). National Museum of American Art (formerly National Collection of Fine Arts), Smithsonian Institution, Washington, D.C.

208. Peto. *Office Board*, April 1885. Oil on canvas. 24⅜ x 19⅞ in. (61.9 x 50.5 cm.). The Metropolitan Museum of Art, New York, George A. Hearn Fund 1955.

209. Thomas H. Hope. *The Artist's Letter Rack*, 1886. Oil on canvas. 20 x 15 in. (50.8 x 38.1 cm.). Private collection.

210. Peto. *Old Time Letter Rack*, 1894. Oil on canvas. 30 x 25⅛ in. (76.2 x 63.8 cm.). The Museum of Modern Art, New York, Gift of Nelson A. Rockefeller 1940.

211. Peto. *Letter Rack on Black Door*, 1895. Oil on canvas. 30 x 25 in. (76.2 x 63.5 cm.). Private collection.

212. Albert P. Ryder. *Marine*, 1890s. Oil on panel. 12⅝ x 9¹³⁄₁₆ in. (32.1 x 24.9 cm.). Museum of Art, Carnegie Institute, Pittsburgh, Howard N. Eavenson Americana Collection.

213. Winslow Homer. *Right and Left*, 1909. Oil on canvas. 28¼ x 48⅜ in. (71.8 x 122.9 cm.). National Gallery of Art, Washington, D.C., Gift of the Avalon Foundation 1951.

214. Piet Mondrian. *Diamond Painting in Red, Yellow, and Blue*, c. 1925. Oil on canvas on fiberboard. Diagonal, 56¼ x 56 in. (142.9 x 142.2 cm.). National Gallery of Art, Washington, D.C., Gift of Herbert and Nannette Rothschild 1971.

215. Betty Hahn. *Chicago Family: Grandmother*, 1979. Polaroid photograph. 24 x 20 in. (61 x 50.8 cm.). Collection of the artist.

216. Peto. *HSP's Rack Picture*, c. 1900. Oil on canvas. 40 x 30 in. (101.6 x 76.2 cm.). Private collection.

217. Peto in his studio at Island Heights, 1890s. Glass plate photograph. 10 x 8 in. (25.4 x 20.3 cm.). Peto family albums, The Studio, Island Heights, New Jersey.

218. Thomas Eakins. *Portrait of a Lady with a Setter Dog (Mrs. Eakins)*, 1885. Oil on canvas. 30 x 23 in. (76.2 x 58.4 cm.). The Metropolitan Museum of Art, New York, Fletcher Fund.

219. William Merritt Chase. *A Friendly Call*, 1895. Oil on canvas. 30⅛ x 48¼ in. (76.5 x 122.5 cm.). National Gallery of Art, Washington, D.C., Gift of Chester Dale 1943.

220. Peto. *Self Portrait with Rack Picture*, 1904. Oil on canvas. 18½ x 12¼ in. (47 x 31.1 cm.). Private collection.

221. Peto. *Artist's Palette with Beer Mug and Pipe*, 1880s-1890s. Oil on panel. 13½ x 9 in. (34.3 x 22.9 cm.). Kennedy Galleries, New York.

222. Peto. *Breakfast*, probably 1890s. Oil on academy board. 5¹³⁄₁₆ x 8⅝ in. (14.8 x 22 cm.). Collection Mr. and Mrs. Paul Mellon, Upperville, Virginia.

223. Peto. *A Closet Door*, 1904/1906. Oil on canvas. 40 x 30 in. (101.6 x 76.2 cm.). Collection Mr. and Mrs. Rodman Rockefeller, New York.

224. Peto. *An English Breakfast*, probably 1890s. Oil on academy board. 5¹³⁄₁₆ x 8⅝ in. (14.8 x 22 cm.). Collection Mr. and Mrs. Paul Mellon, Upperville, Virginia.

225. Peto. *Five Dollar Bill*, c. 1885. Oil on canvas. 10¼ x 14 in. (26 x 35.5 cm.). Brandywine River Museum, Chadds Ford, Pennsylvania, and private collection.

226. Peto. *Old Souvenirs*, 1881/1900. Oil on canvas. 26¾ x 22 in. (67.9 x 55.9 cm.). The Metropolitan Museum of Art, New York, Bequest of Oliver Burr Jennings 1968.

227. Peto. *Sign Painting for Helen S. Peto*, 1903. Oil on academy board. 9½ x 11½ in. (24.1 x 29.2 cm.). Collection Blossom Smiley Bejarano and Joy M. Smiley, Island Heights, New Jersey.

224. Peto. *An English Breakfast*, probably 1890s.

American Still Life Paintings, 1860-1900. Exhibition catalogue, Adelson Galleries. Boston, 1968.

American Still Lifes: 19th and 20th Centuries. Exhibition catalogue, Kennedy Galleries. New York, 1971.

The American Vision: Paintings 1825-1875. Exhibition catalogue, The Public Education Association. New York, 1968.

Barry, Roxana. *Plane Truths: American Trompe L'Oeil Painting.* Exhibition catalogue, The Katonah Gallery. Katonah, New York, 1980.

_____. "Plane Truths: 19th-Century American Trompe l'Oeil Painting." *Art & Antiques* 4:5 (September/October 1981), 100-107.

Battersby, Martin. *Trompe L'Oeil: The Eye Deceived.* New York, 1974.

Baur, John I. H. *American Still Life Paintings from the Paul Magriel Collection.* Exhibition catalogue, The Corcoran Gallery of Art. Washington, D.C., 1957.

_____. "Peto and the American Trompe L'Oeil Tradition." *Magazine of Art* (May 1950), 182-185.

Bergstrom, Ingvar. *Dutch Still-Life Painting in the Seventeenth Century.* New York, 1956.

Born, Wolfgang. *Still-Life Painting in America.* New York, 1947.

Bye, Arthur Edwin. *Pots and Pans or Studies in Still-Life Painting.* Princeton, New Jersey, 1921.

Dars, Celestine. *Images of Deception: The Art of Trompe-L'Oeil.* New York, 1979.

Dee, Elaine Evans. *American Still Life Painting, Nineteenth Century: The Paul Magriel Collection.* Exhibition catalogue, Guild Hall. East Hampton, New York, 1969.

Frankenstein, Alfred. "'After the Hunt'—And After." *Bulletin of the California Palace of the Legion of Honor* 6:4-5 (1948), 1-23.

_____. *After the Hunt: William Harnett and Other American Still Life Painters, 1870-1900.* Rev. ed. Berkeley and Los Angeles, 1969.

_____. "Fooling the Eye." *Artforum* 12 (May 1974), 32-35.

_____. "Harnett, Peto, Haberle." *Artforum* 4 (October 1965), 27-33.

_____. "Harnett, True and False." *The Art Bulletin* 31:1 (March 1949), 38-56.

_____. "Illusion and Reality." *Horizon* 22 (July 1979), 25-31.

_____. *Illusionism and Trompe L'Oeil.* Exhibition catalogue, California Palace of the Legion of Honor. San Francisco, 1949.

_____. *John F. Peto.* Exhibition catalogue, Brooklyn Institute of Arts and Sciences, The Brooklyn Museum. Brooklyn, 1950.

_____. Papers on microfilm, Archives of American Art. Washington, D.C.

_____. *Reality and Deception.* Exhibition catalogue, University of Southern California. Los Angeles, 1974.

_____. *The Reality of Appearance: The Trompe L'Oeil Tradition in American Painting.* Exhibition catalogue, University Art Museum, Berkeley. Berkeley, 1970.

_____. *The Reminiscent Object: Paintings by William Michael Harnett, John Frederick Peto, and John Haberle.* Exhibition catalogue, La Jolla Museum of Art. La Jolla, California, 1965.

Gerdts, William H. *American Cornucopia: 19th Century Still Lifes and Studies.* Exhibition catalogue, The Hunt-Mellon University. Pittsburgh, 1976.

_____. *American Nineteenth Century Still Life Painting.* Exhibition catalogue, The High Museum of Art. Atlanta, 1971.

_____. *American 19th Century Still Life Paintings.* Exhibition catalogue, Noah Goldowsky Inc. New York, 1972.

_____. "The Bric-a-Brac Still Life." *Antiques* 81 (November 1971), 744-748.

_____. *A Century of American Still-Life Painting.* Exhibition catalogue, The American Federation of Arts. New York, 1966.

_____. *Illusionism in American Art.* Exhibition catalogue, Landau-Alan Gallery. New York, 1968.

_____. *Nature's Bounty and Man's Delight, American 19th-Century Still-Life Painting.* Exhibition catalogue, The Newark Museum. Newark, 1958.

_____. *150 Years of American Still-Life Painting.* Exhibition catalogue, Coe Kerr Gallery. New York, 1970.

_____. *Painters of the Humble Truth: Masterpieces of American Still Life, 1801-1939.* Exhibition catalogue, Philbrook Art Center, Tulsa, Oklahoma. Columbia, Missouri, 1981.

_____. "A Trio of Violins." *The Art Quarterly* 22:4 (Winter 1959), 370-383.

Gerdts, William H., and Russell Burke. *American Still-Life Painting.* New York, 1971.

Goodrich, Lloyd. "Harnett and Peto: A Note on Style." *The Art Bulletin* 31:1 (March 1949), 57-59.

Jones, Howard Mumford. *The Age of Energy: Varieties of American Experience, 1865-1915.* New York, 1971.

Langdale, Cecily. *American Still Lifes of the Nineteenth Century.* Exhibition catalogue, Hirschl & Adler Galleries. New York, 1971.

Lears, T. J. Jackson. *No Place of Grace: Antimodernism and the Transformation of American Culture, 1880-1920.* New York, 1981.

Mastai, M. L. d'Otrange. *Illusion in Art: Trompe l'Oeil, A History of Pictorial Illusionism.* New York, 1975.

Maytham, Thomas N. "*The Poor Man's Store,* 1885. John Frederick Peto." *Bulletin of the Museum of Fine Arts* (Boston), 60 (January-March 1962), 137-138.

M. B. "*Discarded Treasures* by Harnett (now, Peto)." *Bulletin of the Smith College Museum of Art* 20 (June 1939), 17-19.

McCoubrey, John W. "The Revival of Chardin in French Still-Life Painting, 1850-1870." *Art Bulletin* 46 (March 1964), 39-53.

"Peto—His Paintings Fool the Eye." *Look* 14:12 (6 June 1950), 68-74.

Schapiro, Meyer. "The Apples of Cézanne: An Essay on the Meaning of Still-Life." *Modern Art, 19th & 20th Centuries: Selected Papers.* New York, 1978.

Schriever, George. "An Endless World of Things: American Still-Life Painting to 1900." *Southwest Art* 10 (February 1981), 42-51.

R. S. [Regina Soria]. "John F. Peto's Studio." *Journal of the Archives of American Art* (January 1964), 8.

Sterling, Charles. *Still Life Painting, from Antiquity to the Twentieth Century.* 2d rev. ed. New York, 1981.

Weisberg, Gabriel, with William S. Talbot. *Chardin and the Still-Life Tradition in France.* Exhibition catalogue, Cleveland Museum of Art. Cleveland, 1979.

Wilmerding, John. "The American Object: Still-Life Paintings." *An American Perspective: Nineteenth-Century Art from the Collection of Jo Ann & Julian Ganz, Jr.* Exhibition catalogue, National Gallery of Art. Washington, D.C., 1981.

Winternitz, Emmanuel. *Musical Instruments and Their Symbolism in Western Art.* 2d ed. New Haven and London, 1979.

Index

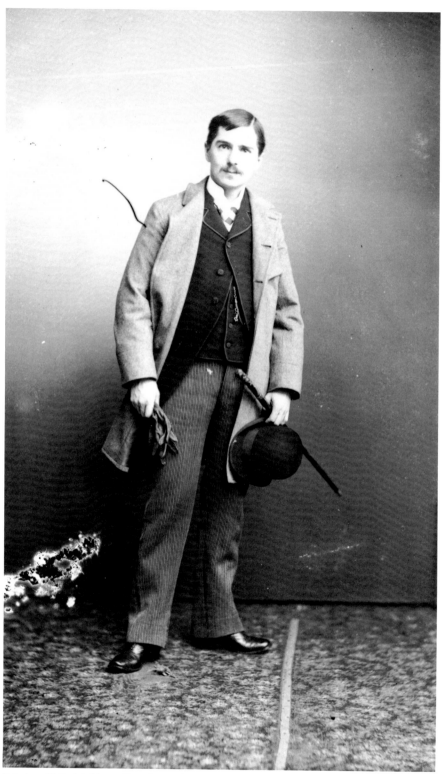

Peto in a Philadelphia studio, 1870s. Photograph. 8½ x 6⅝ in. (21.6 x 16.8 cm.). Peto family albums. The Studio, Island Heights, New Jersey.

Photographic credits

Wayne Andrews: figs. 27, 29, 31, 33, 123
Ankers Capitol Photographers, Washington, D.C.: fig. 187
E. Irving Blomstrann, New Britain, Conn.: figs. 177, 188
Brenwasser, New York: figs. 42, 64, 98, 164
The Brooklyn Museum: fig. 154
Jacob Burckhardt: fig. 111
Leo Castelli Gallery: fig. 181
Chisholm & Kenyon, Inc., Houston: figs. 43, 75, 95, 125, 165
Chisholm, Rich & Associates, Houston: fig. 89
Geoffrey Clements, Staten Island: figs. 57, 68
H. Edelstein, Northampton, Mass.: fig. 117
P. Richard Eells, Milwaukee: fig. 47
Helga Photo Studio Inc., New York: figs. 19, 34-37, 39-41, 51, 56, 66, 71-74, 82, 84-85, 90, 97, 99, 104, 107, 112b, 115, 122, 128-129, 139, 149-150, 159, 170, 173, 176, 180, 202, 211, 216
Hirschl & Adler Galleries, New York: fig. 157
O. E. Nelson, New York: figs. 119, 153
Eric Pollitzer, Hempstead, N.Y.: fig. 181
Larry Reynolds, Los Angeles County Museum of Art: figs. 162, 202-204, 206
Sotheby Parke Bernet Inc., New York: figs. 2, 6, 38, 48, 53, 59, 80, 94, 98, 185
Bill J. Strehorn, Dallas: fig. 101
Studio/Nine, Inc., New York: figs. 78, 88, 108
Joseph Szaszfai, New Haven: fig. 109
Taylor & Dull, Inc., New York: fig. 15
Jann & John Thomson, Los Angeles: fig. 162
Herbert P. Vose, Wellesley Hills, Mass.: fig. 151

Mechanical by Hilary J. Martin

drawn by Mark Leithauser